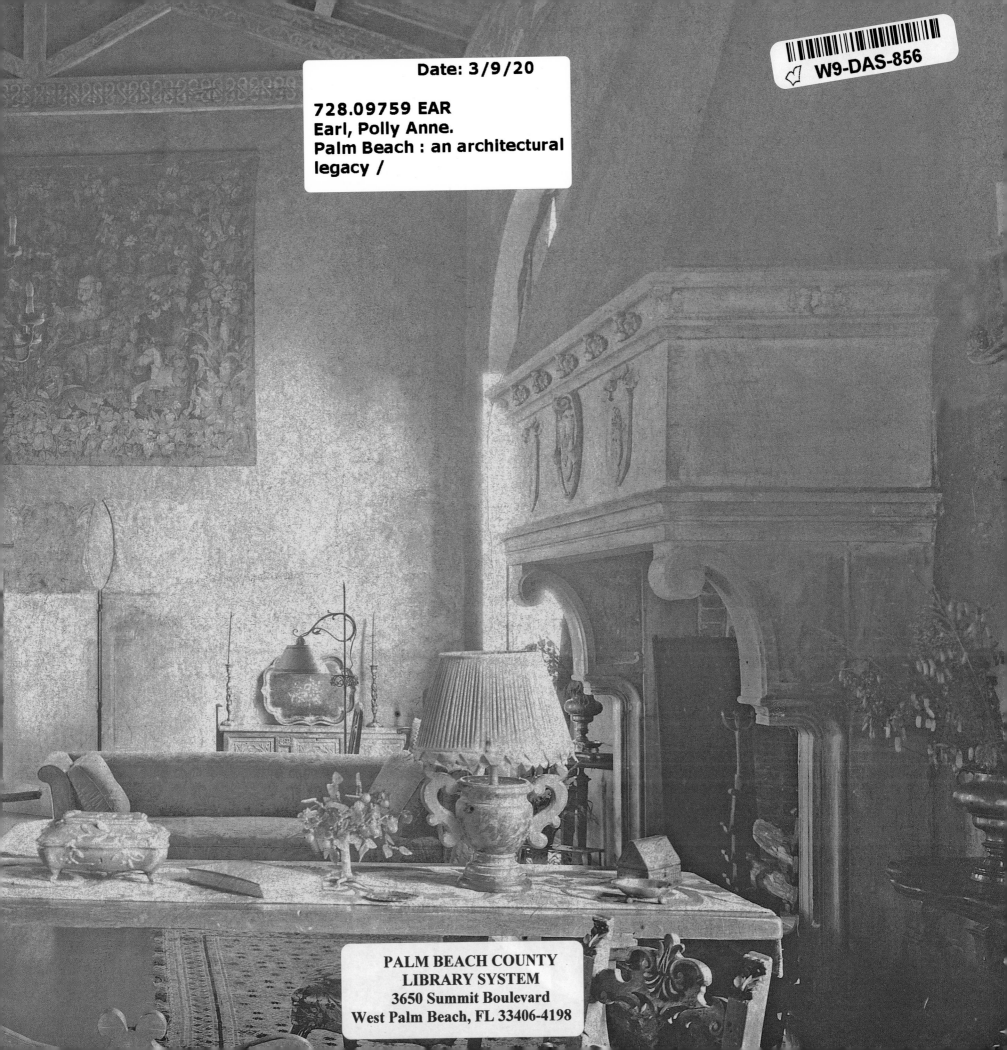

Palm Beach
An Architectural Legacy

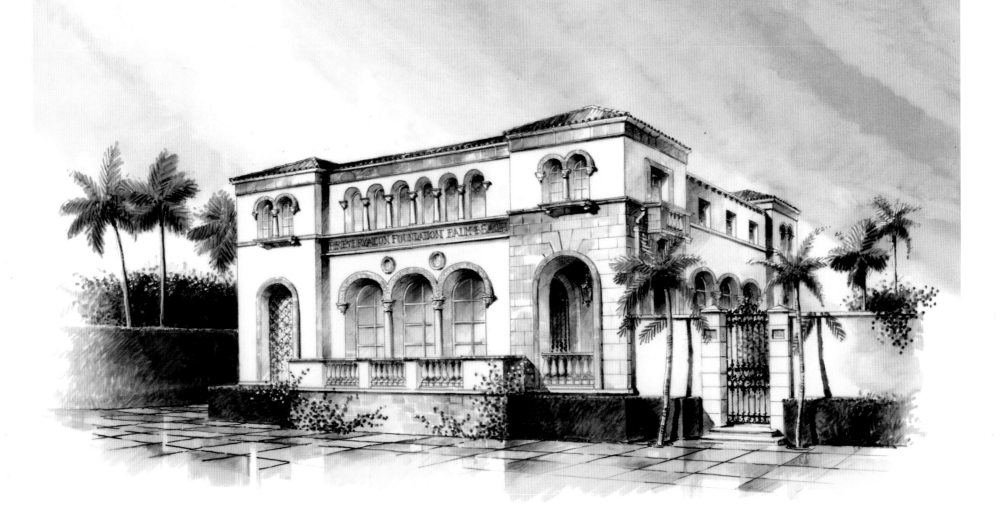

Palm Beach

An Architectural Legacy

Polly Anne Earl

Principal photography by Stephen Leek

Foreword by the Duke of Marlborough

Design by Charles Davey

RIZZOLI
NEW YORK

New York · Paris · London · Milan

In association with the Preservation Foundation of Palm Beach

PHOTOGRAPHIC ACKNOWLEDGMENTS

The author and publisher would like to express their sincere appreciation
to the following persons and organizations:
Duke of Marlborough, Blenheim Palace, Oxfordshire, England 6-8;
Historical Society of Palm Beach County, Palm Beach, Florida 11-12, 16, 17,
top right, 41, 63 right, 121 middle and bottom;
Flagler Museum Archives, Palm Beach, Florida 13 left;
Robert T. Eigelberger, Palm Beach, Florida 20-22, 24-29, 30 top right, 31;
Kim Sargent, Palm Beach Gardens, Florida 108, 116-118, 165, 170 top, 171,
184, 190, 192, 193 top, 195, 224, 229 right, 230-231, 233-235;
Roberto Schezen/Esto, Mamaroneck, New York 54, 59;
Alexandra Fatio Taylor, Palm Beach, Florida 78 bottom left,
79 bottom left, 83 top right;
Mrs. John L. Volk, Palm Beach, Florida 141 bottom right, 143 bottom right,
144 bottom left and far left, 150 right;
Preservation Foundation of Palm Beach Archives 9, 17 top and bottom left,
18-19, 23 bottom, 30 bottom left, 95 bottom right, 97 bottom, 101 left,
109 bottom left and right, 139 right, 141 top, 173 bottom, 175 bottom left,
183 bottom, 185 bottom, 188 bottom, 189 bottom left.

First published in the United States of America in 2002 by
Rizzoli International Publications, Inc.
300 Park Avenue South, New York, NY 10010
www.rizzoliusa.com

ISBN-13: 978-0-8478-2510-3
Library of Congress Control Number: 2002111910

Published in association with the
Preservation Foundation of Palm Beach

Front cover: Casa di Leoni (page 107)
Back cover: Casa della Porta (page 75)
Frontispiece: Artist's rendering of the Preservation Foundation
education and architectural history center
Pages 2-3: South Lake Trail House (page 141)

2010 2011 2012 2013 / 10 9 8 7 6 5 4 3 2

A Charles Davey design book
charles@charlesdaveybooks.com
Printed in China

Contents

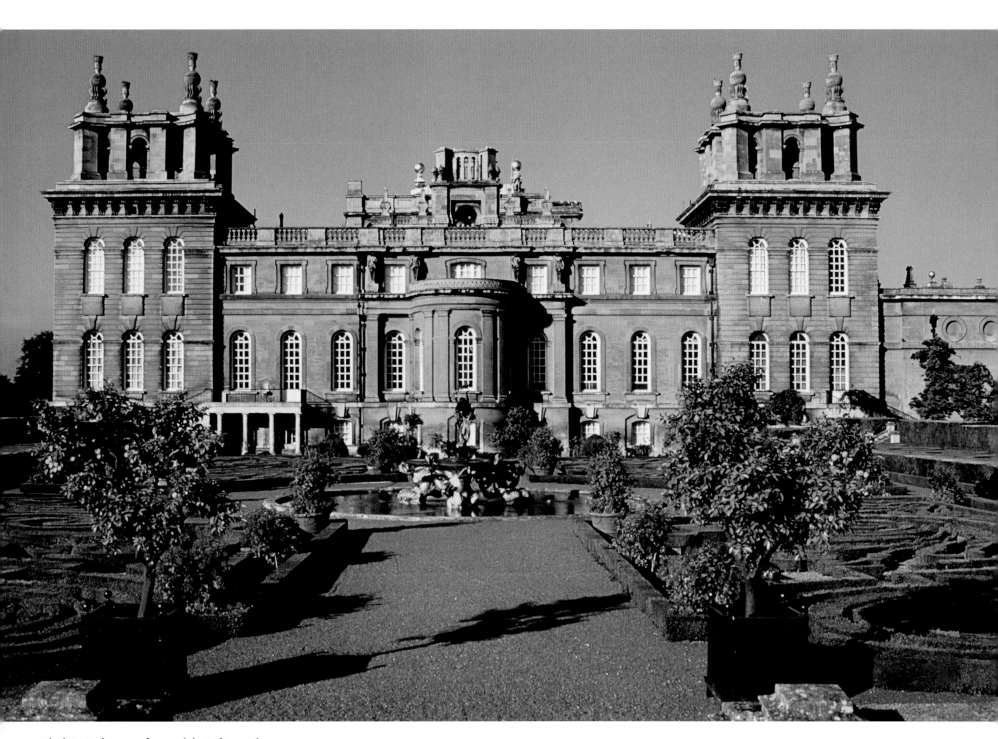

Blenheim Palace, east front and the Italian garden.

Foreword

This book is a celebration of the Ballinger Award winners for outstanding historic restoration in Palm Beach. In a world of accelerating change characterized by redevelopment of traditional architecture and change in historic neighborhoods, the movement to preserve historic areas clings to a tenuous lifeline. Major threats like the Disney feint at developing Civil War battlefields outside of Washington, D.C., may provoke instantaneous public outcry, but day in and day out destruction of historic homes, shops, streets, and neighborhoods proceeds inexorably, driven by the pressure of an era of rising real estate values.

Not all change is bad, but throughout our history we have clung to elements of our past as carriers of our culture and as guidelines to the integration of old and new into our constantly evolving value system. The honor and respect accorded to documents such as the Magna Carta and the Constitution are examples of the values of the past guiding future change. Just so, the built environment that surrounds us and shelters us is a carrier of past values. Where we can, we need to preserve its triumphs and occasionally its follies, the best and even sometimes the mundane examples of how our society lived, worked, worshiped, and played.

In Palm Beach, Florida, as in other areas of the United States, the movement for historic preservation struggles against pressures for change. Palm Beach is a distinctive laboratory for the operation of historic restoration and preservation programs. From its earliest establishment as a formal community, Palm Beach was gifted with an extraordinary architectural endowment. As a resort patronized by the distinguished families of the turn-of-the-last-century, Palm Beach could afford the kind of signature architecture not found in other newly established towns.

By the early twentieth century the town had acquired a world class reputation for its elegant life style dominated by the extravagant homes that ringed it shores. Addison Mizner, Marion Sims Wyeth, John Volk, Joseph Urban, Maurice Fatio, and Howard Major — these were the six names celebrated as the foundation architects of the Palm Beach style.

But, by the 1970s, many of these dramatic architectural statements were deemed old-fashioned and outdated. Pressures for redevelopment and change led to a counter pressure to restore and preserve the treasures of the past. As a result, Palm Beach followed Boston, New York, New Orleans, Pittsburgh, and other communities throughout the United States and took the significant step of establishing a historic preservation ordinance to formally designate its important historical and architectural landmarks. A Landmarks Commission was established in 1979. In the same year a number of prominent citizens joined to create a charitable foundation, The Preservation Foundation of Palm Beach, with the goal of preserving the architectural heritage of Palm Beach and educating its citizens about their heritage.

Through the establishment of the Ballinger Award in 1988, The Preservation Foundation found a way to link its goals of preservation and education. The award (or awards, as some years two are granted) goes to restoration efforts which have made an outstanding contribution to Palm Beach's architectural heritage through the preservation of historic architecture or through the construction of new architecture which is noteworthy for its compatibility with the architectural traditions of Palm Beach.

As the guardian of a major heritage house, Blenheim Palace, in Great Britain, I can speak with authority of the trials and tribulations of safeguarding a historic monument. Blenheim, a private home and a public attraction, differs in age and scale from the recipients of the Ballinger Award, but the problems of restoration and preservation are similar.

The Palace was built for my ancestor, John Churchill, 1st Duke of Marlborough, by Queen Anne and a grateful nation in recognition of his great victory over the French at the Battle of Blenheim, 1704. It was designed to be both a home for him and to be a monument to his great achievement. The resulting Palace, a masterpiece of English baroque, covers, with its courtyards, a total of seven acres.

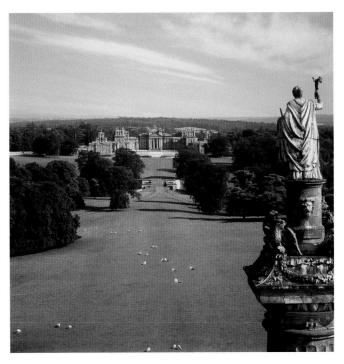

Blenheim Palace and the Column of Victory, from the north.

This is our preservation and restoration task: although the original Battle *OF* Blenheim was won 300 years ago, we feel the battle *FOR* Blenheim continues to this day.

The Palace and the history it represents mark a major moment, not just in national but in international history. Blenheim was one of the very earliest sites chosen by the United Nations via UNESCO to be identified as a World Heritage Site.

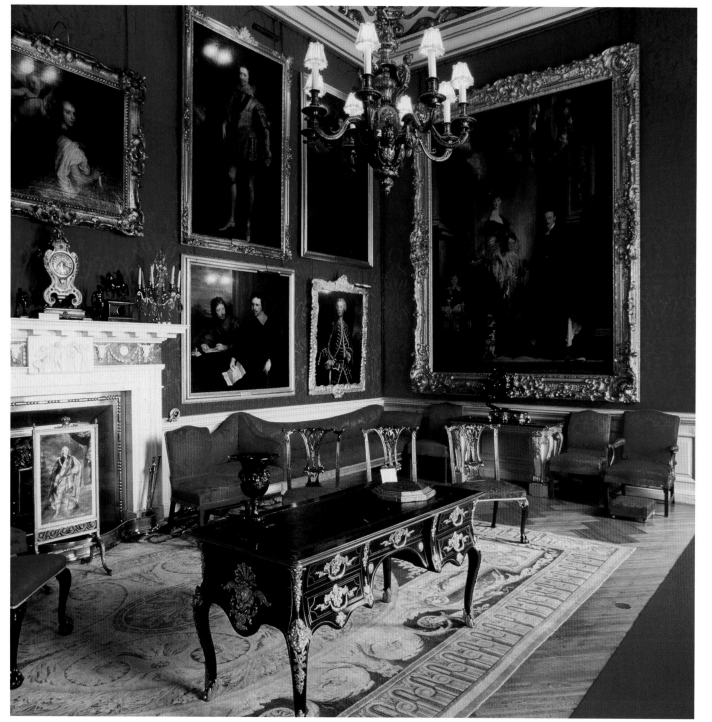

Blenheim Palace, the Red Drawing Room.

many areas are necessary and valuable but are expensive. The taxation system is not always helpful.

My kinsman and godfather, Sir Winston Churchill, who was born at Blenheim, of course, echoed the wish of the 1st Duke that: "Blenheim should last for a thousand years," a dream perhaps but an ambition worth striving for.

By creating the Ballinger Award, the Preservation Foundation found a way to thank the owners who have made the personal choice to maintain a significant structure for the future. The award, which has been granted twenty-one times since 1988, quickly became a coveted prize. While it is given to the owners of outstanding restoration projects, in truth, it also honors the teamwork necessary to create a masterpiece of restoration. Architects, interior designers, landscape architects, construction firms, and other specialists are recognized at the award ceremony. Above all, the award goes to the silent participant at the ceremony — the house itself. This book honors and recognizes those homes which have achieved the singular distinction of receiving the Ballinger Award.

As custodians of the priceless heritage that is Blenheim, my family and I are endeavoring to ensure that this magnificent house will be preserved for future generations; that the pleasure our family home affords to our hundreds of thousands of visitors, national and international, of today, will continue to be enjoyed by their successors of the future.

The task is not an easy one. Costs of labour and materials rise steadily and both must be of the highest quality to match the standards of this magnificent building. Even day-to-day maintenance and conservation are costly, and we must also be prepared for the large-scale demands which regularly occur: at present we are involved in a total electrical rewiring programme. The modern technologies available in

I welcome wholeheartedly this volume, which demonstrates such support for the need to preserve our heritage.

Marlborough

John George Vanderbilt Henry Spencer-Churchill
11th Duke of Marlborough
Blenheim Palace, 2002

Preface

The Ballinger Award was named for the late Robert I. Ballinger, Jr., a forceful advocate for preservation and an early chairman of the Town of Palm Beach Landmarks Commission.

Barbara Hoffstot, a Preservation Foundation trustee who knew Ballinger well, best expressed why the Preservation Foundation's award was named for Bob Ballinger.

The award is named for Robert I. Ballinger, Jr., who was born and educated in Philadelphia, graduated from Cornell's School of Architecture, and returned to Philadelphia to practice in The Ballinger Company, Architects and Engineers. Bob Ballinger was particularly interested in and known for his work in designing and renovating hospitals.

But it is among us in Palm Beach that we knew Bob best. He began by doing La Belucia, a splendid restoration of his own Mizner ocean-front house. After that, he gravitated to the preservationists in the town. He was a member as well as Chairman of The Landmarks Preservation Commission from 1979 to 1985. I had the pleasure of sitting on the Landmarks Commission with him. He was a knowledgeable preservationist and his architectural training and wisdom were invaluable. He ran a competent tight ship. He was smooth in a very rough area. By that I mean, he spoke well before the Town Council and was listened to by them with considerable respect. He seemed to know everyone on the Town staff and was therefore able to explain and convince and yes, get his way most of the time in the various departments of the Town explaining the benefits of preservation, trying to convince all of the need to preserve our heritage. He was an indefatigable ambassador and his enthusiasm was catching. He was always willing to speak out for what was then not a popular point of view. He nailed his colors fast to the mast and would say "This is right."

The award itself is a silver medal designed by the noted medalist, Edward R. Grove, whose work is in the Metropolitan Museum of Art, the Carnegie Institute, the Corcoran Gallery of Art, and the Smithsonian Institute. Grove is also the sculptor of the bicentennial eagle at the western end of Royal Poinciana Way in Palm Beach. In designing the Ballinger Medal, Grove worked from a sculpted head of Robert Ballinger created by his wife Didi Ballinger.

Composing a book is similar to building a restoration. No detail is too small to ignore. This book would have been impossible to construct without the diligent support of the Preservation Foundation staff: Cynthia Curry who oversaw the production process, Carolyn Denton and Janice Owens who pursued every essential fact diligently, and Sharon Kearns who was always ready to deal with the crisis of the day. Dr. Donald W. Curl, professor at Florida Atlantic University whose book, *Mizner's Florida: American Resort Architecture*, began the serious study of Palm Beach architecture and set a standard not yet surpassed, graciously read and commented on the manuscript. Donald Curl's depth and breadth of knowledge about Palm Beach architecture is a treasured resource for any study in this field. Our designer Charles Davey breathed life into these pages with his judicious selections from thousands of Ballinger Award photographs and with their polished presentation. Stephen B. Leek, who was responsible for the great majority of the photographs in the book, was tireless in his pursuit of perfection.

John D. Mashek, Jr., President of the Preservation Foundation of Palm Beach, always believed the story told through the Ballinger Awards would bring meaning and pleasure to people who care for fine architecture. Without his support this volume would never have come into being. Finally, the Preservation Foundation wishes to thank the many Palm Beach supporters who bring us countless tidbits of information about the history and architecture of Palm Beach. Their contributions have built this book. Omissions and infelicities are, of course, the responsibility of the author, who thanks all the officers and board of the Preservation Foundation for their belief in Palm Beach's architecture and its restoration.

The Ballinger Award Medal. One side of the Ballinger Award Medal shows Edward R. Grove's likeness of Robert Ballinger, Jr. The reverse is inscribed with the names of the owners and the building being honored.

The Beginnings

In 1893 when Henry Flagler first came to Palm Beach, the town was still in the process of inventing itself. What had been a quiet settlement of pioneers and genteel sportsmen was galvanized into a hotbed of resort development by the impact of Flagler's Florida East Coast Railway and his destination hotels. The town never looked back as it went on to become, by the turn-of-the-century, an American Riviera without parallel in its wealthy clientele, its reputation for extraordinary entertainment and shopping, and, most of all, its endowment of glorious architecture.

Flagler already had what is known today as a "business plan" for the profitable development of the east coast of Florida. With each extension of his railroad, Flagler, a former Rockefeller partner in the Standard Oil Company, also financed the building of a major hotel. St. Augustine, the terminus of the railway in 1890, required three hotels, the Ponce de Leon (1888), and the Cordova and the Alcazar (1889). They were hotels of distinction and immediately garnered round-trip business for the railway.

The next major terminus for the march down the east coast was a matter of considerable interest to Florida's early settlers, who watched the same process on the west coast as Henry B. Plant extended his railroad, the Southern Express Company, on the opposite side of the state. In Flagler's case, his selection of the hitherto unremarkable barrier island of Palm Beach may have been influenced from the start by Palm Beach's architecture. A tidbit of oral history speaks of an itinerant photographer who showed Flagler photographs of a Palm Beach house in the late 1880s. This house became Flagler's first home in Palm Beach. Ultimately it was known as Sea Gull Cottage. On seeing the photographs Flagler supposedly said, "Why I didn't know there was anything south of Rockledge as beautiful as that."

How Palm Beach came to boast a house that attracted the interest of Henry M. Flagler, one of the authentic Gilded Age pioneers of America's great industrial revolution is the story of the beginning of Palm Beach as an international resort. Palm Beach was an unnamed wilderness on Florida maps in 1870, although Jupiter Inlet just to the north, with its 1860 Civil War lighthouse, was already named. In 1873 the first formal homestead in the Palm Beach area was filed by L. L. Hammond.

In 1878 the brig *Providencia* wrecked off the coast with a cargo of twenty thousand coconuts. The stranded brig provided Palm Beach's first agricultural craze when Hiram Hammon and William Lanehart, two early settlers, bought the cargo and resold it for 2.5¢ a coconut. Through this fortuitous circumstance Palm Beach acquired the fringe of coconut palms that gave it its name.

The Dimick, Geer, and Brown families from Michigan, who all played a role in the subsequent creation of a true community in Palm Beach, settled on the lakefront in 1876. Elisha N. "Cap" Dimick, expanded his lakefront home by eight rooms and opened it to winter visitors as the area's first hotel, the Cocoanut Grove House.

In 1884 the Brelsford brothers, Edmund and John, established the first general store, which later also served as a post office.

In 1885 the famous era of the barefoot mailmen when local residents were hired to walk the beachfront delivering mail from Jupiter to Miami. For five dollars travelers who sought the comfort of an experienced guide could walk along with the mailman. The only alternative at the time was an ocean passage by sail. There were no interior roads.

The year 1886 marked a turning point for Palm Beach. The community joined together to support its first school, a one-room venture that welcomed Hattie Gale, a sixteen-year-old, as its first teacher. Ladies held bake sales to raise money for the school, while the men contributed their labor for its construction. Once completed the school also became the center of pioneer religious life with the Congregationalists holding services there in the morning and the Episcopalians in the afternoon.

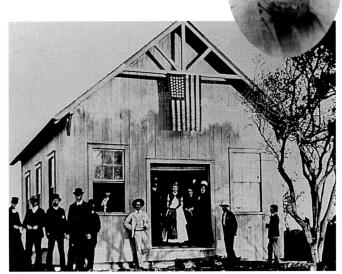

INSET Hattie Gale at age sixteen became the first teacher at the first school in Palm Beach. When it opened in March of 1886 for a limited term, she taught seven students ranging in age from six to seventeen in the one-room schoolhouse. Her father, the Reverend Elbridge Gale, was a former Professor of Horticulture at Kansas State Agricultural College. Dr. David Fairchild, founder of Miami's Fairchild Gardens, was a former student of Gale's.

ABOVE The opening of Palm Beach's schoolhouse was an occasion for community pride, and local residents attended in business attire. Hattie Gale is standing in the doorway.

OPPOSITE The restoration of Sea Gull Cottage took over a year. The opening ceremonies in 1985 featured one of Florida's senators, one of Florida's congressmen, a Marine color guard, and an enthusiastic crowd who gathered to tour the house. Sea Gull's restoration won two Florida Trust for Historic Preservation Awards, as well as an award from the National Paint and Coatings Association, and an award from the Palm Beach Chamber of Commerce.

This schoolhouse was the first school in Dade County, indeed in all of southeast Florida. Palm Beach and Dade counties were not formally separated until 1909. Today the Preservation Foundation of Palm Beach operates a role-playing experience for fourth graders in the original one-room school. It is one of only about two dozen educational programs still operating in one-room schools throughout the entire United States. The one-room school, now moved from its original lakefront location, has become affectionately known as the Little Red Schoolhouse.

Also in 1886 R. R. McCormick, formerly of Denver, built the house that became known as Sea Gull Cottage, the oldest extant home in Palm Beach. In many ways Sea Gull's history mirrors the development of the town. In a community of pioneer subsistence hunters, farmers, fishers, and trappers, Sea Gull, then known as the McCormick Cottage, a substantial shingle-style structure with a third-story cupola, was acknowledged as the "showplace of the lake." McCormick could afford to endow his wilderness cottage with all the fine interior and exterior amenities that Victorians valued as he had recently retired from extensive business interests in Colorado. He had been Secretary of the Denver and Boulder Valley Railroad, Treasurer of the St. Louis and Denver Land and Mining Company, Secretary of the Denver and Pacific Railway, and Secretary of the Denver Ale Brewing Company.

A humorous photo, probably from the gay nineties, shows an early Palm Beach tourist with coconut in hand and also a coconut cap.

Historical records are not clear as to why McCormick left Denver. Apparently a fishing trip brought him to south Florida. What is clear is that with McCormick's purchase of the Albert Geer lake-to-ocean site of fifty-two acres on the island of Palm Beach, the Denver railroad promoter and real estate entrepreneur inaugurated the cycle of ever increasing real estate prices that has characterized land in Palm Beach ever since. Geer had paid 85¢ an acre for his tract. McCormick bought it for a total of ten thousand dollars. It was the largest land transaction up to that time in the community and the wonder of local citizens who quite rightly surmised that even greater profits lay ahead for astute real estate investors.

For his ten thousand dollars McCormick got what he referred to as "truly a paradise." In the words of the previous pioneer owners "the sky was bluer, the water clearer, the flowers sweeter, the song of birds more musical than could be found elsewhere on the continent . . . [Providence provided] sweet potatoes weighing ten and twelve pounds . . . forty pound watermelons . . . as well as eleven pound pineapples . . . the choicest fish, the best flavored venison, the tenderest bear steak . . . was ours, if we would but help ourselves . . . not to mention the generosity of the

waves," which carried in all manner of goods, necessary and luxurious, from lard, to clothing, to iron cook stoves. Balanced against these delights of nature and climate were the difficulties of insects, hurricanes, and remoteness. No minister, mortician, or school teacher resided on Lake Worth's shores at the time of McCormick's coming. Mailmen still walked the beaches and more than one pioneer gave up his stake and headed elsewhere because of the lack of regular transport. The all-water transport of the time precluded any effective marketing of cash crops.

Small wonder local descriptions of the McCormick place marvel over its hundreds of "magnificent and rare plants . . . beautiful promenades . . . redolent with the perfume of flaming tropic flowers." To the nine hundred coconuts from the *Providencia* wreck and six hundred tropical trees of twenty-six varieties planted by the Geers, McCormick added seven hundred roses and two hundred chickens of "Fancy breeds." Visitors spoke of McCormick's horticultural efforts as, in reality, "a private experiment station" with two acres of clear area bordering the lake and

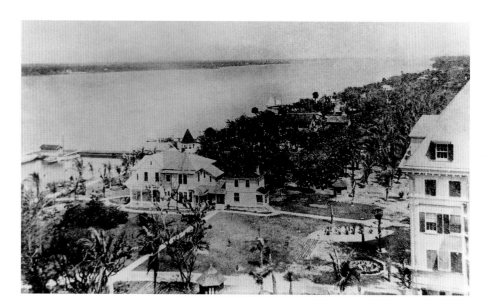

Sea Gull Cottage viewed from the corner of the Royal Poinciana Hotel shows the close relationship between the cottage, which served as Henry Flagler's first winter home in Palm Beach, and the hotel. This photograph predates 1904 when the railroad bridge from West Palm Beach was moved from south of the hotel to the north of the hotel.

" 'colonnades' of coconuts . . . flower-beds . . . containing fancy-leaved caladiums . . . and a bed of crotons, the finest private collection . . . ever seen," as well as lime, lemons, orange, sour-sop, sapodilla, tamarind, mango, date, and alligator pear (avocado) trees, pineapples and for vegetables, peas, lettuce, tomatoes, squashes, and cucumbers completing the fifty-two acres of the estate.

Commentators waxed even more rhapsodic over McCormick's house as "the crowning glory" of his estate. McCormick had moved rapidly to demolish the one and one-half story Geer house built of vertical yellow pine boards in the homestead fashion as evidently unsuitable for the scale and taste of his Florida establishment. Building materials were quickly imported on the first scheduled packet line on Lake Worth, via the schooner *Emily B.* Local recollection was proved correct when during the restoration of Sea Gull, boards were found in the walls marked for

"R.R. McCormick, Lake Worth." Apparently even a former Denver millionaire was not above adopting local customs and profiting from the bounty of the sea, for Sea Gull's still magnificent mahogany staircase is said to have been constructed from lumber scavenged from the beach after a shipwreck. The local press noted other aspects of the house such as its "cool, well-ventilated rooms . . . fancy ornamental woods . . . and floors of Georgia marble. Handsome mirrors and furnishing impart a luxurious appearance . . . and a cupola affords one of the most beautiful views of the surroundings." At a reputed cost of thirty thousand dollars McCormick's home commanded considerable local interest. The completion of such an up-to-date home signaled the beginning of the end of Palm Beach's pioneer days. Efforts to establish regular lake and ocean transport lines pointed toward the development of a stable cash economy and an influx of new residents.

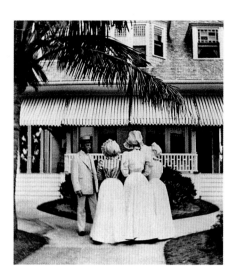

An 1890s photograph of Sea Gull Cottage shows Henry Flagler in front of his first Palm Beach home chatting with three ladies.

By 1893 Flagler had completed his deliberations and purchased the land necessary for his railroad connections and for another jewel in his hotel chain. Once again the McCormick property figured prominently in the history of Palm Beach's development. Flagler's purchase of the McCormick property in 1893 for $75 thousand gave him the location he needed for the Royal Poinciana Hotel, which was to be the largest wooden resort in the world.

With its opening in 1895, the Royal Poinciana became a magnet for the rich and famous who could enjoy either the social life afforded through the hotel or the outdoor swimming, bicycling, fishing, and hunting offered by the Florida climate. McCormick's house, now Flagler's home, stood at the center of all activities. Its original location placed it at the very forefront of the hotel, between the hotel and the lakeside. During his winter sojourns in Palm Beach, Henry Flagler himself occupied the house. It was his first Palm Beach home and became known as "a house with two fronts and no back doors," probably from its proximity to the pedestrian traffic along the lakefront to the west and the bustle of traffic to and from the hotel on its east side. At this time it acquired the name Croton Cottage, perhaps for the magnificent croton beds that McCormick had planted.

By the Flagler era of the 1890s, McCormick's cottage had already served as the stylistic harbinger for a clutch of similar homes along Palm Beach's lakefront. All were built to accommodate the families of wealthy northerners who brought with them, as McCormick had, an architectural preference for high Victorian taste from the style centers of the north. Sea Gull's shingle style, a popular architectural motif of the great Newport resort homes of the era, suited Florida well. Broad porches and high ceilings cooled the Florida heat. Towers or cupolas provided inviting views. An emphasis on wood as the primary construction material utilized the resources of the area.

As an architectural style the shingle style is perhaps the most authentically American offshoot of the Queen Anne style popularized by H. H. Richardson. The anonymous builders of Sea Gull created a typical shingle home in their use of contrasting areas of siding and fish-scale shingles. Volumetric contrasts are also evident in the projecting front flanked by receding side porches. Additional drama is created by balcony projections at the second-story level, one now enclosed to create a modern bath. Other distinctive features are the long gable roof, second-story front dormers, and the, sadly now destroyed, third-story cupola or tower. At the rear a steeply-sloped shed roof covered a passageway to an original kitchen wing of nondescript rectangular character.

As an adaptive restoration Sea Gull's interior was put to new uses based on the needs of the Royal Poinciana Chapel. The original library was not fully decorated as a period room, but a hint of Victorian taste was provided by a late nineteenth-century Neo-Egyptian chandelier and a classical acanthus wallpaper border and ceiling medallion.

As the earliest fine house in the area, Sea Gull no doubt provided a design source for many of the frame homes built in the 1890s which formed the nucleus of Palm Beach's so-called cottage colony. Twentieth-century redevelopment and the vogue for anything associated with Addison Mizner's Mediterranean Revival style has obscured the significance of the shingle style in Palm Beach's architectural history. But it can be truly said that Palm Beach's earliest domestic architecture was typically American and typically shingle.

In 1983 when the Preservation Foundation mounted a major campaign to restore Sea Gull Cottage, restoration consultants found that in its original interior appointments and embellishments, Sea Gull yielded to none in its portrayal of high style decorative taste for its time. The period photographs Henry Flagler saw showed a parlor with a fashionable gilt-patterned ceiling, perhaps a gilt leather, numerous Victorian wallpaper borders, handsome wood accents, and sparkling chandeliers. Of particular note were the vertical strips of molding that divided the wallpaper into sections. This may have been a decorator's touch from a high style center like Philadelphia or New York.

After Flagler purchased Sea Gull's lake-to-ocean tract of land, the Royal Poinciana Hotel was literally constructed around the cottage. The Royal Poinciana at its maximum size included over eleven hundred hotel rooms and thirteen miles of corridors. Guests' every whim was served by fifteen hundred employees. The main dining room could hold 1,640 diners at one time, and the ballroom was the scene every year of the Washington's Birthday Ball, the major event of the Palm Beach social season.

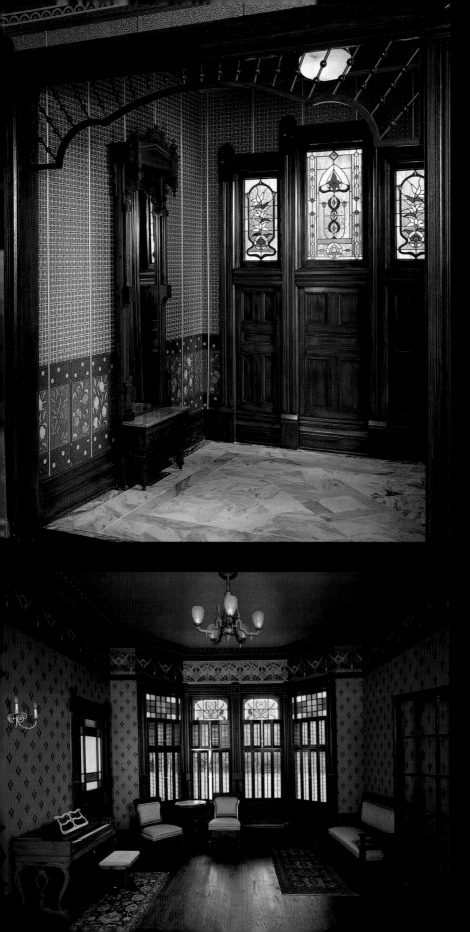

TOP LEFT The front and back entrance halls at Sea Gull contained the only remaining examples of the house's original fine marble floors. The restored front entrance hall preserved the marble and added Victorian wallpaper by Bradbury and Bradbury Inc., similar to patterns shown in the historical pictures. The stained-glass windows were recreated by McMow Art Glass following the designs in historical photographs.

LEFT The original dining room area was restored as a music room. The wallpaper is by Bradbury and Bradbury. The chandelier is Neo-Egyptian, a design source popular in the Victorian period. The stained-glass windows were reproduced by McMow Art Glass from black and white historical photographs. The window shutters were also reproduced from black and white historical photographs.

OPPOSITE The restoration of Sea Gull's parlor included wallpapers from Bradbury and Bradbury Inc. in high-style Victorian patterns emphasizing gilt details and a Japanese influence. Missing spandrels flanking the fireplace were replaced with late nineteenth-century spandrels from Pittsburgh. Period furnishings similar to those shown in the original picture were used, including a red velvet Eastlake style tête-à-tête in the center of the room, a Renaissance Revival inlaid console table, an Eastlake easel with pastoral watercolor, a marble top console table, and oriental rugs. The marble floors were not replaced because of safety concerns on the part of the Royal Poinciana Chapel, which welcomed the adaptively-restored house for its Sunday school.

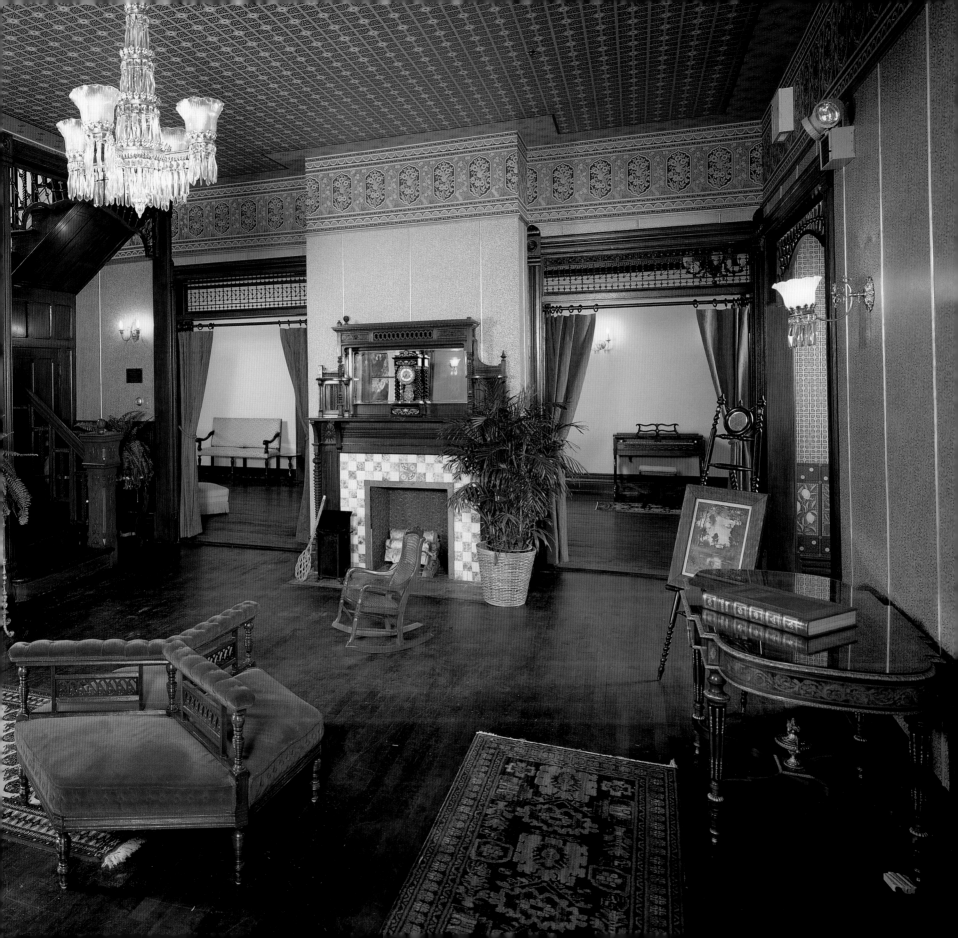

The afternoon tea dance at the Royal Poinciana Hotel's Cocoanut Grove was a popular social event for all ages. In the evening the tea garden was lit with Japanese lanterns. The Waltz of the Flowers was one of the popular dance tunes played by the orchestra. Many a romance began — or ended — at the Cocoanut Grove.

An early newspaper provided a detailed review of the 1898 festivities, which featured an elaborate costume ball.

The brilliant Washington birthday assembly ball of 1898 has been chronicled among the notable events at the Royal Poinciana. The galaxy of handsome and distinguished men of profound learning and great personal

This view of Sea Gull's parlor during R. R. McCormick's ownership, 1886-1893, shows the Georgia marble floors and mahogany staircase which were regarded as opulent features of the interior by local settlers.

magnetism presented a most imposing and bewildering scene, a sight to please the gods. Compliments were showered upon them for their exquisite taste in choice of elegant and becoming costumes, which were worn with the mien and grace of princes to the manor born.

Among the most appropriate costumes was the one worn by Mr. Henry M. Flagler, a Martha Washington gown, combination of the Florida East Coast colors, trimmed with bands of miniature silk flags, palm leaf boutonniere. . . . Hamilton Perkins, fascinating Ven[etian] lace gown with hand embroidered silk panel-map of the Boston & Albany Railroad. . . . James Ridgeway, imported Tammany gown, bodices embroidered with skull and cross-bone designs, lace capote surmounted by the coat-of-arms of New York State. . . . Arthur Clow, Klondike reindeer costume, long handsome feather boa, seal skin cap, gold embroidered. Sidney Maddock, white silk Pelican Island Yacht Club gown, a most stunning creation. . . . Harry Stearns, a gown of life insurance policies, gilt-edged, all wool. . . . Henry Phipps Jr., a William Penn costume, elaborately trimmed with Carnegie cut steel ornaments. . . . C. I. Cragin, military costume of the reign of the Grand Monarque, a regular Reve d'Ete affair, with a halo about his head of iridescent soap-bubbles Commodore Clarke, a Lake Worth creation of palm-green silk, bands of alligator skin, rattlesnake bodice, genuine article, cocoanut fibre hose and slippers, and gorgeous hand bouquet of palmetto flowers with pineapple fragrance.

The oral history of early days is filled with stories of private railroad cars lined up at the Royal Poinciana after the lavish Washington's Birthday Balls to carry their owners northward until the next winter season.

The Royal Poinciana's delights were not confined to the Washington's Birthday Ball. In 1896 Flagler constructed the Palm Beach Inn, renamed the Breakers Hotel in 1901, on the oceanfront. The hotel burned to the ground in 1903 and again in 1925, when it was rebuilt in fire-resistant stucco from an Italianate design by the New York architects Shultz and Weaver.

The hotel guests at both hotels could avail themselves of the Breakers ocean fishing pier where steamers called for the trip to Havana. They could golf and play tennis and watch the boat parades on Lake Worth. They could bicycle or stroll along Lake Trail, which remains today a pedestrian byway along Lake Worth, to visit the local attraction of Alligator Joe's, which displayed alligators and manatees in a jungle setting. New York stores were available for shopping at both hotels. Guests could travel down the pine walk between the hotels by a railcar drawn by a mule named Molly. Perhaps the most popular pastime of all was the afternoon tea dance at the Royal Poinciana's Cocoanut Grove where cocoanut cake was the dessert of choice.

Flagler built his own Beaux Arts mansion, Whitehall, in 1902, next to the Royal Poinciana Hotel. The success of Flagler's hotels gave rise to the great era of hotels in Palm Beach. Sea Gull Cottage became a part of the hotel age when it was moved to the oceanfront in 1913 and became one of the Breaker's rental cottages. For seventy years the cottage that had been the pride of the early lakefront community served valiantly as a seasonal rental accommodating whole families and their staffs for the winter season.

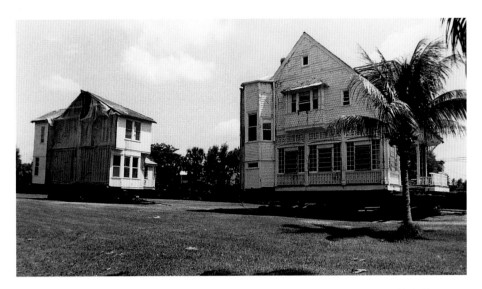

In 1984 the Preservation Foundation moved Sea Gull Cottage back to its original lakefront orientation at a site approximately two blocks south of its original location. The moving process involved cutting the house in half. Note the truncated, formerly three-story stair tower on the lead house section. This photograph shows Sea Gull's stately progress as it rolled over the Breakers golf course toward its new home. When the cottage first turned onto the street, at midnight to avoid traffic, it was cheered by a crowd of Palm Beachers in evening clothes.

At its new site on the grounds of the Royal Poinciana Chapel, Sea Gull required construction of a new foundation, a new roof, and extensive woodwork repairs. The cottage had been subjected to over seventy years of unrelenting Breakers maintenance which relied on painting everything white once a year. As a result, decorative moldings which appeared to be intact were found to be simply shells of paint with the wood beneath reduced to dust.

In 1983 when the Preservation Foundation discovered Sea Gull was menaced with destruction as a result of the Breakers' plan to replace its cottages with new condominiums, protracted negotiations began in an effort to save Palm Beach's oldest house. An agreement was forged between the Breakers, the Preservation Foundation, and the Royal Poinciana Chapel, the interdenominational house of worship founded by Henry Flagler (ca. 1895), to move Sea Gull Cottage to the chapel's grounds. The Preservation Foundation agreed to restore Sea Gull as an adaptive restoration to serve the needs of the chapel and its own needs for a library. Sea Gull, which had been an active presence in the early development of Palm Beach and in the hotel era, thus played a continuing role as Palm Beach entered a new stage of preserving its architectural heritage.

By the Roaring Twenties America's economic prosperity coupled with the vibrant Florida land boom had changed Palm Beach into a major resort with a hotel based economy. The Alba (later named the Biltmore) was built in 1925, as were the Palm Beach Hotel and the Vineta Hotel. The Billows and the Brazilian Court were other early hotels. Flagler's original railroad-only bridge was transformed into an auto access to the island. As a result the northern commercial area of Palm Beach exploded with development. The Fashion Beaux Arts, a lakefront shopping area (1917), was said to be the earliest shopping mall in America.

The hotel boom also provided a catalyst for entrepreneurs to create a residential infrastructure. In the teens subdivisions were laid out and interior streets began to be dotted with speculative houses, often in the then popular Bungalow style or in a Mission influenced variant of the American foursquare house. Developers provided a complete range of housing services from auctions of raw land ready for construction of spec or custom homes to rentals of fully furnished and staffed cottages.

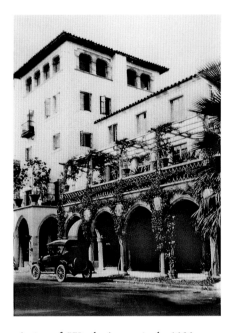

A view of Worth Avenue in the 1920s shows Mizner's personal five-story apartment in the background. Despite the social success of the Everglades Club, Worth Avenue competed with the Fashion Beaux Arts area on the lakefront for recognition as Palm Beach's premier shopping area into the 1930s.

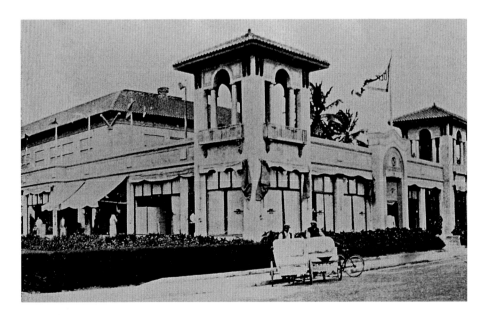

The Fashion Beaux Arts, designed in 1917 by August Geiger, was reputed to be the first shopping mall in America. It remained Palm Beach's primary shopping area into the 1930s well after Addison Mizner and Paris Singer started development on Worth Avenue with the Everglades Club in 1918. The Fashion Beaux Arts was not demolished until after 1944.

17

With the growth of the residential community, demand grew for amusements outside the hotels. Clubs and theaters appeared. Colonel E. R. Bradley opened Bradley's Beach Club, an elegant gambling and dining establishment in 1898. The Fashion Beaux Arts building featured a popular rooftop movie theater.

In 1918 when Singer sewing machine heir Paris Singer, with his friend Addison Mizner, the architect, opened the Everglades Club, Palm Beach became captivated by Mizner's theatrical Mediterranean Revival architecture which seemed to express the romance and opulence of the times. Singer distanced his development of the Everglades Club and Worth Avenue from Flagler's earlier enterprises with a single depreciating remark. When asked what color he wanted to paint the club he is said to have answered, "anything but that damn yellow," referring to Flagler's liberal use of a color that sometimes appeared close to railroad switching engine yellow. Along with his appealing architectural designs, Addison Mizner's promotional talents and gregarious personality made him the architect of choice for many of Palm Beach's great mansion builders.

The vogue for extravagant mansions culminated with the construction of Mar-a-Lago for Marjorie Merriweather Post Hutton, which began in 1923. The estate occupied seventeen acres and included fifty-eight rooms. Mar-a-Lago was a collaboration between Joseph Urban, an architect best known for his stage designs for the Ziegfeld Follies and Marion Sims Wyeth, a local architect of note.

By 1926 and 1927 when Urban and Wyeth were completing Mar-a-Lago, Mizner had largely transferred the focus of his attention to his ill-fated development of the city of Boca Raton. Mizner's list of projects in 1926 includes only one house in Palm Beach. In 1925 Mizner had formed, with many prominent investors, the Mizner Development Company to create, at Boca Raton, "the world's most beautiful architectural playground." But with the collapse of the wondrous Florida boom in real estate, influential backers like T. Coleman du Pont disassociated themselves from Mizner's firm. The dream of Boca Raton died in 1926 leaving only a few Mizner buildings completed, like the original building of the Boca Raton Resort and Club and some charming smaller homes in the Old Floresta area. However in Palm Beach Mizner's legacy of astounding homes and the rise of Worth Avenue to the stature of one of America's international fashion and shopping meccas provided an enduring foundation for Mizner's reputation as a founding father of Palm Beach's architectural importance.

Palm Beach's hotel era was supported throughout the 1920s by the rise of the automobile. In a time before transatlantic flights to Europe, an auto vacation in Florida was everyman's dream. Palm Beach provided accommodations for America's industrial elite in its magnificent hotels. The rising middle class also found resort accommodations in more modest residential rooming houses on Palm Beach's interior streets. In the 1920s Palm Beach probably boasted more hotel rooms than it does today. Above all other destinations the town offered the enormous appeal of its character and its streets – a built environment without parallel in its architectural presentation.

The prosperity of the hotel era also saw the final definition of the Town of Palm Beach with the completion of its outstanding civic center. The Town Hall Square, today a landmarked historic district, is dominated by the 1924 Harvey and Clarke

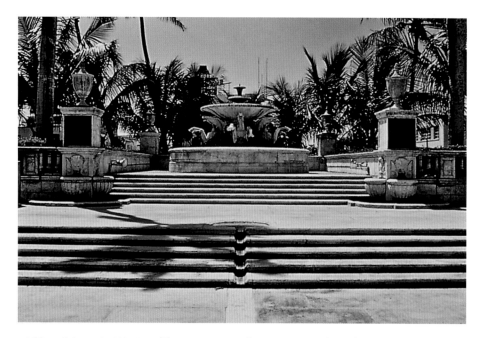

Addison Mizner's 1929 World War I Memorial Fountain completed the design of the central island in the historic Town Hall Square. The Town Hall is hidden behind the foliage at the back of the fountain. In front of the fountain, but not pictured in this photograph, space was provided for a landscaped area with a water feature and benches.

designed Town Hall. The local firm of Harvey and Clarke were Mizner's rivals in terms of commercial designs with flamboyant Mediterranean details. The Town Hall Square was completed by Mizner's contribution in 1929 of the design for a monumental fountain, reminiscent, according to Dr. Donald W. Curl, Mizner's foremost architectural biographer, of a historic fountain in Madrid.

The completion of the major buildings in Town Hall Square also marked Palm Beach's first explicit self-recognition of its own architectural character and heritage. In 1929 the Garden Club of Palm Beach published its influential *Plan of Palm Beach* which called for gracious arcades in the Town Square as well as other far-sighted refinements. The same year saw the establishment of the Art Jury numbering the architects Addison Mizner, Marion Sims Wyeth, and John Volk among its members. This civic body was a forerunner of the town's present Architectural Review Commission and, like the Architectural Commission, attempted to ensure the high quality of architecture in Palm Beach.

The great expectations of the Florida Boom were conclusively ended by the 1929 stock market crash and the subdued years of the Great Depression. Palm Beach had established itself as a leading American resort and its development continued but without some of the magnificent excesses of the earlier era. Appropriately in the 1970s and 1980s, when the Town of Palm Beach became concerned about its disappearing heritage of historic architecture, the Town Hall Square, the focal point of local government, became an area of major interest.

Over the years the Town Hall had lost its imposing tower through the battering of a hurricane, and the formerly open central motor court had been filled in with a compatible mid-sixties addition of administrative offices by the architect John

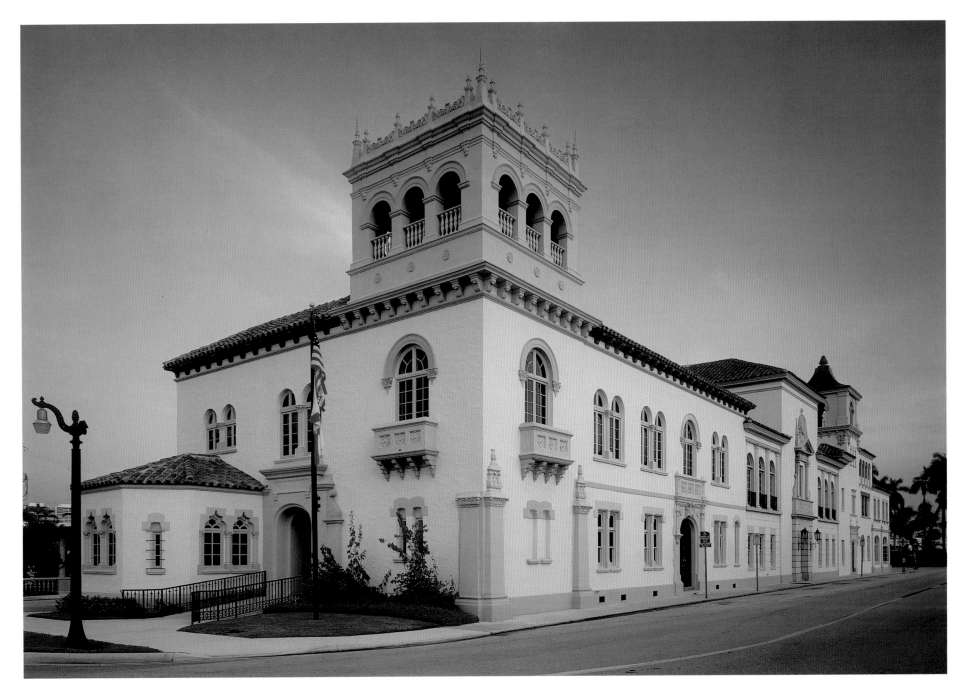

The Palm Beach Town Hall, which occupies an entire block in the center of the historic Town Hall Square, is distinguished by its arched windows, decorative balustrades, and a variety of cast stone embellishments. The blank windows on the corner were a feature of the original 1924 Harvey and Clarke design. The tall arched windows on the second floor are part of the 1963 John Volk expansion.

Volk. The building had been painted an unrelenting chalk white and festooned with numerous projecting window air conditioners and conduits for electrical and telephone cables. Windows had been blocked with concrete. As a symbol of the Town of Palm Beach, the Town Hall had simply become a white elephant.

The restoration of the Town Hall, under the direction of the architect Jeffery W. Smith, focused public attention on the significance of restoration in renewing the vitality and usefulness of historic architecture. The project was funded by the Preservation Foundation of Palm Beach and included opening all the blocked windows and restoring the lost tower and its cast stone decoration. Details found on the original drawings which had never been built were incorporated in the restoration. Arched windows long covered at the fire station end of the building were exposed to view. Magnificent wooden fire engine bay doors were reinstalled. The original colors were discovered.

The restoration, which was completed in 1989, became, as the best restorations do, a process of moving "back to the future." Like the Ballinger Award restorations whose stories follow, the Town Hall project showed that the tiring and expensive process of stripping away tasteless accretions obscuring the clear architectural heritage of the past leads to a renewal of that heritage for the future.

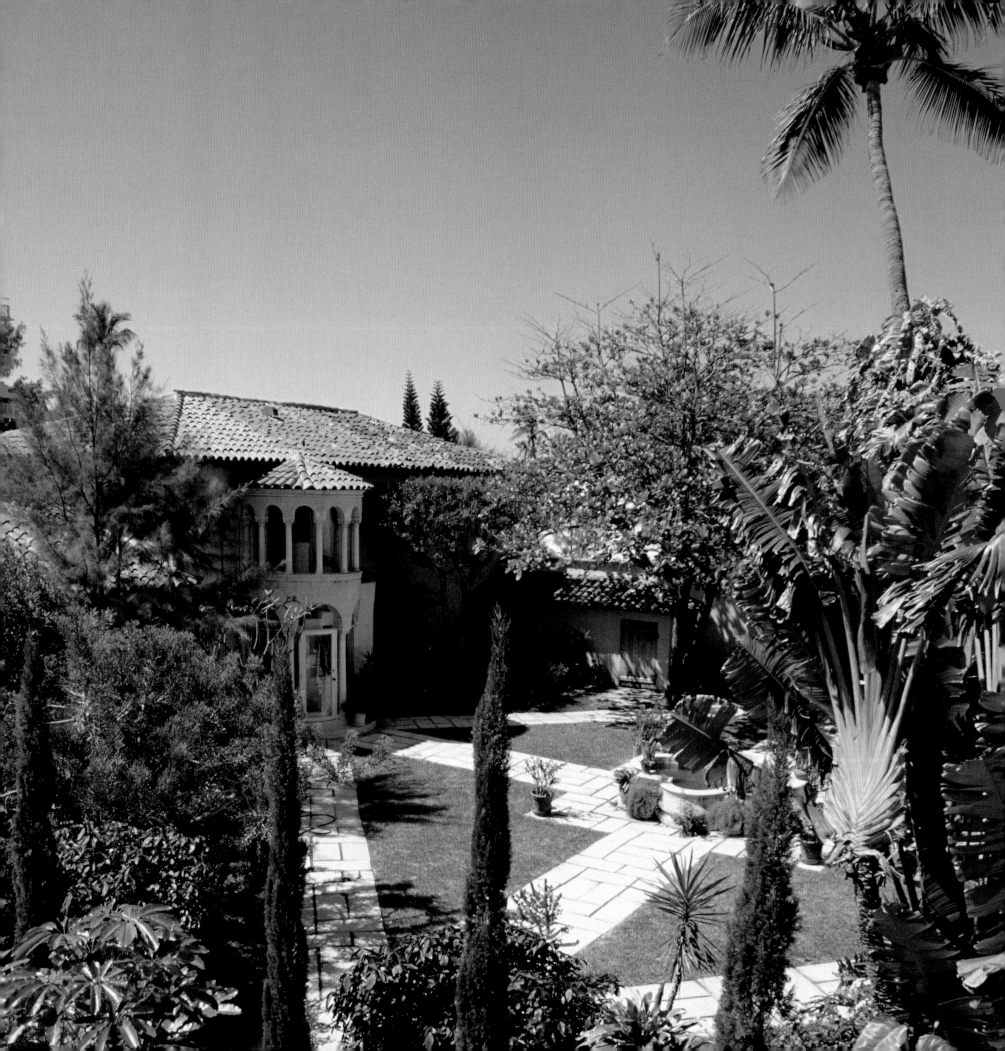

Warden House & Bienestar

It was entirely appropriate that in 1988 when the Preservation Foundation made its first Ballinger Award presentation, the award went to Robert T. Eigelberger for his restorations of Warden House and Bienestar, which are by far the most impressive private adaptive restorations completed to date in Palm Beach. In addition these two homes represented the work of two of Palm Beach's most famous architects. Addison Mizner, the designer of Warden House, has come to be the single architect most prominently identified with the Palm Beach style. Marion Sims Wyeth, the designer of Bienestar, has had an equally important influence on Palm Beach architecture because of the great number of his commissions and their survival to the present.

Adaptive restoration is a special and powerful tool of the historic preservation movement. By altering the usage of buildings, while preserving their essential features, adaptive restoration recognizes the strong economic imperatives of modern redevelopment yet safeguards buildings that represent a treasured heritage.

Projects such as the transformation of textile mills in Lawrence, Massachusetts, into profitable shopping malls are a testament to the success of well thought-out adaptive restoration supported by federal tax credit opportunities. In Palm Beach rigorous zoning ordinances severely limit the ability to alter the usage of buildings. Consequently adaptive restoration, for example the adaptation of a large private home into smaller condominium residences, is very difficult. As a result many fine Palm Beach mansions by Mizner, Wyeth, and other notable architects, deemed too large, too deteriorated, and too costly, were simply demolished in the decades from the 1950s to the 1980s. Almost half of the thirty-eight Mizner designs in Palm Beach have been demolished.

In the early 1990s even Palm Beach's most famous residence, Mar-a-Lago, was seemingly threatened with, if not demolition, almost certain dismemberment. After its purchase by Donald Trump in 1985, when Trump attempted to resell the mansion with its expansive, for Palm Beach, 17.6 acre grounds, including a 9-hole golf course, he found buyers for such a large estate sparse. Plans were presented to the town for a subdivision to be built surrounding the Mar-a-Lago mansion, which would have irreparably damaged its imposing situation. After tense negotiations with the town, another avenue of adaptive restoration was approved. Mar-a-Lago became a private club restored and maintained in its entirety. The estate was recognized as a National Historic Landmark in 1980, and today its facade and important views are protected by deeded preservation easements.

It was simply a fortuitous coincidence that Robert T. Eigelberger was able to purchase two important mansions standing in an area where he could secure concessions from the town for a conversion to multi-family use. Warden House, a highly praised Mizner design dating to 1922, was the town's first adaptive restoration.

Built for William Gray Warden, a Standard Oil partner, Warden House occupied a select oceanfront location. By 1978, however, people thought it too large and deteriorated to attract a single family buyer. Threatened with a lawsuit to force demolition, the Palm Beach Town Council allowed Robert Eigelberger to proceed with adaptive restoration. In Eigelberger, Mizner's design acquired a supporter who understood both the drama Mizner sought in his designs and the painstaking craftsmanship that produced his special effects.

Critics like to dismiss Mizner's work as some kind of lucky hit by an untrained eccentric. In fact Mizner apprenticed with Willis Polk, a notable California architect, and had had worldwide exposure through his travels in Guatemala, Hawaii, China, and Europe, to both current and historical architectural practices. Ada Louise Huxtable, who said "anecdotes about Mizner . . . have been more appreciated than his architecture," put her finger on the truth of the matter. Regarding Warden House, Huxtable wrote, "these are expert plans . . . their spaces work superbly as architecture; even empty their functional and decorative logic gives extreme visual and sensuous pleasure."

Eigelberger's adaptive restoration, which created six condominium apartments from the forty rooms in Warden House focused on "details, details, details." By Eigelberger's estimate only five percent of the interior was altered. Successful restoration sometimes makes an obsession of detail, but only this kind of thoroughness can convey the subtlety and variation of Mizner's original work. Restoration of the house took eighteen months. In 1984 Warden House was accepted for listing on the National Register of Historic Places, a testament to the authenticity of Eigelberger's work. Subsequently the condominium owners granted a facade easement to the Preservation Foundation of Palm Beach to ensure the maintenance of Warden House's historic features in perpetuity.

OPPOSITE Before the days of air conditioning, Warden House was constructed in a u-shape with a central patio so each side of the house would be open on two sides to ocean breezes. ABOVE Mizner's design featured many different interesting roof lines.

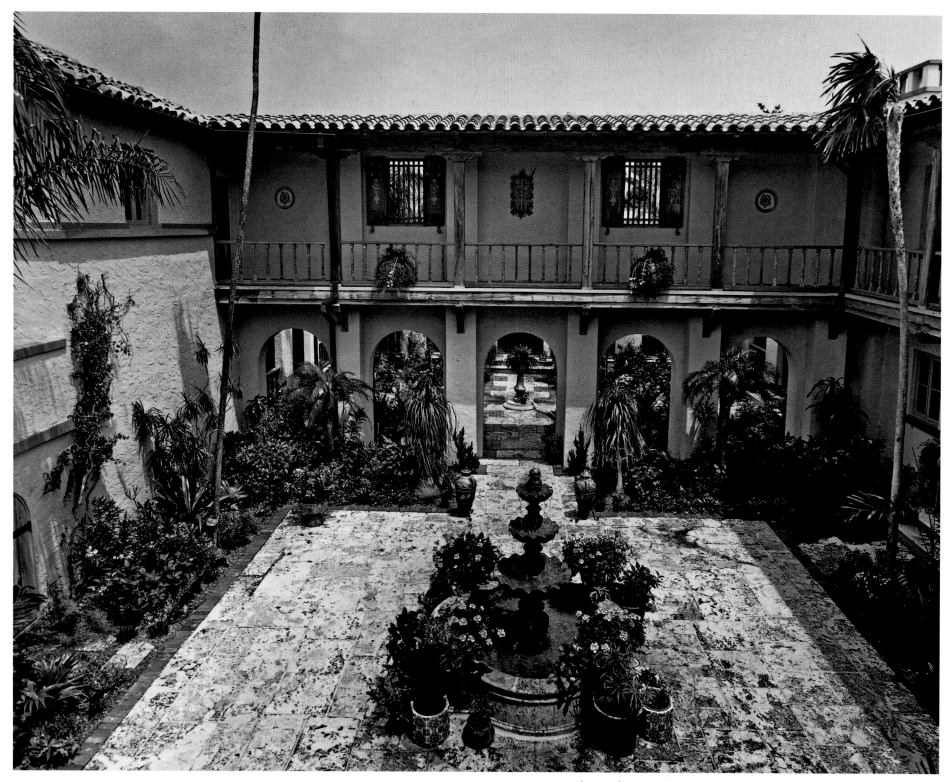

ABOVE *Bienestar's central courtyard with the graceful embellishment of a three-tiered fountain.*

OPPOSITE *Bienestar's entrance.*

OPPOSITE BOTTOM *A historical photograph from the Wyeth Collection in the Preservation Foundation of Palm Beach Archives shows one of Bienestar's original interiors.*

The first Ballinger Award in 1988 also honored Robert Eigelberger's adaptive restoration of Bienestar, a Marion Sims Wyeth home just a stone's throw away from Warden House. Bienestar was restored by the same meticulous standards as Warden House. The six private "villas" created by the restoration preserve the original layout of the house around a central patio.

In retaining Wyeth's original courtyard design, Eigelberger recognized what is one of the most outstanding characteristics of most Wyeth designs. Of the six early master architects working in Palm Beach, Wyeth was the most notable for the grace and style of his patios. Other architects might add a patio here or there for effect. In a Wyeth design the patio was always an integral part of the total design. His patios felt so natural, so in tune with the house and the Florida climate, it is difficult to imagine Wyeth's designs without these carefully formulated outdoor rooms.

Marion Sims Wyeth arrived in Palm Beach in 1919 after studying at Princeton, at the École des Beaux-Arts in Paris, and after serving his architectural apprenticeship in New York with Bertram G. Goodhue and Carrère and Hastings. In Palm Beach one of his first jobs was the original Good Samaritan Hospital. By 1921 he was designing a home for E. F. Hutton and his wife Marjorie Merriweather Post Hutton. He followed with over one hundred homes on many of Palm Beach's most distinguished streets. Some of these homes, in today's parlance, would have been called spec homes, but their dignity and enduring presence over time have earned thirty-five Wyeth-designed homes listing on Palm Beach's official roster of landmark buildings.

Wyeth's most famous house, Mar-a-Lago (1923-27), was actually a collaboration with Joseph Urban, a theatrical designer and architect with a celebrated New York reputation. Wyeth drew the first plans for the house while Urban finished the interior and exterior designs. Ironically Wyeth later commented that Mar-a-Lago, "isn't my taste," a remark best understood in the light of Wyeth's description of his own architectural approach as "quiet, subdued and rational." In an oral interview he went on to say Urban " was not classical at all. He just went out high wide and handsome, but the house [Mar-a-Lago] is dramatic as the devil."

Wyeth's emphasis on quiet beauty resulted in some of Palm Beach's most outstanding estates, as well as major buildings in other areas. He designed Doris Duke's Shangri-La in Hawaii, the Church of the Epiphany in New York City, and the Governor's Mansion in Tallahassee. With his partners William Johnson and Frederick King, Wyeth opened offices in Palm Beach and New York City. The Palm Beach office of the firm executed over 735 commissions.

In Palm Beach, his residence until his death, Wyeth also typified the architect as good citizen. He served as a director of many local organizations and as chairman of the town's Art Jury, which set forth early standards for homes in Palm Beach and was a precursor to the town's Architectural Commission. His classical training, many commissions and long career make Wyeth one of the most influential architects ever to practice in Palm Beach.

Bienestar, Wyeth's 1924 design for J. S. Wheeler, typifies the architect's best work in the Mediterranean Revival style. Its ample courtyard unites the different areas of the house. Mediterranean details of cast stone, wrought iron, and pecky cypress decorate the interior and exterior facades. It is worth noting that the contractor in charge of the original construction was Benjamin Hoffman. At Bienestar, Hoffman worked on Wyeth's designs, but on other properties he executed noteworthy designs by his own firm which have given him the status of a master builder in the record of Palm Beach architecture.

Both Bienestar and Warden House are official Landmarks of the Town of Palm Beach. The awards to Bienestar and Warden House give Robert Eigelberger the distinction of being the only honoree to ever receive two Ballinger Awards.

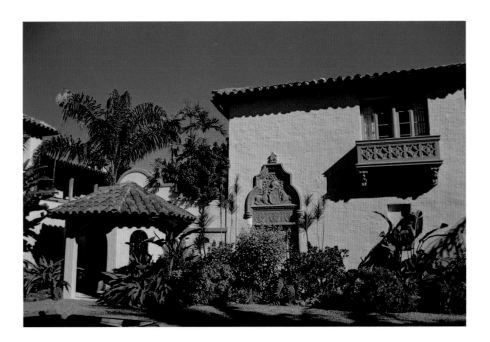

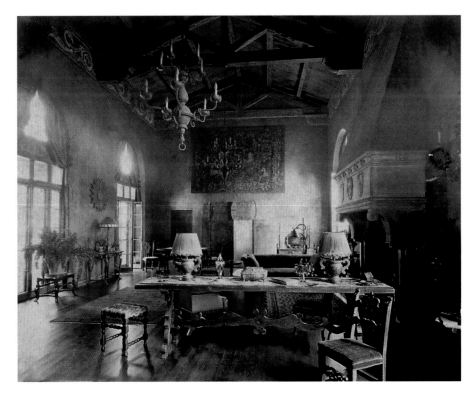

ABOVE Warden House stairway with its decorative chandelier.
RIGHT A Warden House living room space with tile mosaic.

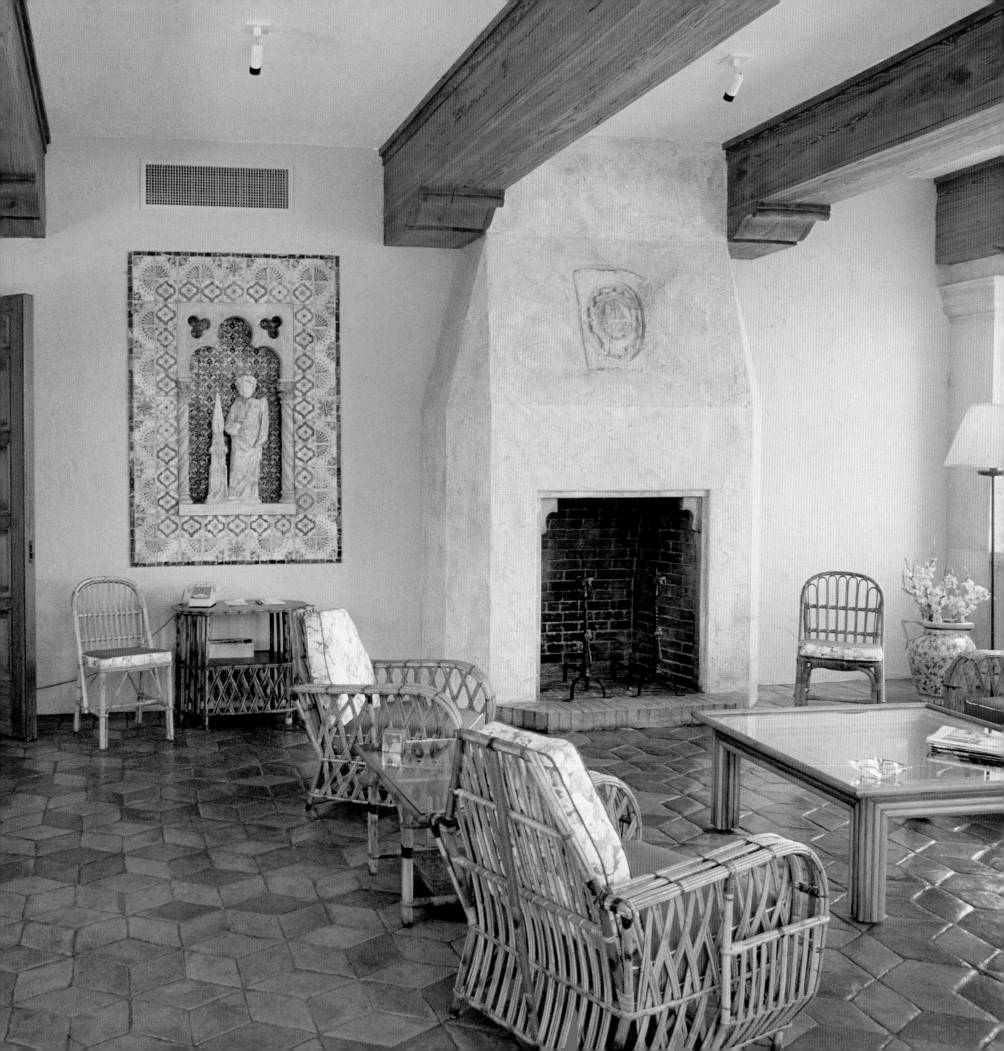

LEFT An inviting colonnaded passageway at Warden House leads to an open door.

RIGHT The complexity of Mizner's architectural projects and the scarcity of building materials at the end of World War I led Mizner to establish a vertically-integrated construction business. Mizner's kilns used Georgia red clay for roof tiles. Mizner Industries produced ironwork, decorative tiles, ceramic pots, and furniture for Mizner's commissions and those of other architects.

ABOVE A Mizner pot found at the Warden House site. Mizner also specialized in distinctive colors on his tiles. Among his most imitated colors is "Mizner pink" for buildings, which is often shown as a simple bright pink that in fact totally distorts the color Mizner used. The few original examples of Mizner pink that have been found, including one area protected by a period wooden barricade at Warden House (unfortunately, not photographed at the time), show a color of iridescent hues - pink enlivened by glints of white, blue, yellow, and other shades, almost surely applied in different layers and wiped off by hand.

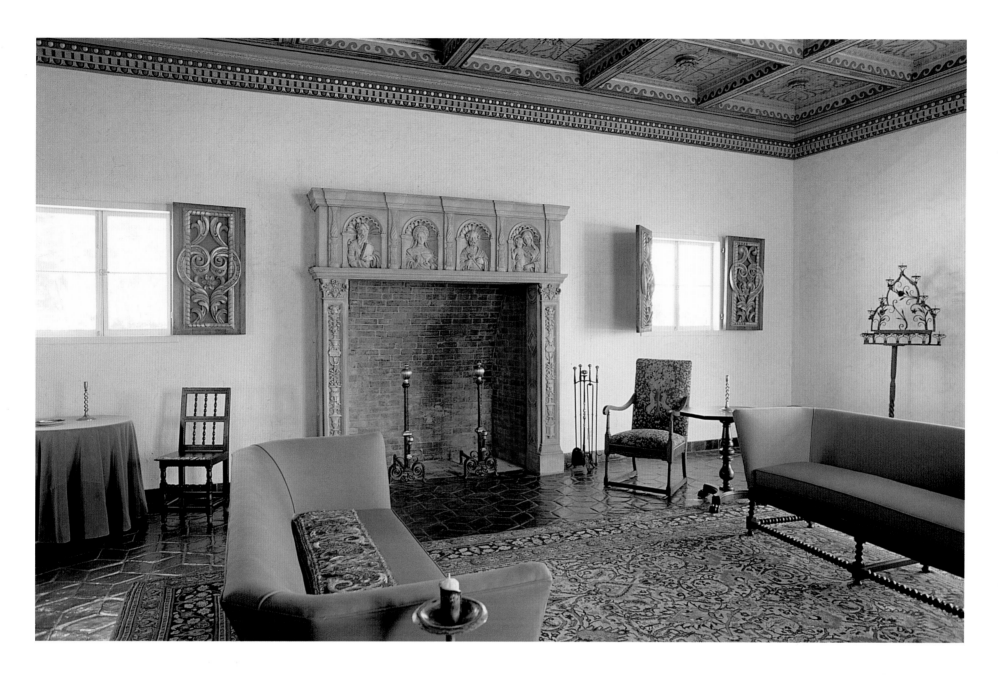

ABOVE *Living room at Warden House — note the use of wooden shutters as window treatments. The stone mantel and decorated wood ceiling are also Mizner interior treatments.*
RIGHT *The dining room in the apartment Robert Eigelberger reserved for himself shows typical Mizner features, a tiled floor and a pecky cypress ceiling. The subtlety of Mizner's water-based paint treatment contrasts with the glossy effect of some modern ceilings treated with oil-based paint.*

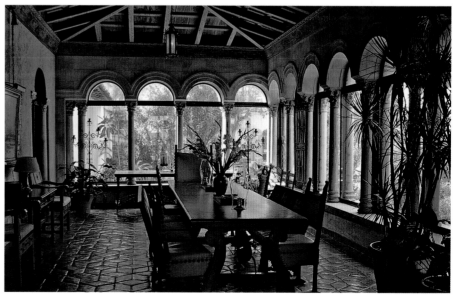

TOP *An interior front door at Warden House after restoration.*
ABOVE *Exposed nail heads are a frequent decorative motif on Mizner's doors.*
LEFT *Geometrical designs on Warden House's doors carry Mizner's decorative touches throughout the house.*

RIGHT The south facade of Warden
House highlights the monumentality of
Mizner's structure, which was enlivened by
windows of different sizes and shapes and a
balustrade decorated with playful figures.
Mizner evolved many strategies for dealing
with his sometimes demanding clients. To
allay William Gray Warden's concern
about the size of the house, when he pre-
viewed the design for Warden, Mizner
claimed he showed the Warden House com-
mission in half scale against a background
of surrounding full scale houses.

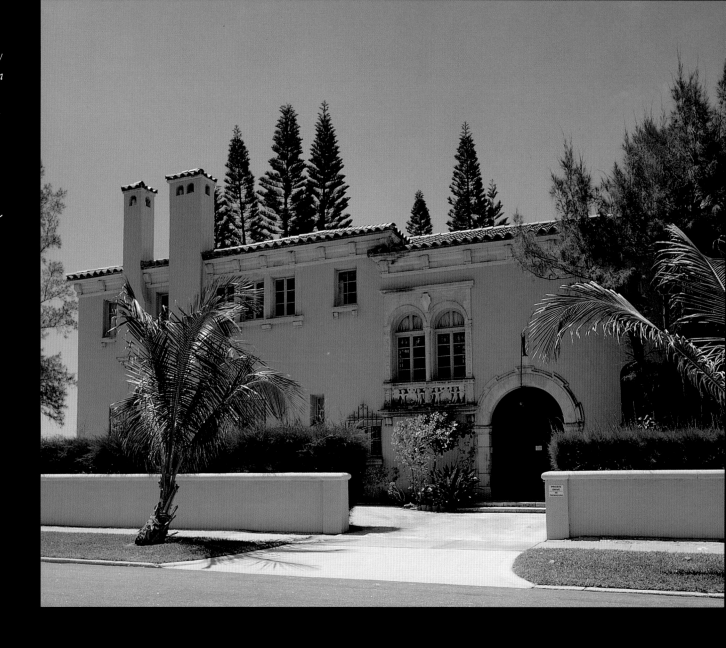

RIGHT A historical photograph shows
Warden House's front door after the house
was completed.
FAR RIGHT Exterior door after restora-
tion. Typically Mizner treated decorative
wooden surfaces with a water-based paint
which was then wiped off to leave traces of
color in the grain of the wood. This
painstaking process was repeated many times
by the skilled workers employed on the
Warden House restoration.

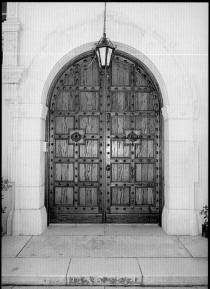

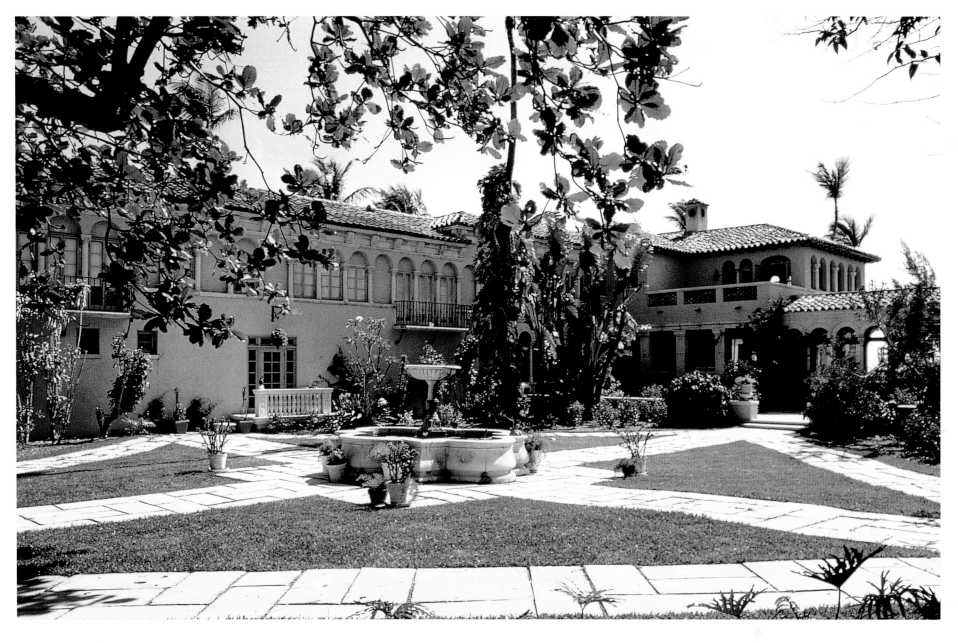

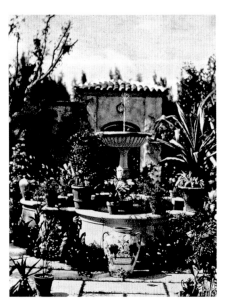

TOP The courtyard pictured after the restoration shows the restored fountain.
LEFT A historical view shows Warden House's original fountain.

RIGHT Warden House occupies a commanding position on Palm Beach's oceanfront. The front yard pool was added as part of the adaptive restoration. Its shape repeats the form of the historic patio fountain.

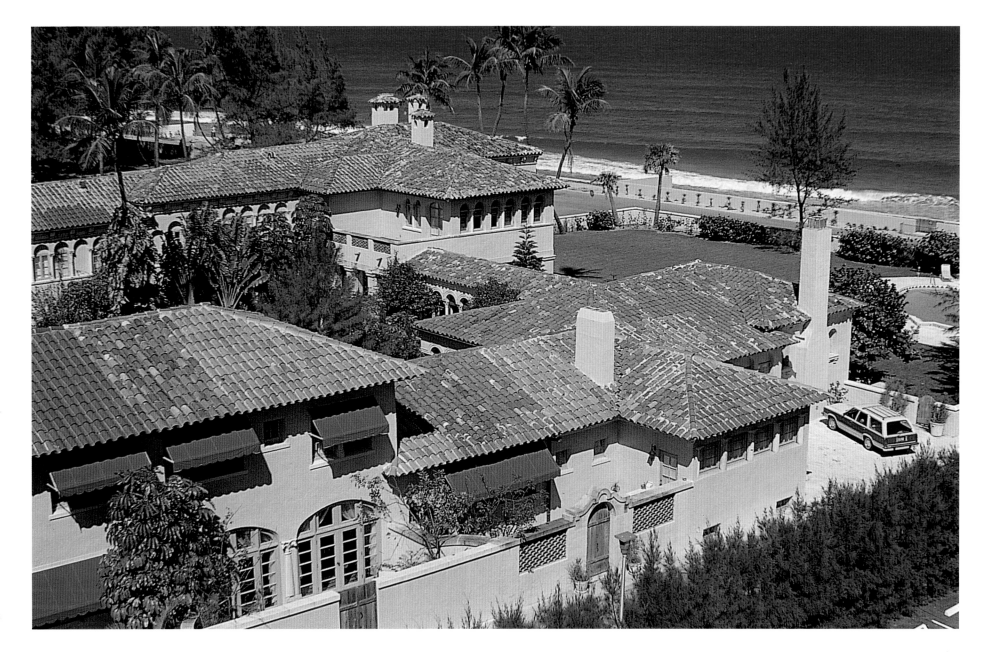

ABOVE A detailed view of the pool added as part of the adaptive restoration with Warden House's front facade in the background.

RIGHT An aerial view shows the many subtle differences in tile color and shape preserved in the restoration. Traditionally, barrel tiles for roofs were handmade in Cuba and formed by being shaped over the workman's thigh. Mizner valued the aura of age created by the subtle differences resulting from these hand processes. While many well-meaning restorations install new factory-made tiles, some of the town's landmark commissioners have suggested a better restoration would result from the use of modern tile rejects, which are discarded simply because of small variations in shape and color.

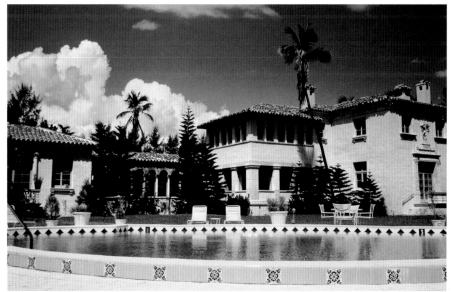

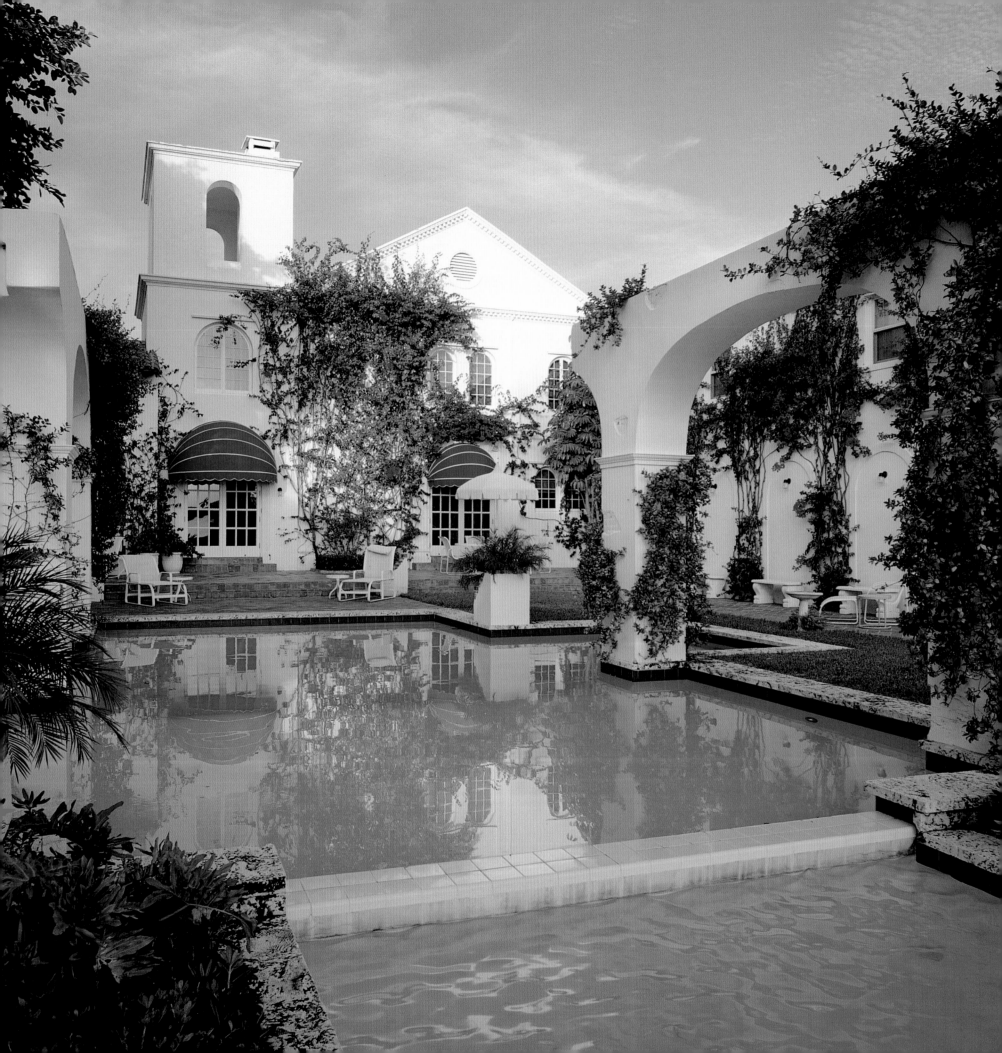

The Mission House

In 1989 the Ballinger Award went to a home that was not a landmark and not designed by a notable architect. The Mission House, constructed in 1923 by master builder Benjamin Hoffman, was a testimony to the quality of architecture that became typical throughout the town during the boom years of the early 1920s. In addition to imposing creations along the ocean and lakefront by well-known architects, Palm Beach's interior streets began to fill with commodious homes built by land development and construction firms. Sometimes these firms platted whole streets, sometimes they purchased a few lots on a new street. Usually their homes were speculative ventures. As speculators, these builders had to have a keen appreciation of the market, and the market in Palm Beach rewarded Mediterranean and Spanish influenced homes.

The Mediterranean Revival influence, one of many revival influences across the country in the 1920s, became, in the hands of master builders, an accepted vernacular in Palm Beach. Many fine homes and buildings survive today to color and flavor the character of the town, which trace to the contributions, still too often unrecognized and undocumented, of master builders.

The subject of the Ballinger Award in 1989 was a Mission influenced interpretation of the Spanish revival known in earlier years as Mission House. Endowed with an important lakefront site, it was changed over the years. After significant alterations by Marion Sims Wyeth in 1947, it assumed its modern form. In 1983 local architect John Gusman created the original pool area. With its most recent alterations and restoration by its owners in 1987, which included a new garage and apartment, original details were enhanced. Many of the changes qualified as renovations rather than strict restoration; still the Ballinger committee decided to honor the extraordinary creativity and vitality of the renovation. The Mission House restoration demonstrated how the Palm Beach vernacular could be integrated with modern influences to reflect a new standard of excellence in blending the old with the new.

The 1989 award home has another distinction. It is the only Ballinger Award home ever demolished. Despite good intentions, the new owners could not meet goals for modern usage and still preserve Hoffman's structure. Its demolition is a tale of caution alerting the town's preservationists to the potential pitfalls of even the most outstanding restoration. The Mission House's recognition as an award winner demonstrates the existence of uncelebrated treasures created by master builders that may still be discovered behind the hedges on the streets of Palm Beach.

ABOVE A number of different window forms enliven the front facade of the Mission House.
OPPOSITE A third-story tower balances the massing of the two wings of the house on either side.
FOLLOWING PAGES The addition of modern arches spanning the pool suggests motifs of the Spanish style and recognizes the historical period of the home's construction. Yet the free-standing arches bring the design of the house forward in time and integrate past and present.

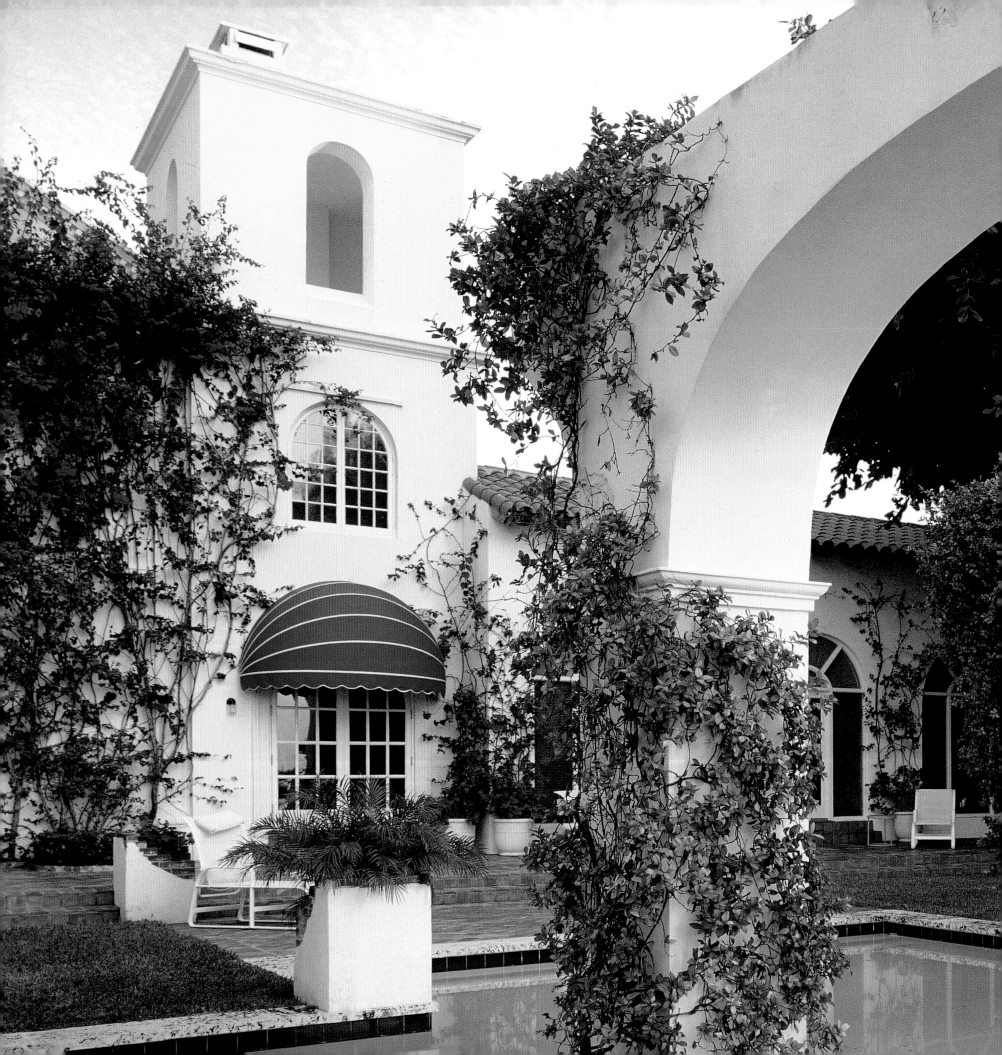

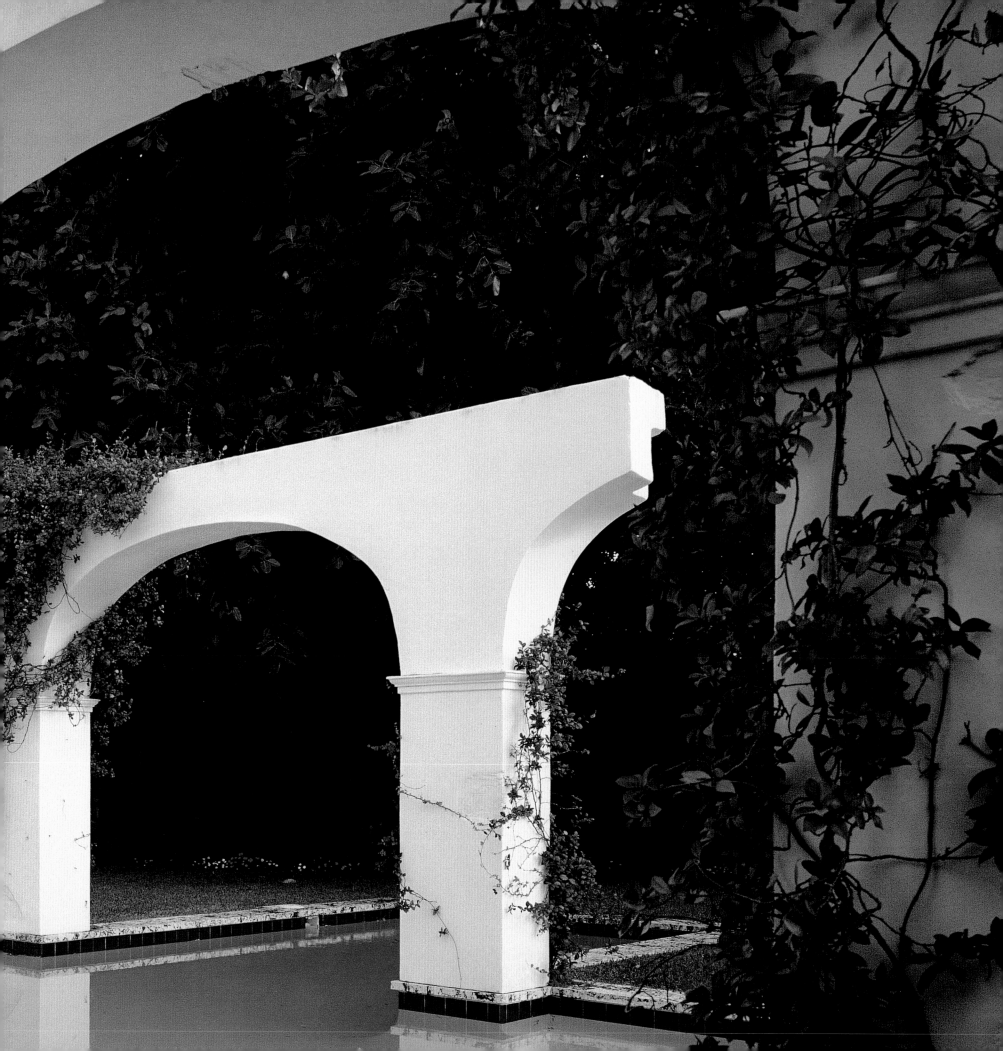

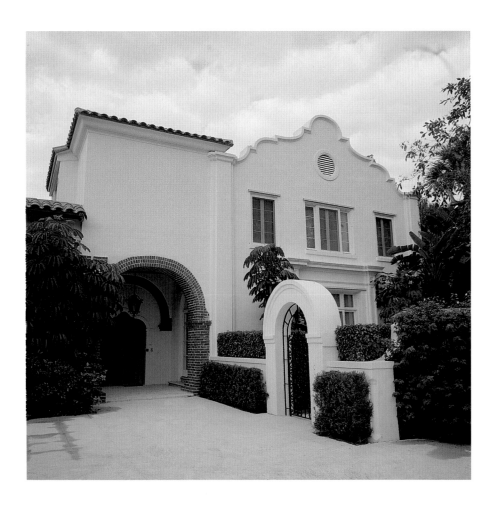

LEFT *Unlike more elaborately detailed Mediterranean Revival designs, on the Mission House, undecorated elements like the Baroque facade silhouette and simple entrance arches make a strong statement when contrasted to the flat, unarticulated stucco wall surfaces.*

OPPOSITE *The interior courtyard continues the theme of simple decoration using brick for an accent. The low roof to the left adds the feeling of a Spanish hacienda. Wyeth's 1947 alterations created the general look and proportions of the courtyard.*

BELOW LEFT AND RIGHT *Details at the Mission House gain vibrancy from a contrast of flat surfaces with carefully selected decoration. (Right) A monochrome tile background accents a period fountain. (Left) In a planter the decorative impact of simple bricks is enhanced by an absolutely plain encasement of flat stucco.*

FOLLOWING PAGES *Modern arches and a zero horizon reconfiguration of the pool create a stunning corridor to the lake and form a linkage between the architecture and the landscape.*

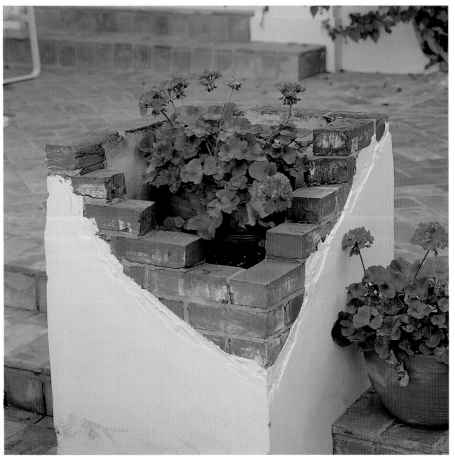

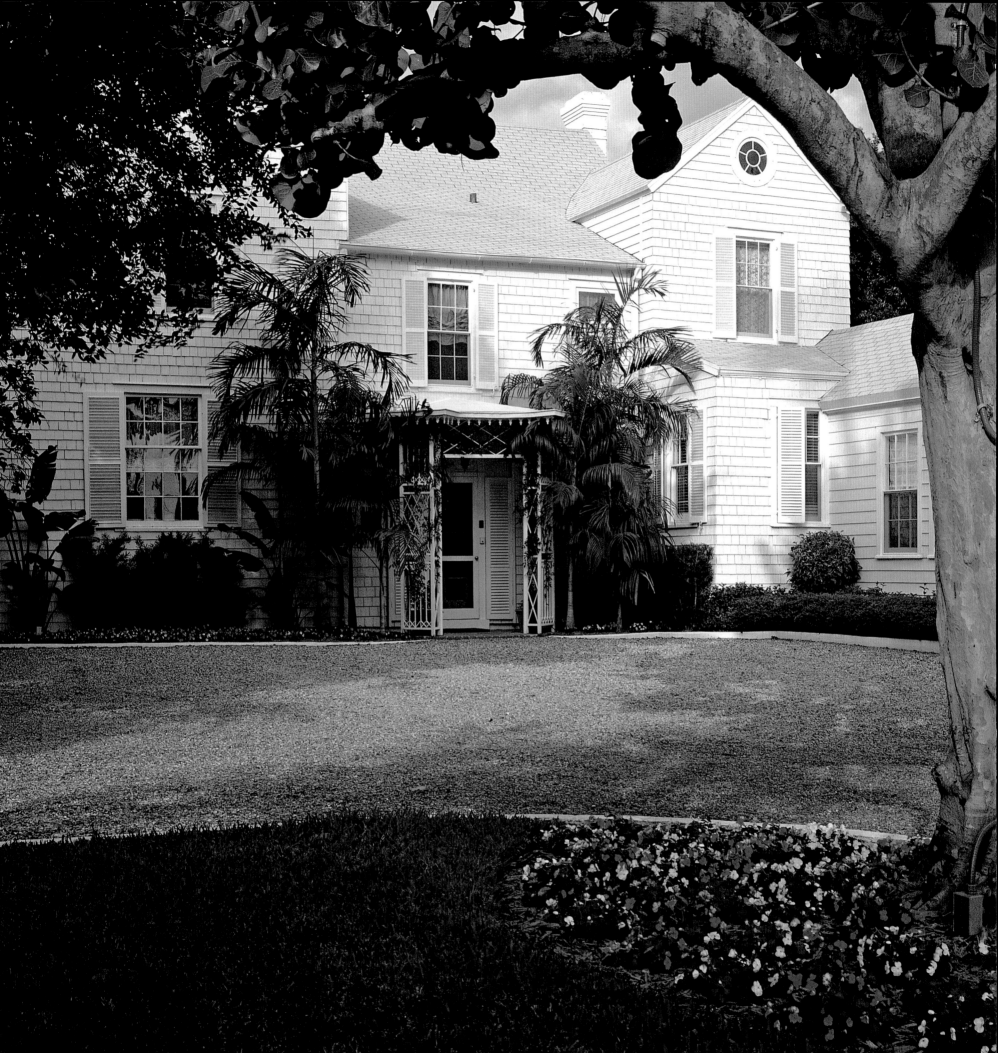

The Vicarage

In 1990 the Preservation Foundation of Palm Beach honored one of the oldest homes in Palm Beach reborn in its newest restored form. Built before architectural permits and records were a requirement, the Vicarage has been a part of life in Palm Beach since 1897, when it was constructed as a simple wood frame clapboard and shingle structure by an unknown architect or more probably a master craftsman. It was built for the vicar of the Bethesda-by-the-Sea Episcopal Church.

Throughout its history, the Vicarage's story has been intertwined not only with the town's architectural history but also with its social history. It is a prime example of the ways that our built environment links the past with the future. As early as 1886 the Episcopal congregation was sharing the town's newly constructed one-room schoolhouse with the Congregationalists. The Episcopalians held their services in the afternoon and the Congregationalists worshiped in the morning. Three years later the Episcopal congregation moved to its own simple wooden structure built at a cost of six hundred dollars. By 1895 the growth of the congregation demanded larger quarters. A picturesque Moorish influenced shingle style structure was constructed on Palm Beach's picturesque Lake Trail, the major artery of transportation on the island. Churchgoers arrived at what is known as the first church of Bethesda-by-the-Sea, on foot or by boat. Naturally, the cottage for its vicar, the Vicarage, was built nearby on the lakefront.

Records about the next decades are sparse, but in 1927 the congregation moved to a splendid new church. The Vicarage apparently suffered severe damage in the 1928 hurricane. In 1929, with its purchase by Howard Brougham Major, the Vicarage entered its second life as the home of one of Palm Beach's master architects. Major made significant alterations to the old structure. The main entrance to the home was moved from the lakefront to the land side. A wing for bedrooms and staff quarters was constructed. He also added the distinctive octagonal gazebos that define the lakefront of the Vicarage.

The original vernacular structure was surrounded by Major's changes, and the architect made his own statement by designing not a Mediterranean alteration but a blending of traditional shingle style and British West Indies influences. By the time he purchased the Vicarage, Howard Major had already made a name for himself as a perceptive critic of the prevailing Mediterranean influence in Palm Beach. Like

OPPOSITE *The front facade of the Vicarage, as designed by Howard Major, displays West Indies influences yet preserves the shingle style character of the original house.*
ABOVE *This imposing and quixotic Moorish-influenced shingle-style church has long been a prominent feature of Palm Beach's famous Lake Trail. After 1926 it was deconsecrated and became a private home. It is being carefully preserved by its owners and is officially designated as a landmark of the town.*

many of the first master architects in Palm Beach Major's original professional base was New York City. A product of the Pratt Institute and the atelier of Henry Hornbostel of the Society of Beaux Arts Architects, Major built many homes, often in the Greek Revival style, on Long Island and in New England before coming to Palm Beach in 1925 at age forty-three. In 1927 he published a book espousing the Greek Revival style as the most appropriate template for American domestic architecture. After his arrival in Palm Beach he publicized the Bermuda style as the most suitable for a Florida setting.

In Palm Beach he is most frequently remembered as the architect of Major Alley, a charming pedestrian enclave of Bermuda style townhouses built in 1925. Although Major's legacy of West Indies influenced homes can be found throughout Palm Beach, as well as Nassau, Naples, Hobe Sound, and Gulf Stream, he also demonstrated his versatility and command of many different architectural vocabularies by designing homes in other styles.

As testimony to the fact that architects must frequently respond to clients' stylistic preferences rather than their own, Major's outstanding homes in Palm Beach include work in the Mediterranean Revival, Tudor, and Japanese styles. In the introduction to Palm Beach Villas, published in 1929, he even recognized Spanish architecture as the first architecture of Florida and complimented Addison Mizner and Marion Sims Wyeth for their work in the Spanish genre.

After its sale by Major's widow, the Vicarage came into the hands of Douglas and Mary Fairbanks, Jr. As their home, it was a center for the many theatrical celebrities who visited Palm Beach, which has been from its earliest years an important destination for famous names in the dramatic arts. Wilson Mizner, Addison's brother, a renowned wit and author of theatrical pieces, and Joseph Urban, the master designer of the Ziegfeld Follies, to name two of Palm Beach's theater personalities, drew their friends and collaborators to Palm Beach in the 1920s to form a show business community.

After the Fairbanks, the Vicarage underwent a major restoration by its owner Eileen Fairchild under the direction of architect Jeffery Smith of Smith Architectural Group in Palm Beach. The restoration, completed in 1989, earned the Ballinger Award in 1990.

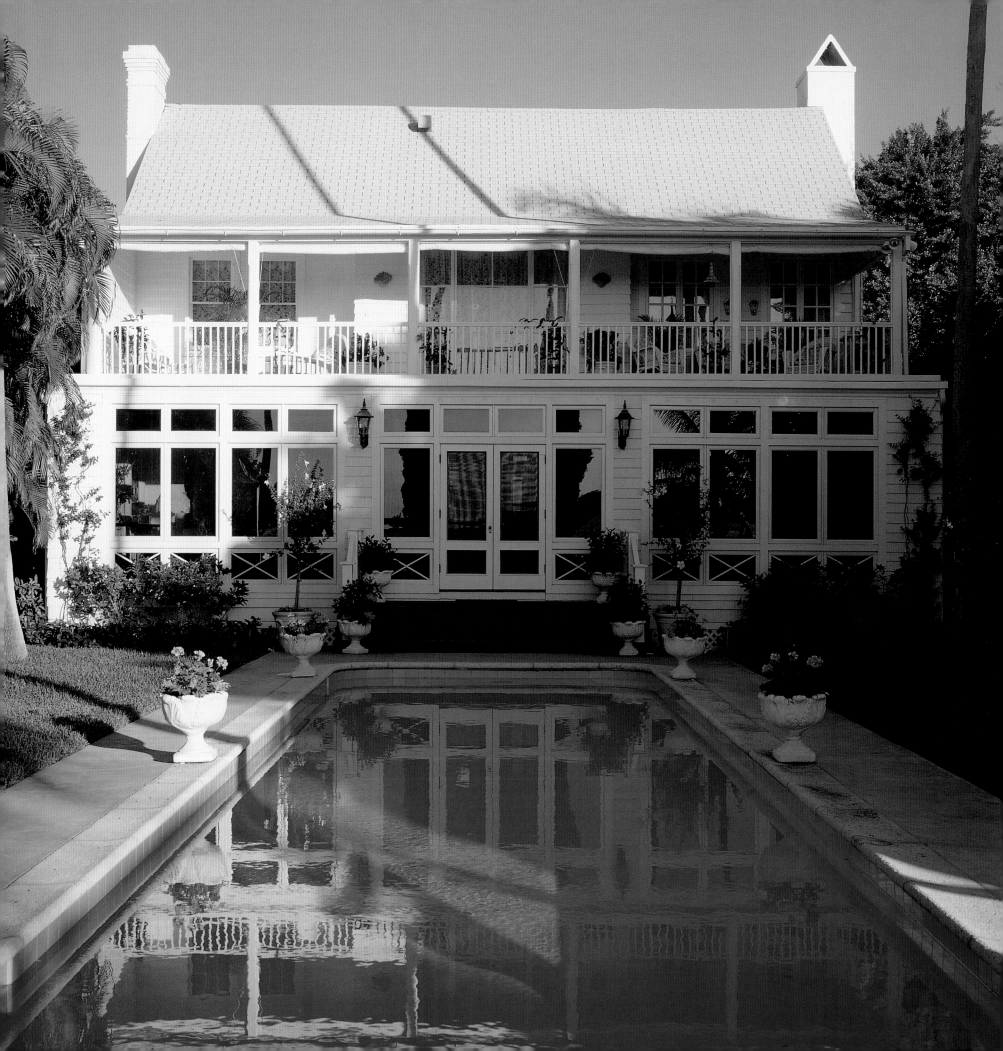

OPPOSITE *The lakefront facade at the Vicarage shows deeply shadowed veranda spaces, which form part of the architectural statement of the house.*

ABOVE *A detail of the front door hints at Chinese motifs of decoration.*

TOP RIGHT *On the lakefront facade of the Vicarage, an upstairs veranda provides a British West Indies accent.*

RIGHT *A south side loggia of the Vicarage was created as part of the restoration. Restoration landscaping was provided by the firm of Sanchez and Maddux.*

ABOVE *Designed by Howard Major, two octagonal gazebos and a wall mark the lakefront limits of the Vicarage property. The two extra-ordinary gazebos act as sentinels, introducing and defining the lakefront focus of the house and its lap pool.*

OPPOSITE *An elongated pool flanked by twin gazebos provide views to and from the vicarage.*

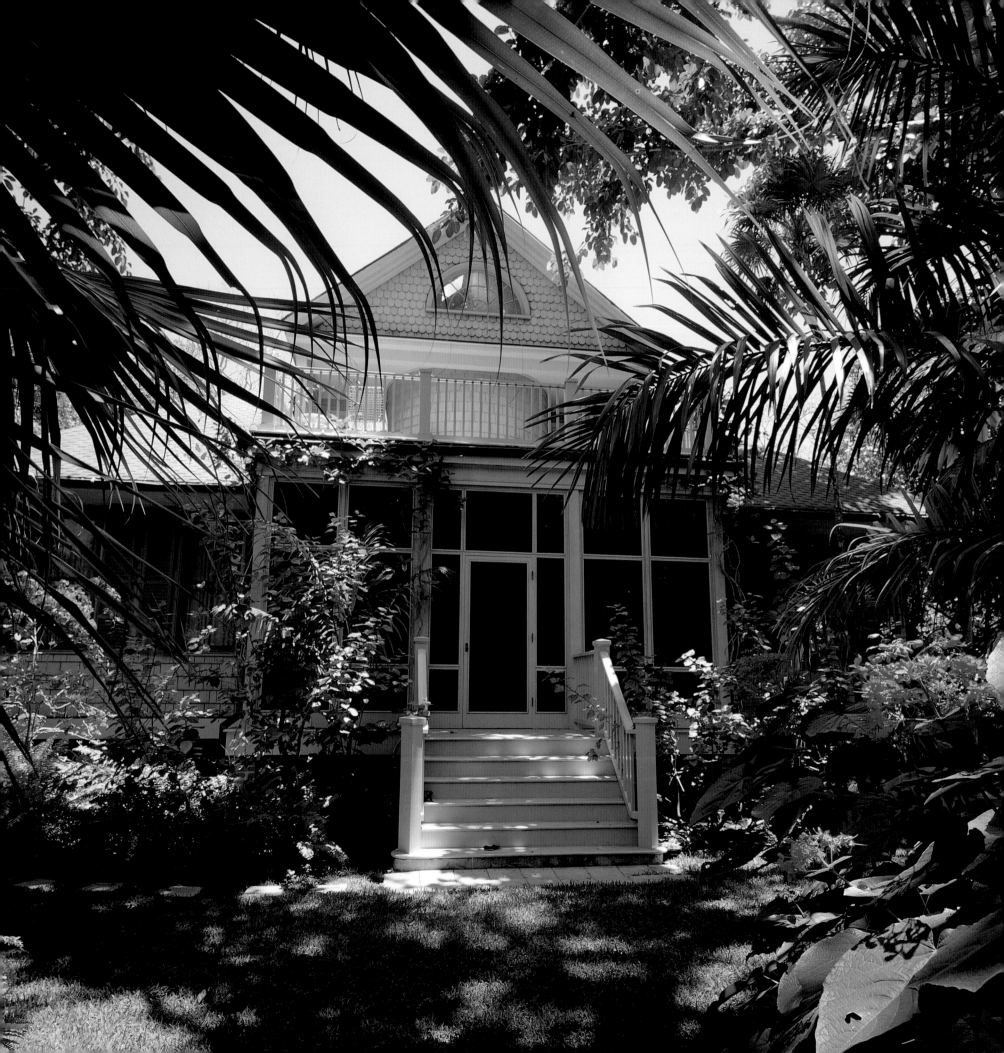

Figulus IV

The Ballinger Committee, in 1991, signified its intention of recognizing the best representatives of Palm Beach architecture throughout the history of the island by departing from the restoration theme to bestow the only award ever given to a new house, Figulus IV. The first Figulus was built in 1893 for the pioneer Bingham family from Ohio. The name Figulus, which means potter in Latin, recognized the Potter family from whom the expansive tract had been purchased. An 1886 post office in the area was also named Figulus for the Potters. The Figulus house was one of the first major oceanfront homes at a time when most buildings in Palm Beach were still built on the lakefront. In the 1890s oceanfront property commanded a sale price of about $4.30 a foot. When the Binghams built a typical wood shingle home, Native Indians roamed the oceanfront area. Indians often stopped at the Bingham home to trade their handcrafted baskets and beadwork for the red cotton fabric the Binghams brought from Cleveland.

In 1918 Abram Garfield, a Cleveland architect and the son of President Garfield, designed Casa Apava nearby for Frances Bolton, Charles W. Bingham's daughter. Casa Apava has the distinction of being one of the first grand Mediterranean Revival homes in Palm Beach. Frances Bolton's husband was a Republican congressman in Ohio. When he died, she was elected to complete his term and ultimately served in Congress for twenty-nine years. She was also the first woman congressional delegate appointed to the United Nations. Casa Apava serves as a continuing reminder that Addison Mizner was not the first Palm Beach architect to design elaborate Mediterranean Revival homes in Palm Beach.

Another early Bolton family home was known as Figulus II, and later, Kenyon C. Bolton III, a Boston architect and descendant of the Bolton family, designed Figulus III, a Mediterranean Revival home, as well as Figulus IV for his mother, Mrs. Kenyon C. Bolton. Figulus IV is a celebration, not a copy, of Palm Beach's pioneer shingle style architecture. These traditional homes, typical of turn-of-the-century architecture throughout the United States, have almost entirely disappeared from the Palm Beach scene. Kenyon Bolton's contribution to the preservation of Palm Beach's architectural heritage flew in the face of modern taste and developers' prejudices, yet its commodious proportions and simple dignity illustrate why the shingle style, an original American contribution to the history of architectural styles, served so long and well as a national favorite.

Designed as a family vacation cottage, Figulus IV is a welcoming home whose east-west orientation, high ceilings, broad porch, and informal plan capture the ocean breezes. Kenyon Bolton was also responsible for the landscape design, which sites the house in perfect harmony with its surroundings, and the interior design of comfortable family spaces. In creating Figulus IV Bolton accomplished the difficult task of demonstrating how a new entirely modern home can recall the spirit of Palm Beach's past. Figulus IV won the Ballinger Award for its harmonious balance between the new and the old, which was achieved with skill and distinction.

OPPOSITE *A casual porch at the back of the house is framed by extensive landscaping. The tropical site contains over twenty historic and specimen trees.*
ABOVE *Detail of skylight.*

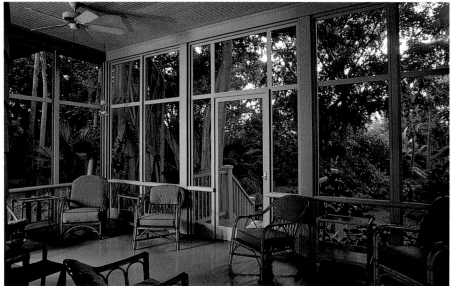

ABOVE *The graceful stairway was reproduced from a classical design of the 1890s. African art is a decorative theme throughout the family areas.*

LEFT *The comfortable back porch serves as a transition and link to the outdoors.*

OPPOSITE *Beaded paneling and a tile fireplace surround create a traditional setting for a family gathering room.*

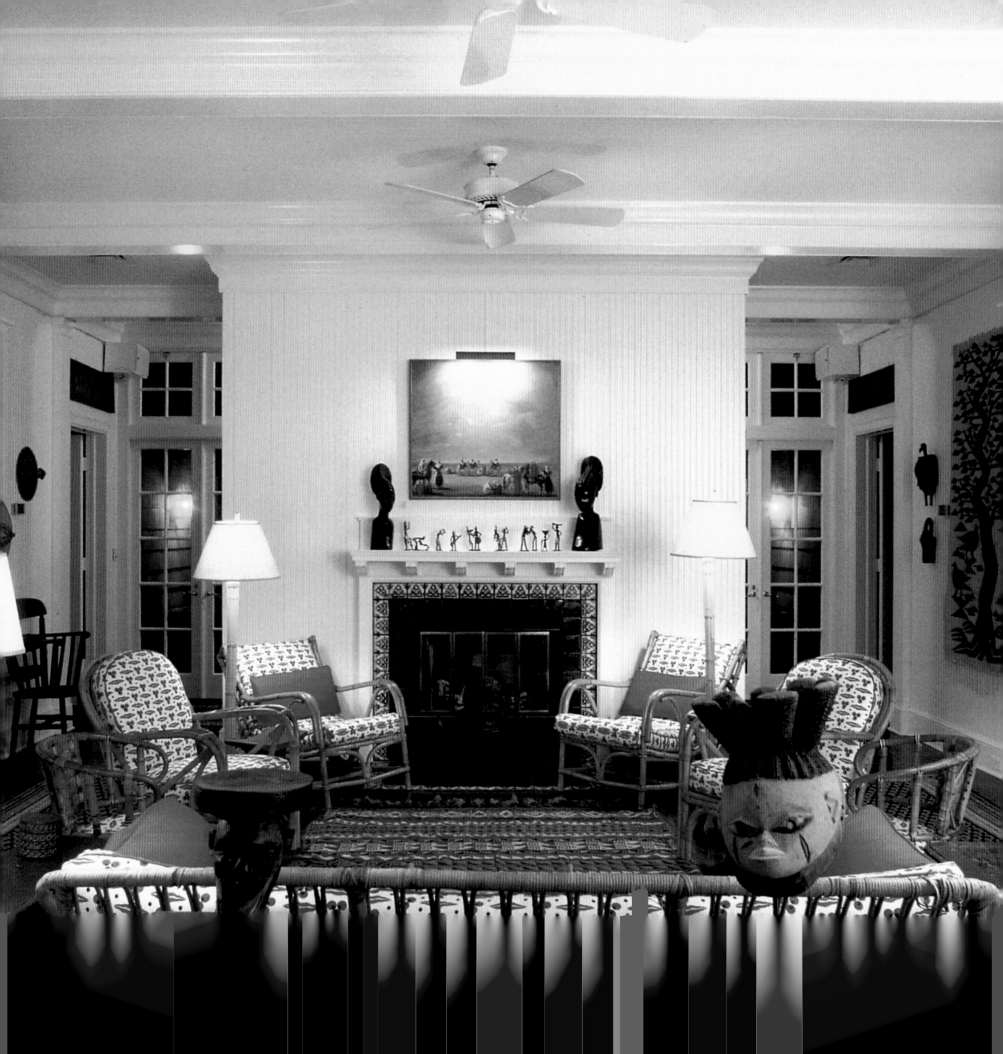

TOP LEFT *A close up of the front porch shows a variety of simple wood details in the siding, balustrade, columns, and shutters. All these details add interest and vitality to the facade.*

BOTTOM LEFT *A shed roof and dormer window accent the simple domesticity of Figulus IV.*

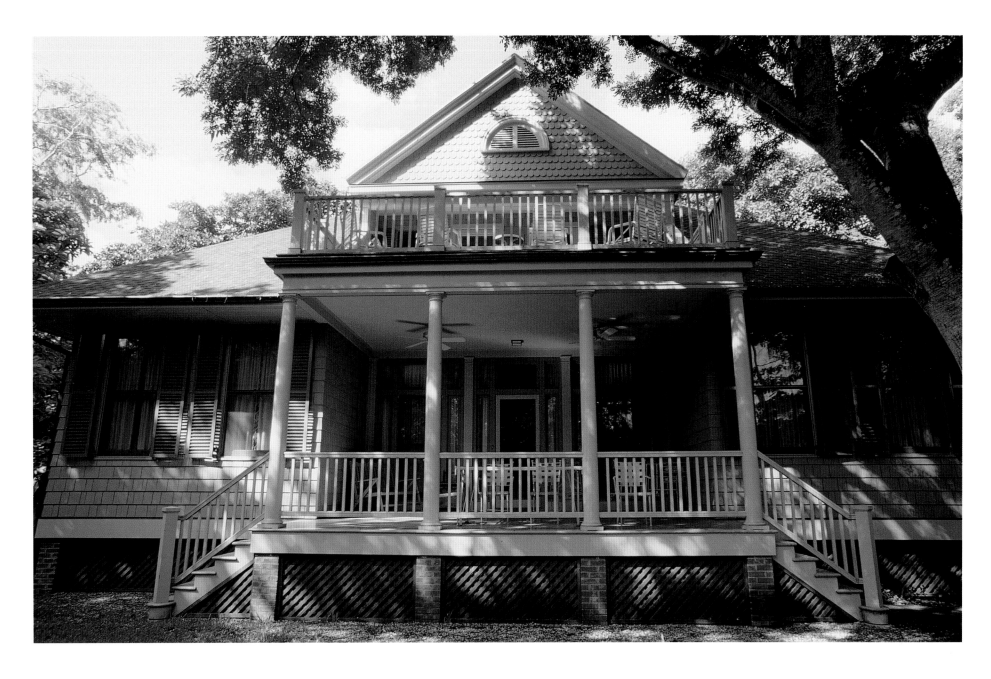

ABOVE *The simple classical elements of the porch, balustrades, and pediment create a dignified facade for Figulus IV. Shingle cladding and horizontal siding became decorative elements on the facade.*

RIGHT *Figulus IV at night projects warmth and openness.*

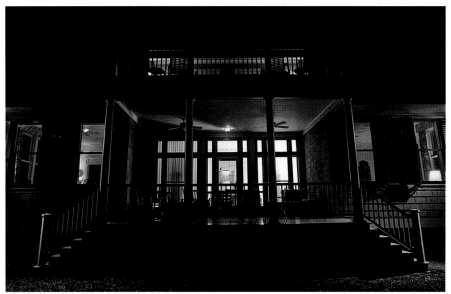

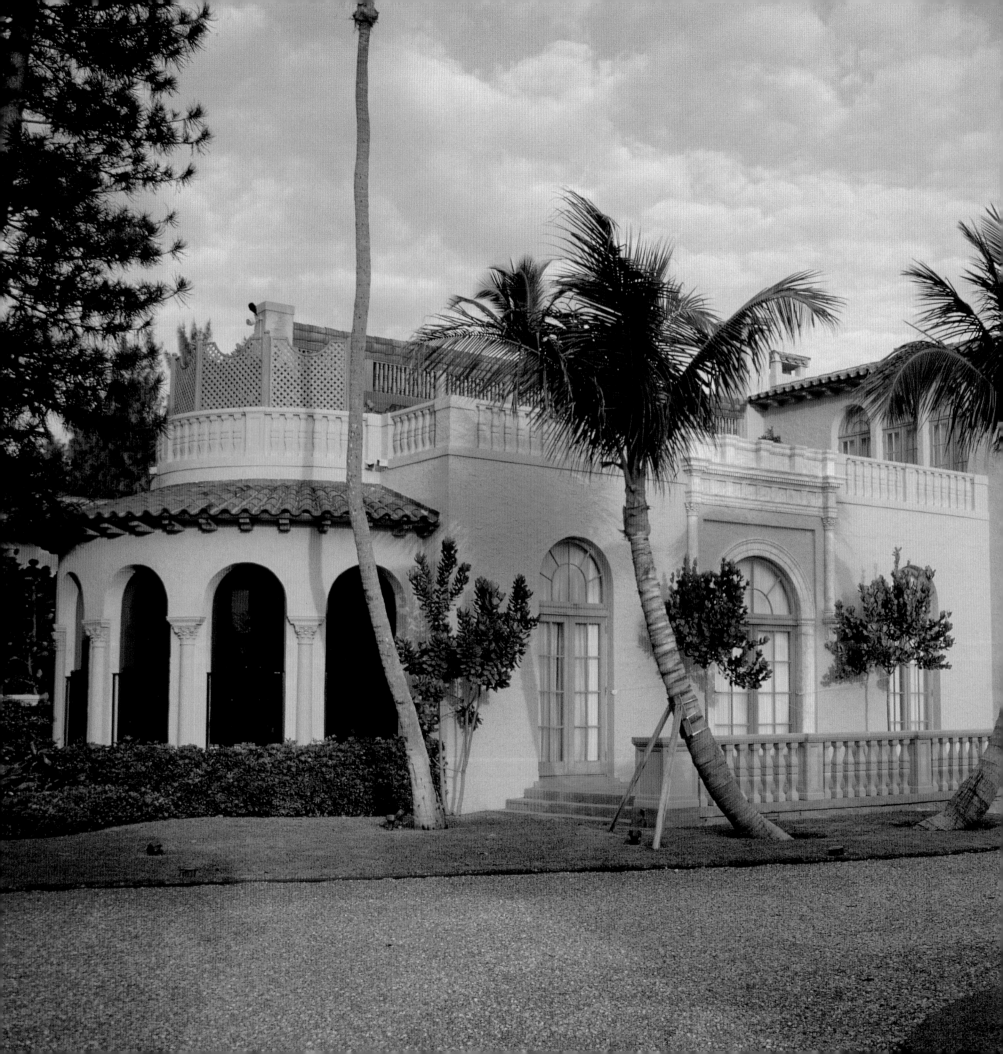

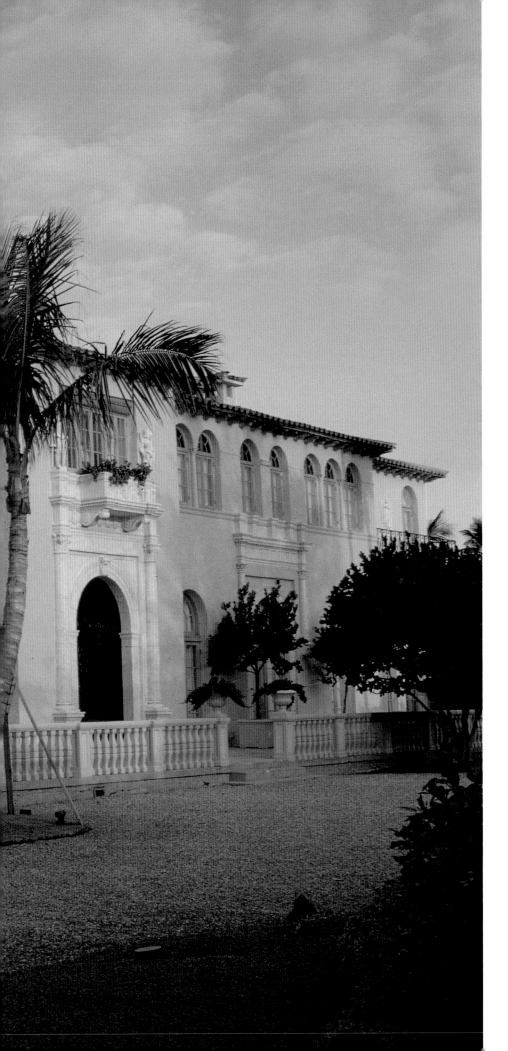

El Sarmiento

While the 1991 award to Figulus IV recognized an owner and architect who took a new home and looked to the past for inspiration, a second award in 1991, to El Sarmiento, recognized an owner and designer who took an old home and looked to the most modern influences for inspiration. El Sarmiento is an outstanding representative of a number of Palm Beach homes that have been remodeled many times by the most renowned Palm Beach architects. El Sarmiento, originally designed by Addison Mizner and built in 1923 for Anthony J. Drexel Biddle, Jr., had additions by Joseph Urban in 1927 and further additions by Maurice Fatio of the firm Treanor and Fatio in 1936. In the annals of Palm Beach architecture a more distinguished progression of architectural parents cannot be imagined.

In spite of the many architectural egos at work on El Sarmiento, the home maintains an architectural continuity of the Mediterranean Revival style in its massing and detail. For the restoration the owner engaged New York designer Juan Pablo Molyneaux to create a striking redefinition of the interior spaces as a setting for a unifying decor of exceptional modern art and trompe-l'oeil decorative treatments that complemented the theatricality of the original design.

El Sarmiento, an oceanfront property, began with a Mizner courtyard design. But the house is perhaps most notable as one of the few surviving examples of Joseph Urban's important contributions to Palm Beach's architectural history. Urban was born in Vienna. Although his parents assigned him a career as a lawyer, he managed to attend architectural classes at the Polytechnium and at the Imperial and Royal Academy. In 1911 when he came to Boston and subsequently New York City, Urban was steeped in the artistic ferment of late nineteenth-century Vienna and already a well-recognized architect and theatrical designer.

In America, Urban, in the words of his biographers, introduced a new "stage-craft" whose aim "was to fuse all the various elements of a theatrical piece – settings, costumes, lighting, stage movement, and, in some cases, music – into a unified artistic whole that would have maximum aesthetic and emotional effect upon the audience." In his designs for the Ziegfeld Follies, for over fifty Metropolitan Opera productions, and for William Randolph Hearst's movies, he was at the forefront of

OPPOSITE Joseph Urban's new dining room with its stage area is highlighted on the exterior by tall arched windows, which give prominence in the overall design to Urban's additions. Urban's alterations established a new location on the oceanfront facade for the main entrance.

ABOVE The carved cast stone capitals on the dining room pillars recall those Urban used at the Paramount Theatre, in Palm Beach, on interior pillars.

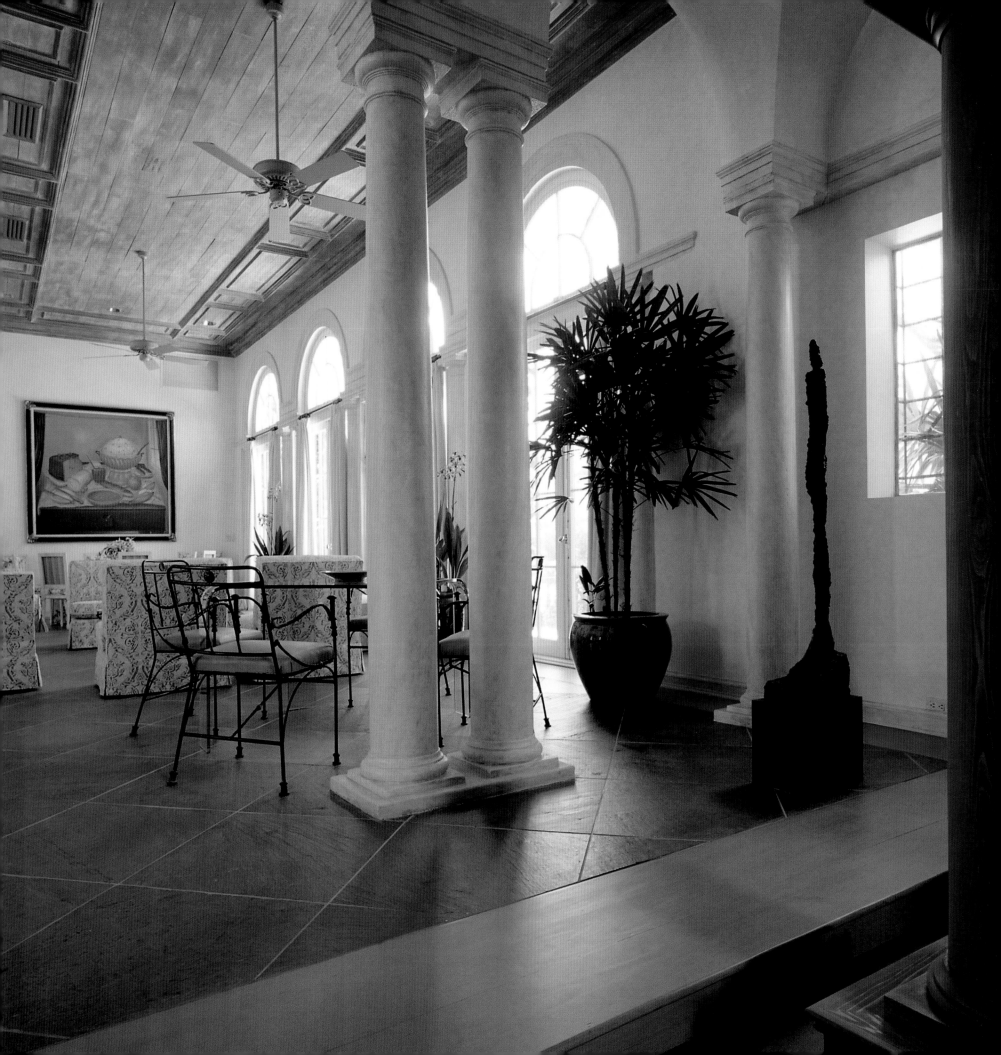

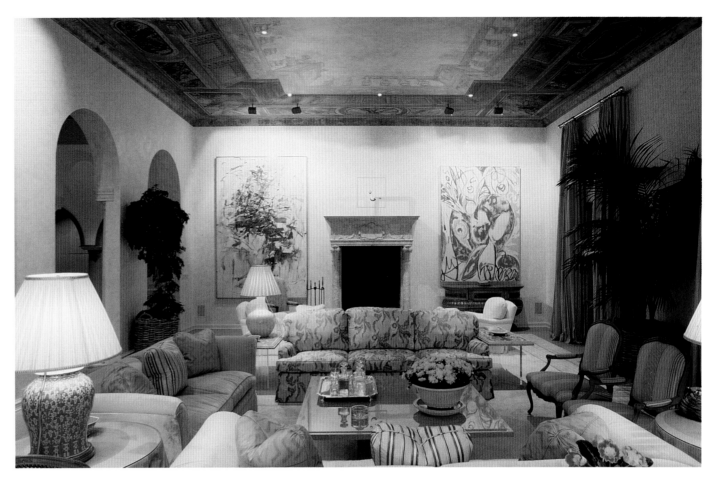

American theatrical design. His architectural designs in New York City, such as the Ziegfeld Theater and the New School for Social Research, and many others which have not survived, were equally significant.

Anthony Drexel Biddle, Jr., of the eminent Philadelphia banking family, was an early mover and shaker on the social scene in Palm Beach. He was a founder of the Bath and Tennis Club and of the Club Momartre, which was located where the Society of the Four Arts, a local organization for the performing and fine arts, now is. Urban met Biddle through Paris Singer, the father of the Everglades Club, and the two men formed an immediate friendship. Biddle and E. F. Hutton were to be the sources of Urban's major Palm Beach commissions. Today Urban's reputation in Palm Beach rests solely on four major buildings that survive, the Bath and Tennis Club (1927), Mar-a-Lago (1925-1926), the Paramount Theatre (1926), and his revisions to the Biddle house (1927).

All of Urban's buildings in Palm Beach reflected his familiarity with and fondness for the stage. How remarkable that during its great years of mansion building, Palm Beach attracted two master architects, Urban and Addison Mizner, with such a similar fondness for dramatic designs and fantastic details. Both Urban and Mizner were great party goers and givers. Both understood their architecture was expected to function as a stage for life styles of luxury and exoticism. And both maintained a firm hand on all the details of their work. Urban wrote,

> An architect, to do justice to his constructions, must do as much as he can himself and personally supervise whatever is beyond his powers. He must know the problems of ventilation. He must intimidate the plumber

until that wrench distributes his pipes in keeping with the general scheme. He must sketch, plan and consult on every detail, and the more of an expert he is in all related fields, the more unity he will achieve.

> This is where the experience of my early days [in Vienna] comes in handy. I do all the decorating and ornamentation myself. Frequently I select the furniture and fittings, personally, and I should even like to choose not only the people who live in my houses, but the clothes they wear and the things they do.

Urban's glowing interiors at Mar-a-Lago and at the Paramount Theatre were testament to his skills in producing theatrical presentations.

At El Sarmiento, Urban created the major change that gave the house its future character. He moved the entrance to the original dining room area and added a new oceanfront dining room of grand proportions. At one end a raised area provided a stage. The room could hold eighty people for a theatrical. Its ceiling was copied from the Alhambra, and Urban's stage was built of black marble. It could be transformed into a fountain area for everyday use.

The restoration of El Sarmiento took the theatricality of the bones of the house and expressed it through the interior decoration. The illustrations depict El Sarmiento in 1991, although in recent years El Sarmiento has been expanded and reinterpreted by new owners. Just as architecture can only rarely endure unchanged, restorations too are subject to reinterpretation. In this process the best of our built environment is preserved and speaks with both a new and old voice of changes in the culture that produced it.

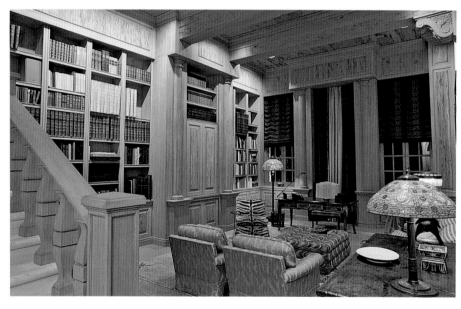

TOP AND OPPOSITE *The massive main stairway at El Sarmiento was transformed by a trompe-l'oeil painting by Robert Archer and Emma Temple, which continues to the second floor.* ABOVE *Pecky cypress wood paneling in the new library area maintains a continuity with the period wood ceilings throughout.*

ABOVE *The stage end of Urban's dining room addition references its theatrical inspiration through black marble columns with intricately carved capitals.*
OPPOSITE *Another view of the 1927 dining room alteration with modern furnishings suggests the room's size could easily have accommodated private theatricals.*

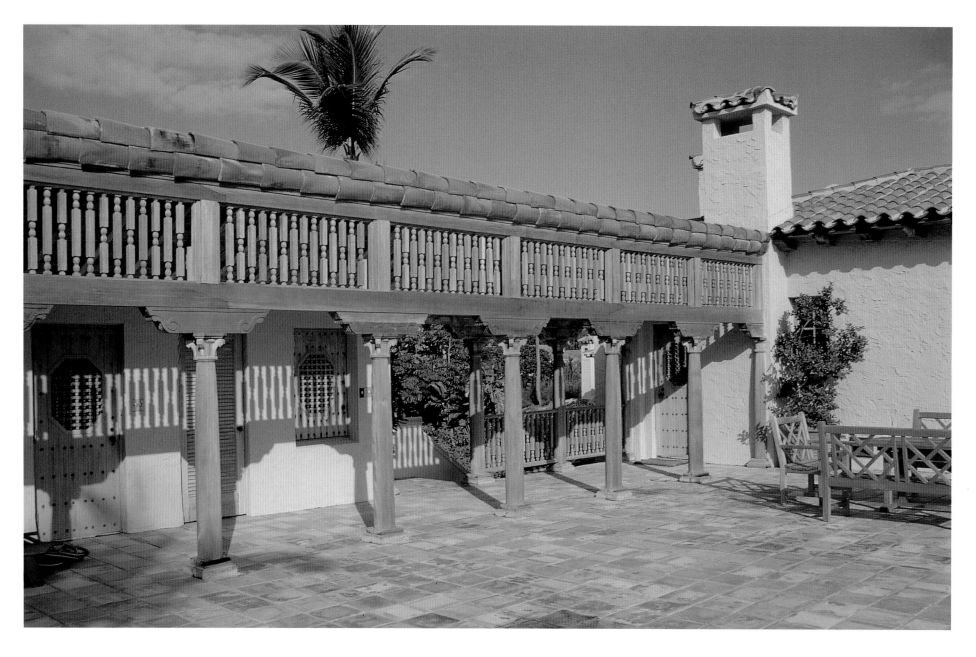

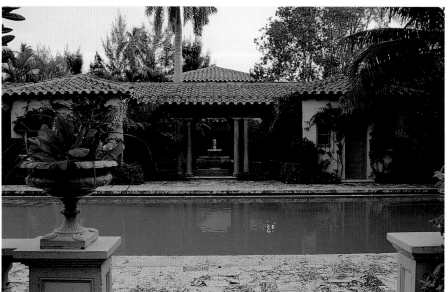

ABOVE *The second floor patio is decorated by a pecky cypress rejas which was also restored.*
LEFT *An open air loggia defined by columns provides lounging space beside the pool.*

ABOVE The restoration addressed all the concerns of renewing and restoring columns, woodwork, ceilings, and arched windows. Mizner's original courtyard plan is still an important feature of El Sarmiento.

Buttonwood

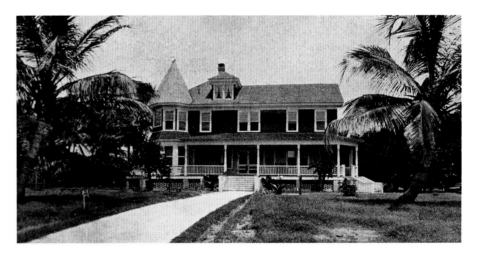

Beyond the official dictates of the Secretary of the Interior's Standards for Restoration and Rehabilitation, there is no single road map for a successful restoration. Certainly for a home, not a museum, there are no magic instructions for how to go beyond the requirements of architectural fidelity to infuse a house with the spirit of its past. Sometimes there is a fortuitous concatenation between the history of a house and the taste of its owners. This kind of happy synergy marked the restoration of Buttonwood, the 1992 Ballinger Award winner. Buttonwood, one of Palm Beach's early surviving homes, found, in Betsy and Michael Kaiser, owners who enhanced the charm of its Victorian origins through their own collections of antique artifacts and decorations and extended its Florida character with compatibly designed additions and landscaping.

Buttonwood's first owner, the honorable E. N. "Cap" Dimick, was an 1876 pioneer, hotel proprietor, banker, businessman, developer, state senator, and the first mayor of Palm Beach. In 1903-05 Dimick built a commodious lakefront house, first known as Orangerie and later renamed Buttonwood. These were the idyllic days when Palm Beach was both a resort and a wilderness. The oral recollections of Thomas Reese, Dimick's grandson who was born in the house, speak of roasting marshmallows on beach bonfires, canoeing in the shallow lagoon in the center of the island, and running a trap line for raccoons. A boy could earn the veritable fortune of $12 for a prime pelt, but if a skunk was trapped the result was not always so fortunate. There were alligators and ostriches at Alligator Joe's tourist attraction, and in the early 1900s Indians still came to Palm Beach. It wasn't unusual for the Dimick family to wake and find half a dozen Indians sleeping on the broad porch or in the yard after a nocturnal excursion to the beach searching for kegs of rum washed up as salvage from a shipwreck.

After "Cap" Dimick's death in 1917, his lake-to-ocean property became the Stotesbury estate where Mizner erected one of his finest designs, El Mirasol, and Orangerie moved on, literally, to become Buttonwood. Using hundreds of wooden rollers and a mule turning a capstan, in 1919, the house was moved several blocks to the south where it was renamed Buttonwood, for the imposing tree in its front yard. In its new location it became the home of Amy Lyman Phillips, who authored the 1920s society column in the *Palm Beach Post*, which in the 1920s, which was known as the "Diary of Mistress Samuel Peeps."

Over decades of occupancy as a family home, Buttonwood endured many changes and additions. Its tower was lost, its octagonal second floor bedroom was squared off, and its interior appointments were altered. When the Kaisers acquired Buttonwood, they enlisted the architectural help of Peter Mullen of Mullen, Palandrani in New York City and Steven and Lynn Trezise of Trezise Design Associ-

ates in West Palm Beach to help formulate plans for the house. But the Kaisers wanted a hands-on restoration, and throughout the process Michael Kaiser acted as general contractor and Betsy Kaiser was her own decorator.

The Kaisers' restoration painstakingly reproduced the exact dimensions, to the 1/8 of an inch, of the old clapboard covering the house. The simple colonial columns that add elegance to the front porch were split and reinforced before reinstallation. Despite the many alterations over time, Buttonwood retains many of its distinctive features, such as the third-floor dormer in the center

OPPOSITE The sprawling Buttonwood tree in the front yard gave the home its new name after it was moved from the Stotesbury property.

TOP Betsy Kaiser's travels in Indonesia led her to design a series of garden ornaments, each one original, in the form of frogs. Found throughout the Buttonwood property each frog projects its own mood and personality and serves the useful function of providing an anchor for a patio umbrella by a carefully placed hole at the top of its head.

ABOVE Buttonwood, when it was the Dimick home and known as Orangerie, was a typical frame shingle vernacular style home with the embellishment of a Queen Anne style tower.

of the front facade. Another gracious feature of the original Dimick structure was the parlor wing octagonal bay window. Like other early Palm Beach builders, Buttonwood's anonymous local designer worked in the familiar vernacular of a resort style that borrowed stylistic elements, such as colonial columns or Queen Anne derived octagonal forms, from more academic styles.

Buttonwood's Victorian idiosyncrasies were well met with its owners' international backgrounds in fashion and photography. For the restoration, the result was a fortunate conjoining of taste and devotion to creating an enduring restoration.

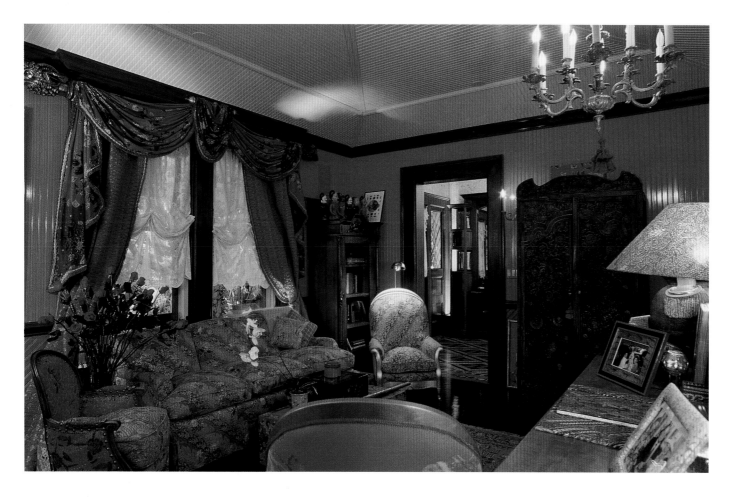

TOP LEFT *Jewel tone hues in the library and a profusion of patterns recall the late Victorian Age's delight in the counterpoint of many designs and decorative motifs.*

BOTTOM LEFT *A bath displays the interplay of many different tile designs.*

BELOW *In the entryway refinished Dade County pine floors were hand painted in a Victorian diamond pattern. Dade County pine was an early wood building material of choice. It not only resisted insects; it was so hard that restoration carpenters today have difficulty driving nails into the wood.*

OPPOSITE *Historically accurate beaded paneling and wainscotting in the halls were repaired or recreated as conditions dictated.*

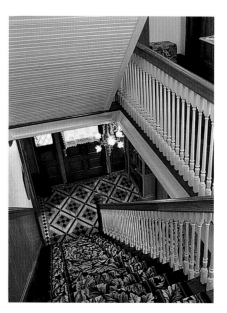

ABOVE *The parlor displays Betsy Kaiser's collection of antique, museum quality silks and batiks. Window treatments by Robert Tree unify the room. Antique Dutch tiles and an antique fire screen embellish the fireplace.*

RIGHT *The family room again displays Indonesian batiks. Through the use of pattern and color, each room at Buttonwood takes on its own personality. The theme of Indonesian batiks is a unifying element.*

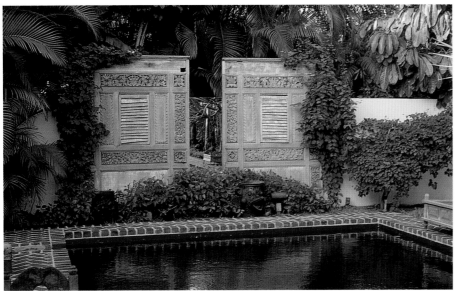

ABOVE *The dining room, with its French wallpaper, reaches out to its Florida setting.*
LEFT *Weathered antique door panels and a mirror define the end of the patio and pool.*

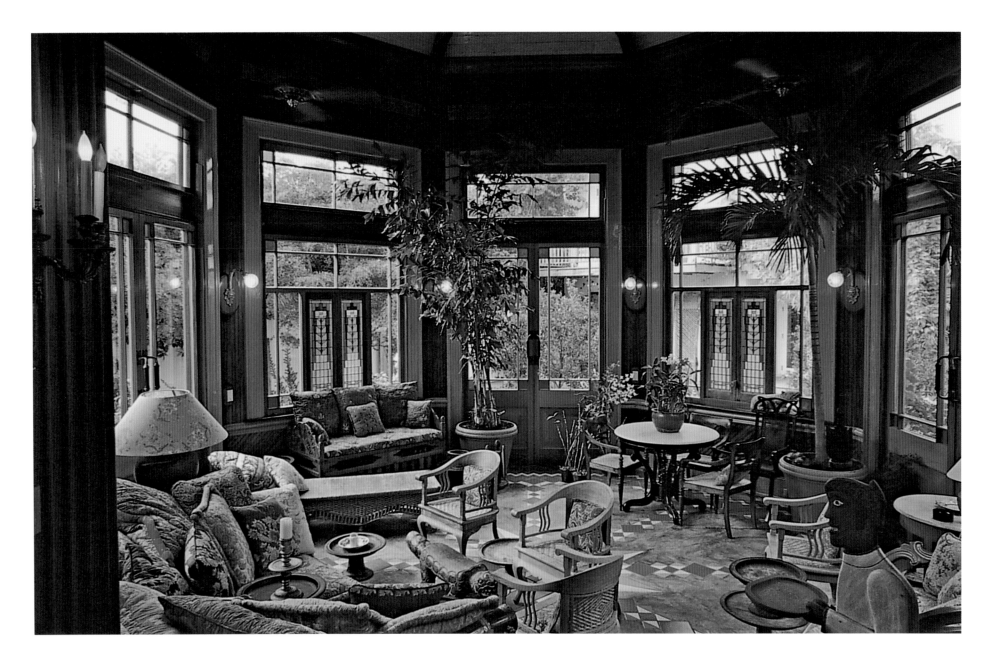

ABOVE *The conservatory is an example of a compatible architectural addition in a restoration. Its historical reference point is the octagonal living room projection on the front facade, and in the restoration it, like the original house, was covered with custom-milled siding. The octagonal form is derived originally from Queen Anne influences.*

LEFT *Indonesian etched glass doors hung in the conservatory windows form a transition to the outdoors. The Kaisers researched the history of Victorian follies before the conservatory was built.*

OPPOSITE TOP *An old-fashioned front porch displays imported Indonesian pieces at Buttonwood. The projection of the living room is at the far end.*

OPPOSITE BOTTOM *The projecting eaves on the exterior of the conservatory were designed to both carry rain gutters and hold flower baskets.*

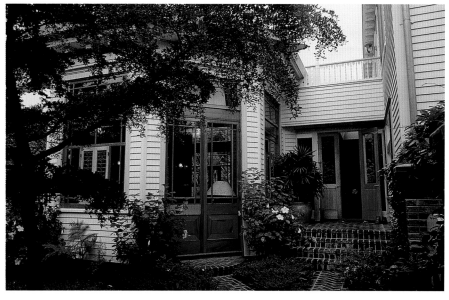

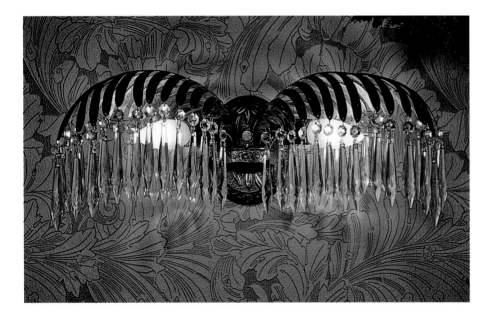

TOP AND ABOVE *Period lighting fixtures are used throughout Buttonwood and provide another theme that unifies the interior decoration, as well as binding the decoration with the history of the house.*

RIGHT *A bedroom displays an antique fan. Instead of relying on conformity, the decorating plan called for a different batik pattern for each window shade, a subtle incorporation of Victorian sensibility into an Indonesian setting.*

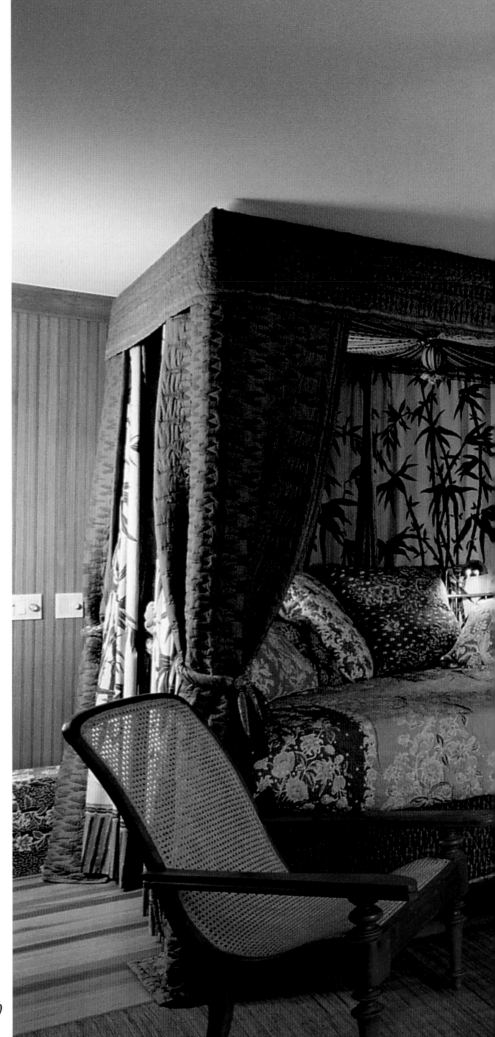

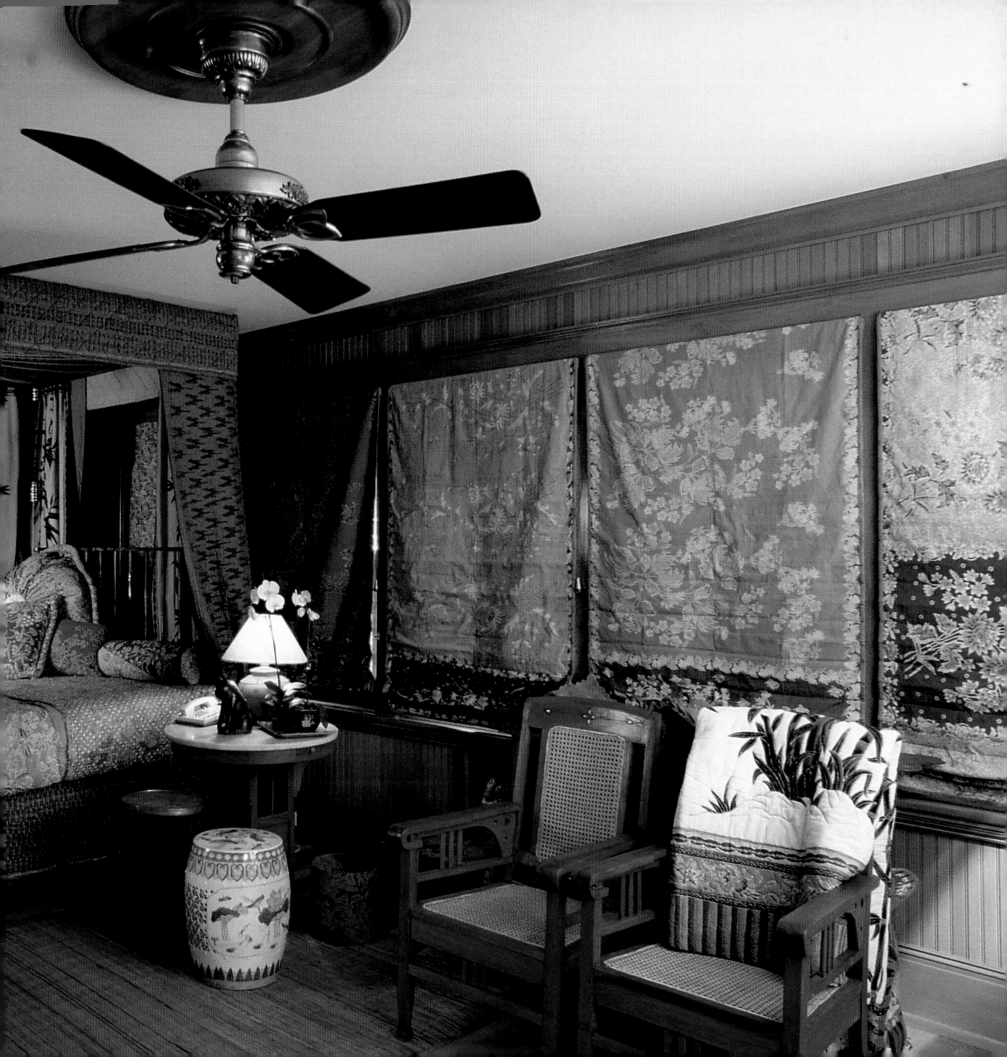

ABOVE *Weathered Dutch doors are mounted on patio walls to carry the decorative theme outdoors.*

RIGHT *Buttonwood's rear facade shows the dining room, pool, and conservatory areas, which were all added in the restoration.*

Casa della Porta

Historic restoration is a process. Every restoration takes on a life and character of its own. Some restorations are outstanding for the way they blend modern, but architecturally appropriate, additions with the original historical fabric. Casa della Porta is not one of these. Instead its owners, Lynette and Howard Gittis, accepted the enormous challenge of restoring a huge deteriorated stone structure within the limits of rigorous and uncompromising authenticity. They respected the original design of Maurice Fatio, one of Palm Beach's master architects, as a work of art to be accepted on its own terms and restored with intelligence and self-discipline.

Maurice Fatio, the son of a banking family, grew up in Geneva, Switzerland. Before coming to New York City in 1920, he studied architecture at Zurich Polytechnic where his mentor was Karl Moser. In New York he worked briefly with the Harrie T. Lindeberg firm and in 1921 formed a partnership with William A. Treanor, one of Lindeberg's architects. The firm of Treanor and Fatio rapidly won a clientele of wealthy and distinguished New Yorkers. In 1925 Fatio followed his client base to Palm Beach where he established the Florida offices of Treanor and Fatio in picturesque Phipps Plaza in the center of town.

Fatio's extensive legacy of letters to his family show him to have been a man who worked and played hard. In Palm Beach during the season he described an endless round of sea bathing, luncheons, golf, tea dances, and charity balls. His daughter, Alexandra Taylor, in her book on his life and work, described him as the epitome of the "social architect." The term was intended as a compliment to his polished personality and manners. Indeed, his popularity on the Palm Beach social scene paved the way to significant architectural commissions and success.

Treanor and Fatio, and especially Maurice Fatio as the personification of the firm in Palm Beach, are credited with many of the most famous homes in the area from the Harold Vanderbilt and Jacques Balsan residences in Manalapan to Joseph Widner's Il Palmetto in Palm Beach. Fatio's work endures today in some of the most prominent locations in town — the Gucci building and courtyard on Worth Avenue, the original First National Bank building, and the Society of the Four Arts Library building. Fatio's palette ranged from an appreciation of American bungalows to designs relying on Mediterranean influences to later Art Deco and even modernist influenced designs. In 1937, the Reef, an oceanfront design for the Vadim Markoffs, won a gold medal at the Paris International Exhibition as "the most modern house in America." As an architect and a resident of Palm Beach, Fatio joined with his colleagues, like Addison Mizner and Marion Sims Wyeth, in serving on the town's Art Jury, the forerunner of its Architectural Commission, and in supporting the beginnings of urban planning and zoning.

For Palm Beachers Casa della Porta has always held a special cachet. Frequently described as the "finest doorway in Palm Beach," Casa della Porta del Paradisio, the House of the Door to Paradise, portrays the story of Adam and Eve and draws on carvings Fatio saw in an Italian monastery for its design inspiration. Fatio's European background and extensive travel led him to expand Palm Beach's display of Mediterranean architectural sources beyond the prevailing Spanish influence. Casa della Porta, like many of Fatio's buildings, brought about a refined interpretation of Italian sources.

Like many of his other compositions, Casa della Porta was executed in coquina stone. Coquina is today among the rarest of building materials. It was used in north Florida from the time of the early Spanish settlements and today is found only on the east coasts of North Carolina and Florida. Much imitated in modern cast concrete products, only the stone slabs cut from reefs created by marine shells and coral show the range of diversity and nuances of texture and color available in the natural material. A similar product, Quarry Key Stone, was found along the Florida Keys and is still available today. Addison Mizner was the first Palm Beach architect to use Quarry Key Stone extensively. It was one of Fatio's favored materials and together with the Tuscan designs that were his preferred sources of inspiration, it marks Casa della Porta as one of his most memorable houses.

Typically, Palm Beach homes were commissioned in the spring. Then architect, workers, and craftsmen labored feverishly to complete the commission before the owners returned for the next winter season. Casa della Porta was recognized as a showplace when it was completed in 1929. Majestic and almost overpowering in its asymmetrical massing and roof lines, Casa della Porta was a fitting castle for one of America's industrial elite, William McAneeny, President of the Hudson Motor Car Company. In 1993 it received the Preservation Foundation's Ballinger Award. Fatio spoke of it as "the greatest house I have ever done."

OPPOSITE The front doorway of Casa della Porta is distinguished by its sumptuous coquina stone decoration of biblical motifs. The coquina stone adds depth, color, and texture to the facade, while it unifies the asymmetrical Romanesque massing of the house. Differing window styles and cornice treatments add punctuation to the weight of the stone. It was said to have taken six months for Italian stone cutters to create the entrance carvings. Casa della Porta had seventeen bedrooms and eighteen baths including staff quarters. In 1929 it cost approximately $1 million, including its antique furnishings. The original contractor was Harry Voight. The restoration architectural work was supervised by the Lawrence Group, and the restoration contractor was Worth Builders.

ABOVE Detail of stone design at Casa della Porta.

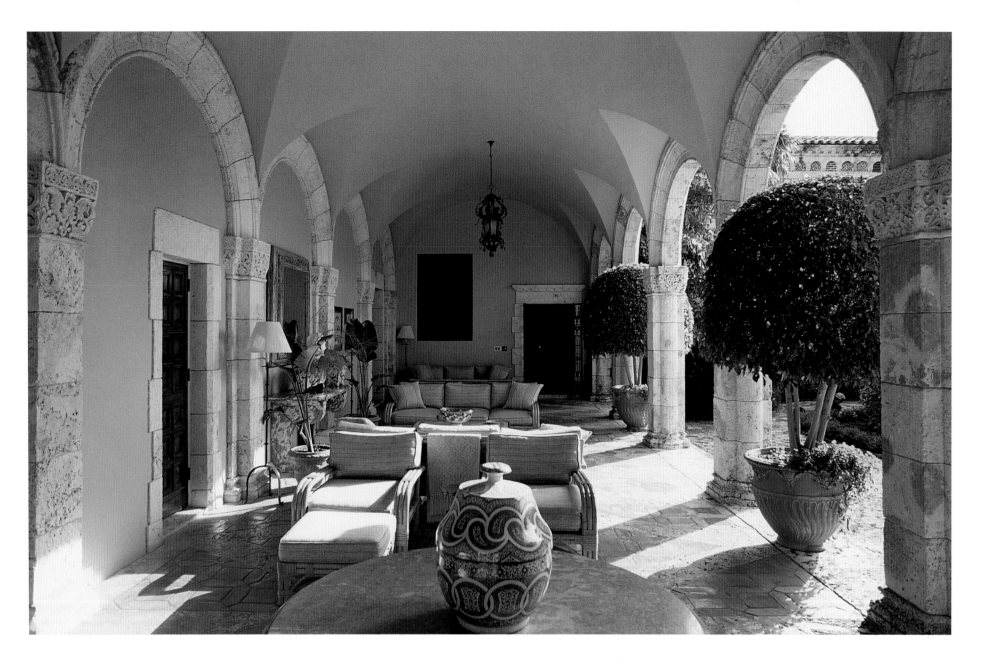

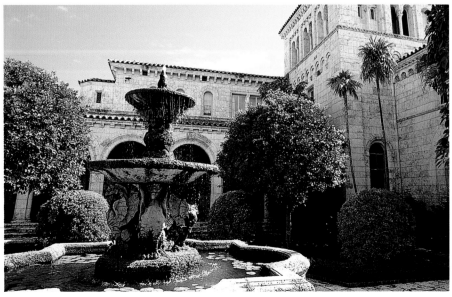

ABOVE The open loggia extending around the sides of Casa della Porta's central courtyard underscores the romantic Italianate character of the house. Here as elsewhere antique lighting fixtures were repaired or, if necessary, copied and reproduced.

LEFT The restoration program included relaying every single patio stone. Many days more than one hundred workmen descended on the job. The Gittises, when out-of-town, supervised every excruciating detail, including the remossing of the patio fountain with its guardian griffins, through regular taped video reports.

OPPOSITE The loggia leading from the tennis court to the central patio is decorated with an elaborate wooden ceiling. Decorated ceilings are a frequent theme throughout the house.

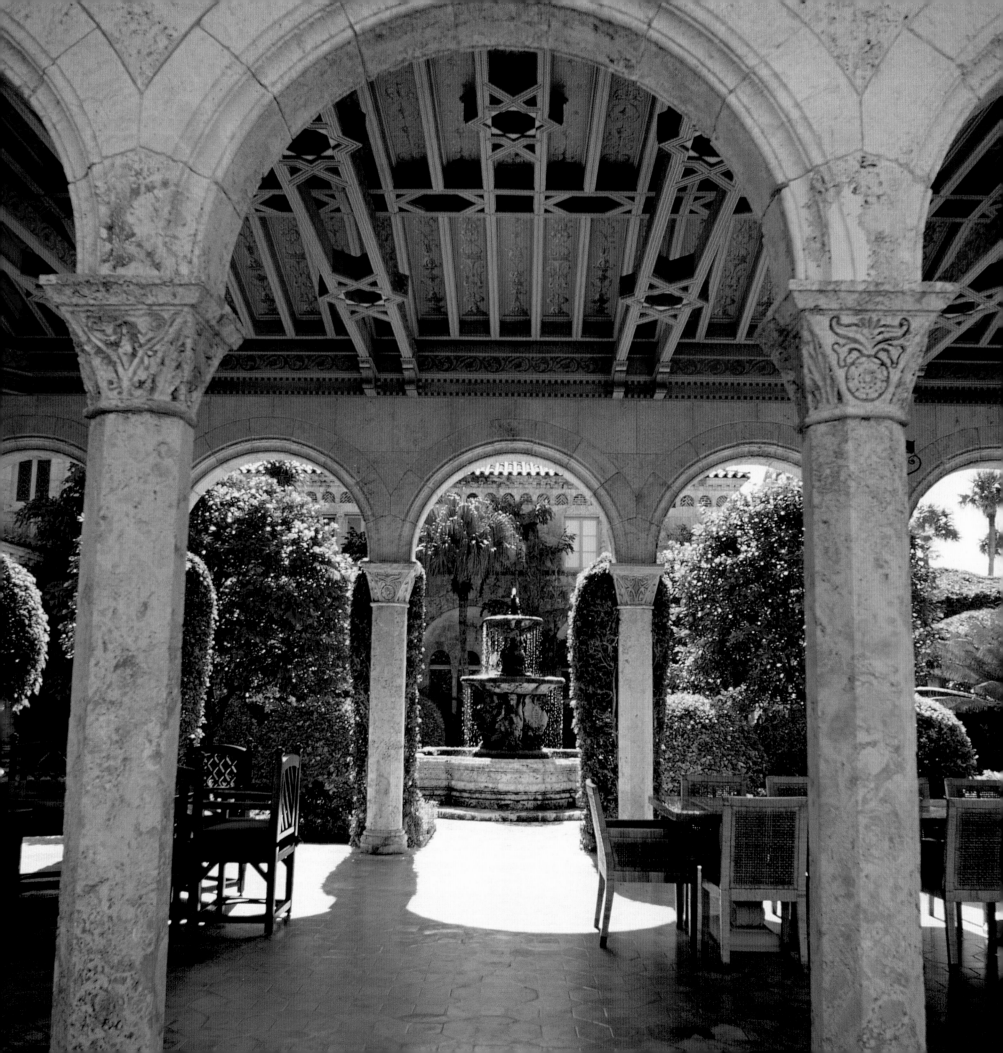

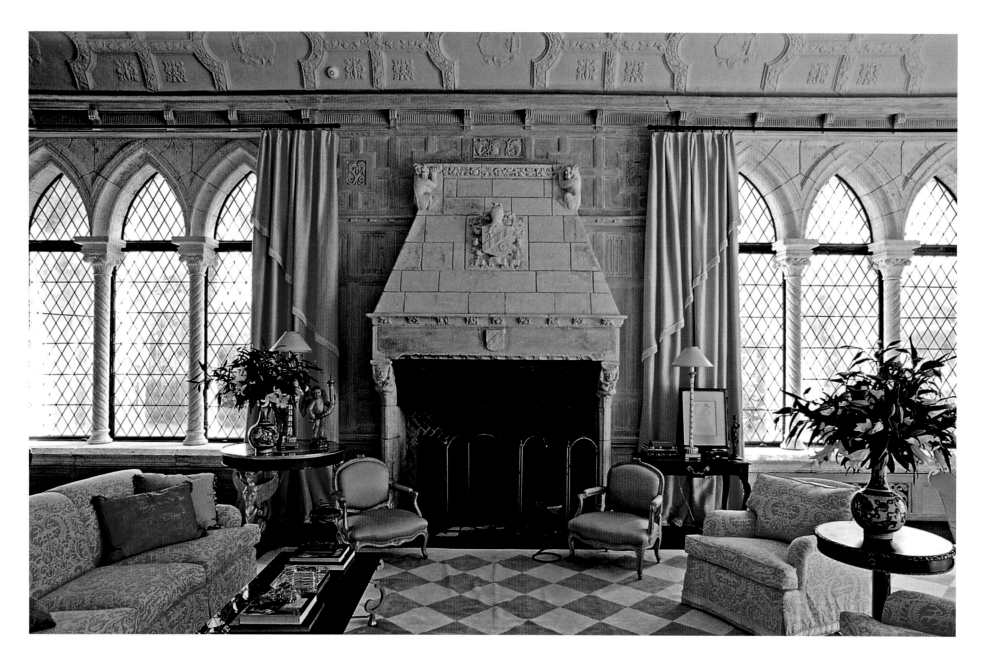

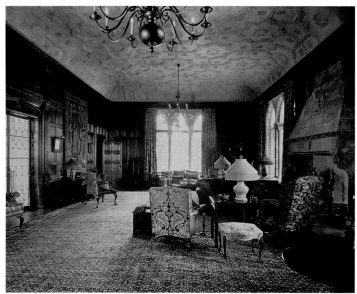

ABOVE *Casa della Porta's magnificent living room featured a hearth of truly noble proportions flanked by gothic leaded glass windows. During the restoration when disassembled pieces of window mechanisms were found in the basement, they were painstakingly reassembled and reinstalled.*

LEFT *Historical photographs show decorations chosen by Ruth Campbell Bigelow, the New York interior designer who worked with Mrs. McAneeny. An interior theme of Jacobean English decoration reinforced the impression of a castle, whose windows looked out on the sea.*

OPPOSITE TOP *The dining room returned to an Italian theme with heavy wooden doors brought from a Florentine palace. The restoration required cleaning the doors with a tooth brush to remove an unfortunate coating of black lacquer that had been applied at some time in the past.*

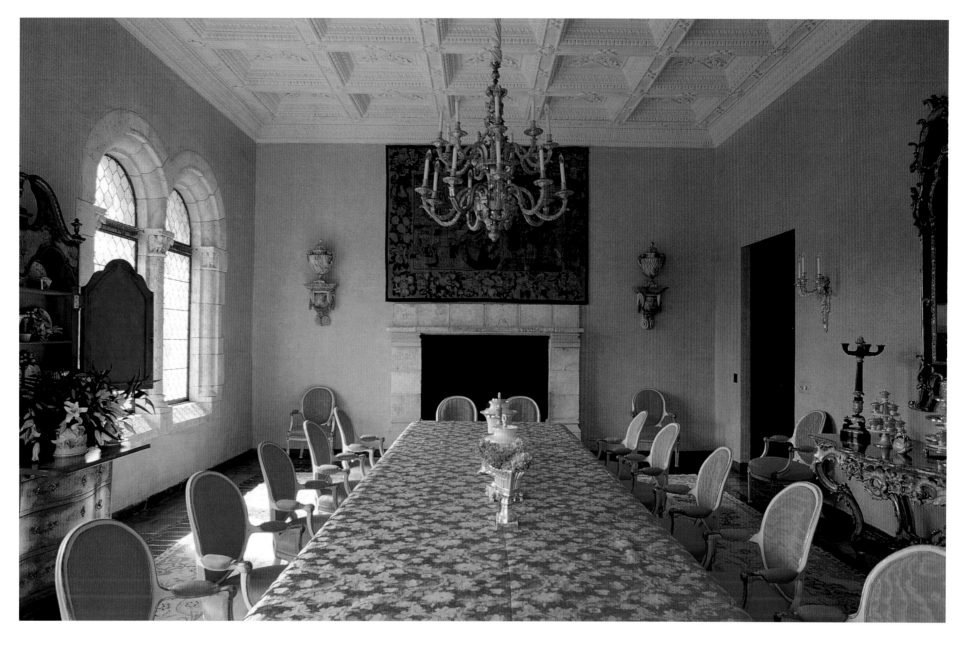

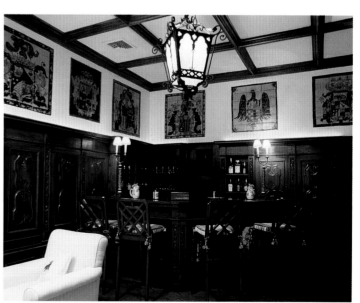

RIGHT The Irish pub, some-
times called the grillroom, shown
in this historical photograph, is
another example of Jacobean in-
fluences blended with Italian.
FAR RIGHT The restoration of
the pub room features the same
heavy walnut presence as the
original room, touched with color
from antique Italian tile panels,
which were said to have been
taken from an old chapel, inset
in the walls.

TOP LEFT *A loggia ceiling features an intricate painted wood ceiling with an antique lighting fixture of Kokomo-colored glass.*

LEFT *Glorious painted ceilings are found throughout Casa della Porta.*

BELOW LEFT *The painted ceiling of the third-story tower room is a fittingly elegant decoration for this extraordinary room whose tall windows offer three hundred sixty degree views from the Atlantic Ocean on the east to Lake Worth on the west.*

ABOVE *Detail of loggia ceiling.*

BELOW RIGHT *The ceiling of the breakfast room adjoining the loggia was totally rotted. It was completely restored and the breakfast room's open sides were seamlessly enclosed in glass to preserve its view of the interior courtyard.*

OPPOSITE *Decorative iron grillwork separates the entrance foyer from the patio.*

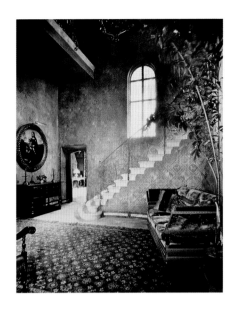

OPPOSITE *An impressive hallway that recalls a European cloister separates interior spaces from the central patio. Early descriptions of Casa della Porta remarked on the mechanism that allowed these windows to descend into the basement at the touch of a button, transforming the cloister hallway into an open air passageway.*

ABOVE *This historical photograph shows Fatio's use of a rather delicate iron baluster design to soften the massive stone stairway.*

RIGHT *The restoration preserved Fatio's ironwork. This stunning view highlights the original proportions of the stairway. The ceiling rises twenty-eight feet above the stair.*

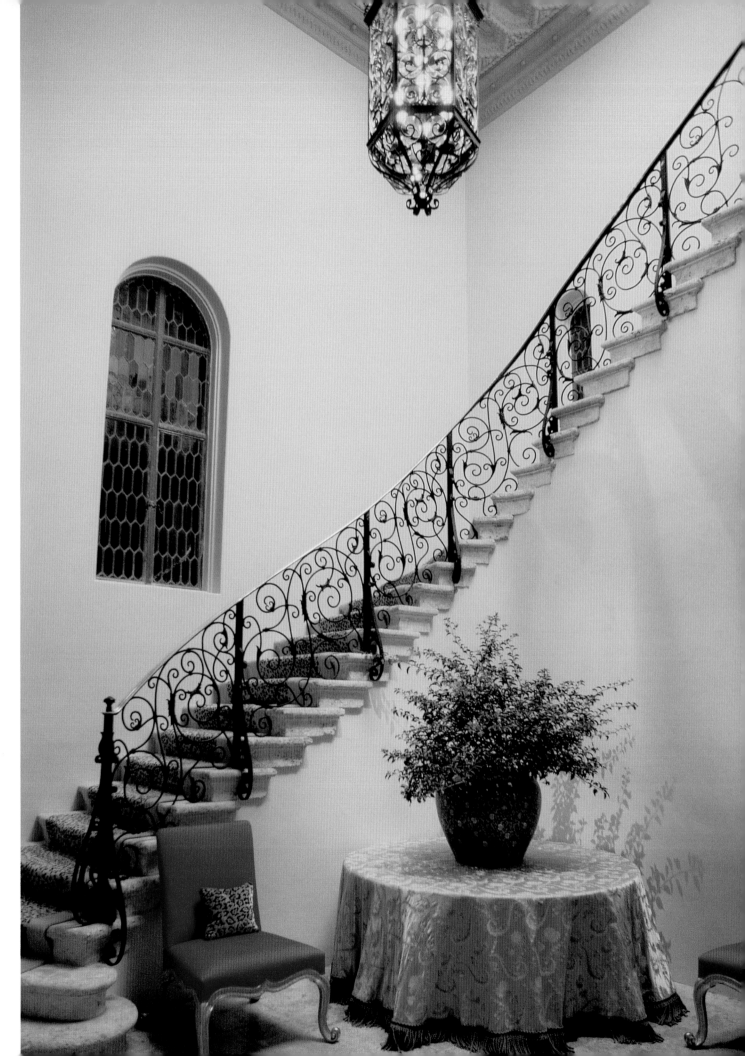

LEFT Casa della Porta's varied and intricately intersecting roof lines add interest and variety to break the mass of the architectural composition.

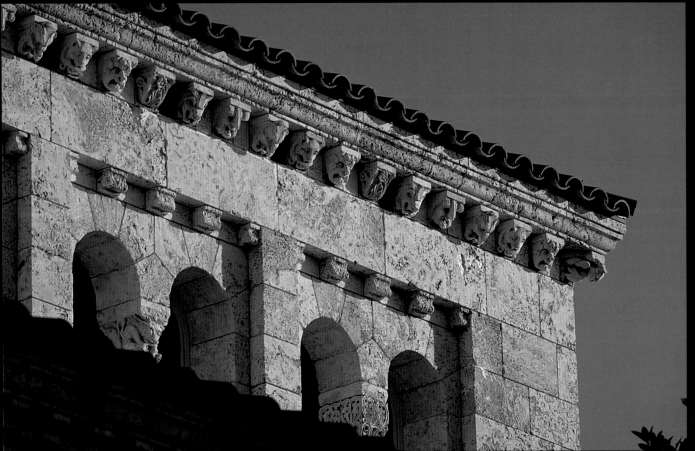

LEFT AND ABOVE Everywhere on Casa della Porta there are carvings. They represent hundreds of hours of laborious, detailed skilled restoration. They are sometimes humorous, sometimes grotesque, sometimes elegant, often abstract, never repetitive, and always delightful.

RIGHT AND ABOVE *A historical view (right) shows the original pool on the east side of Casa della Porta. Today (above) the pool remains in the spacious side yard. Like many Palm Beach properties, additional open space was sold off by an earlier owner so Casa della Porta has lost its original expansive ocean views from the living room and pool areas.*

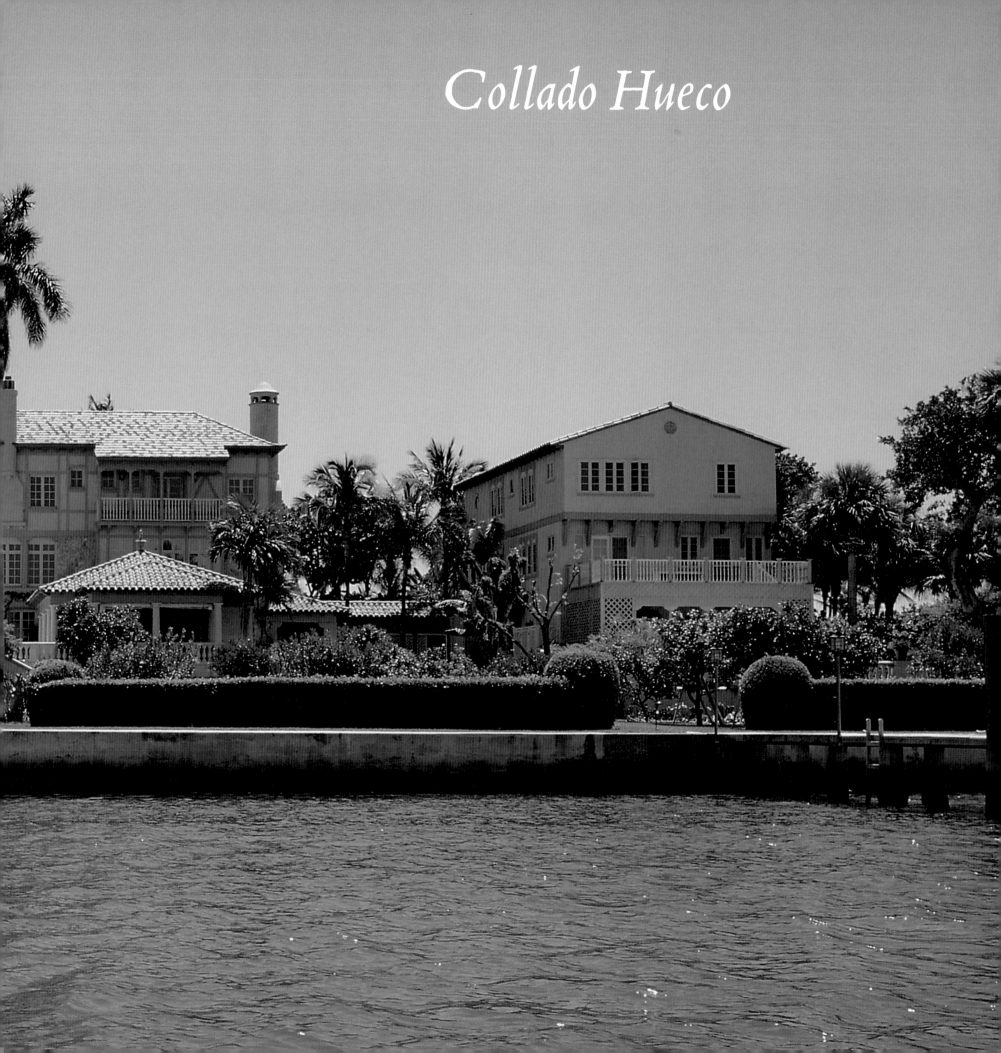

Collado Hueco

PRECEDING PAGES *Collado Hueco seen from Lake Worth presents more of an emphasis on horizontal massing than the typical Mizner design. By siting the house on the top of the ridge, Mizner preserved ocean and lake views for the major rooms. The wing to the far right is a guest house, added later and executed by the architect John Volk .*

A ddison Mizner always wanted to tell a story through his architecture. At Collado Hueco, the 1994 Ballinger Award winner, he found the perfect site to speak through his architecture. Mizner, Palm Beach's most famous architect, drew on a background of international adventure for his narratives. Raised and schooled in California, he moved to Guatemala City with his family in his teens when his father won a diplomatic appointment there. Later he studied in Spain at the University of Salamanca. In search of riches he traveled to Alaska during the Gold Rush before he apprenticed with the architect Willis Polk in San Francisco. Drawn by the promise of large commissions, he spent two years in Hawaii, traveled to Australia, and then around the world.

By the early 1900s Mizner was establishing an architectural career in New York City. With a ready wit, an agreeable social presence, and proper social connections, Mizner developed a cadre of influential friends, like Mrs. O. H. P. Belmont and Mrs. Herman Oelrichs with whom he partied and traveled. His connections led Mizner to a number of New York and Long Island commissions and to a friendship with Paris Singer, an heir of the Singer sewing machine family. Mizner came to houseguest with Singer in Palm Beach in January of 1918. Although the architect was ostensibly severely ill from the recurrence of a childhood leg injury, by July Singer and Mizner had broken ground for the Everglades Club. The Club opened in January of 1919 and established Mizner as Palm Beach's most renowned architect. Mizner moved on to a frenetic schedule of designing pleasure palaces for the social elite who flocked to America's new Riviera during the Roaring Twenties.

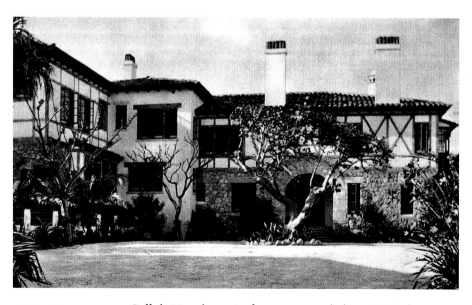

ABOVE AND RIGHT *Collado Hueco's massive front entrance arch shows Mizner's departure from his usual stucco construction. Here he used coquina stone for the first floor with half-timbering on the second level.*

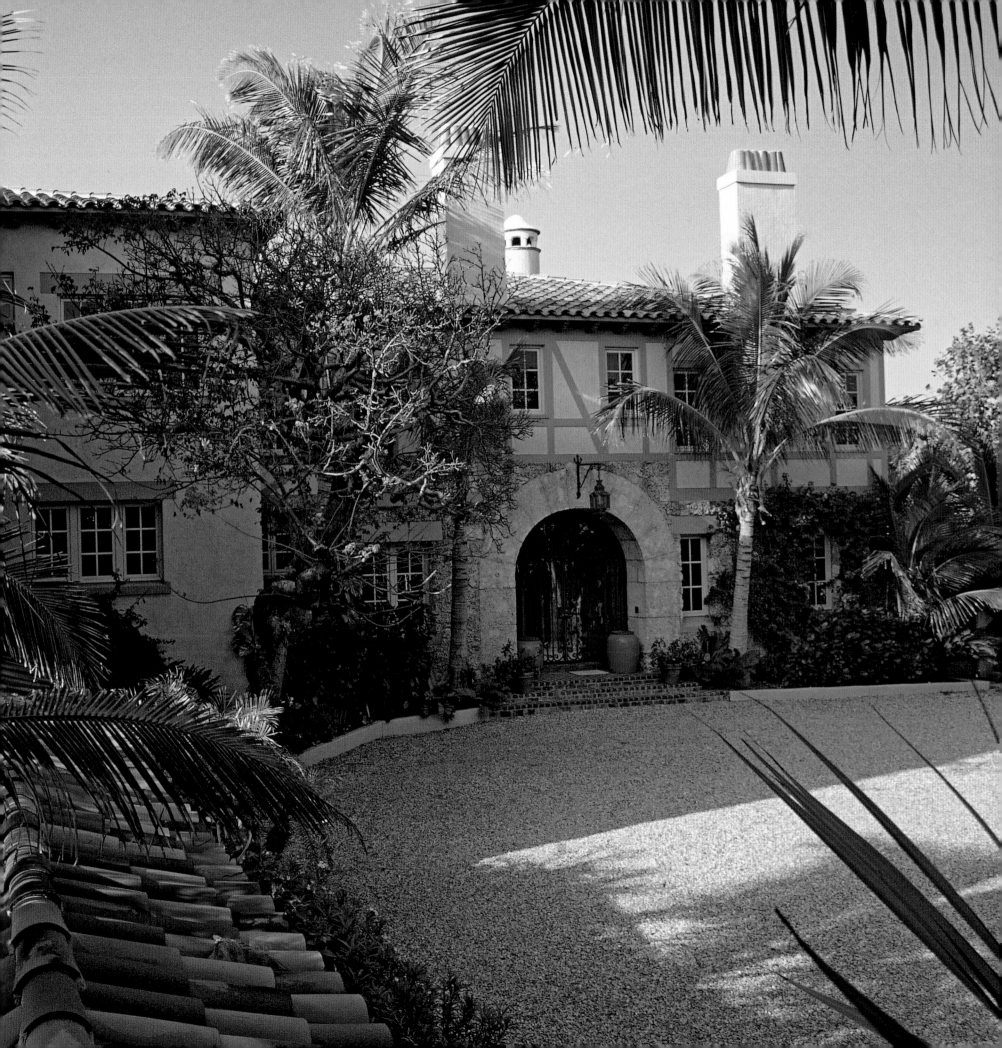

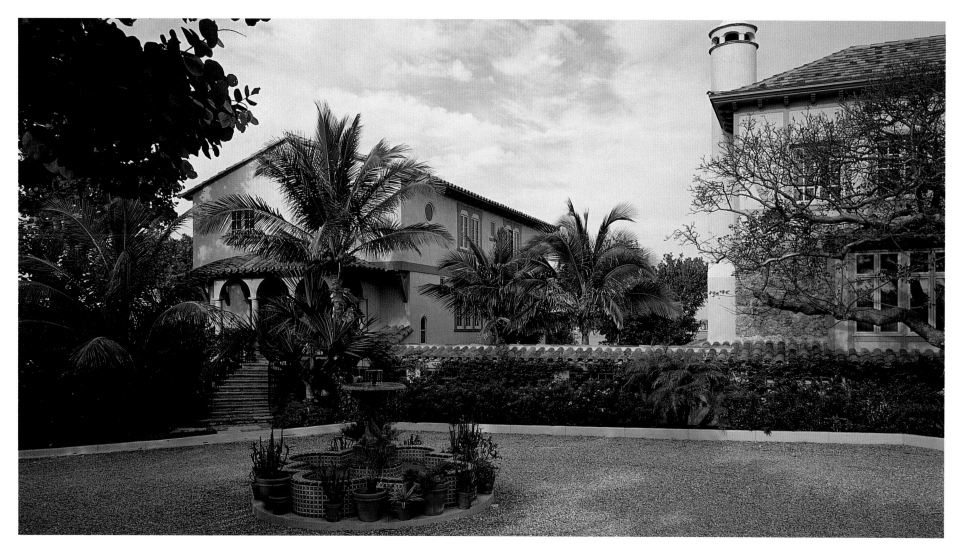

Although Mizner had designed alterations for Paris Singer's Peruvian Avenue villa in Palm Beach in a Chinese style, the success of the Everglades Club cemented the theme of Mediterranean Revival architecture as his trademark style for Palm Beach and for all his Florida work.

Mizner did not invent the American vogue for Mediterranean Revival architecture, but he was its most astute and active popularizer. The historical associations of the Mediterranean Revival and its adaptation to a warm, seaside climate provided Mizner the perfect vocabulary to express the privileged life styles of his clients. In his 1924 commission for Paul Moore, Collado Hueco, Mizner executed one of his most beautifully sited expressions of the Mediterranean Revival. In writing about his architecture Mizner observed,

> most modern architects have spent their lives carrying out a period to the last letter and producing a characterless copybook effect. My ambition has been to take the reverse stand — to make a building look traditional and as though it fought its way from a small unimportant structure to a great rambling house that took centuries of different needs and ups and downs of wealth to accomplish.

The name Collado Hueco combines the meanings of a prominence and declivity. In his design for the house, Mizner was forced to balance the architecture and its striking site. As a result this home is one of Mizner's most strongly architectural creations. It relies for effect less on typical Mediterranean Revival decorative details than on the massing of solid architectural forms that spill down its hillside site to the lake — one house, yet its cubical massing recalls vividly the impression of a Mediterranean village of many houses tumbling down a hillside to the sea. One wonders if the name Collado Hueco was not meant as a double reference, both to the essential balance the architect must create between the structure and the land and to the balance achieved by this house as it surmounts a natural ridge between the ocean and the lake.

Collado Hueco's organic relationship with its hillside site is reflected in the contrast between its stucco surfaces and the natural coquina walls that seem to emerge from the earth itself. But Mizner could never leave a house totally without decoration. At Collado Hueco he chose an exterior vocabulary of red roofs, half timbers, and other elements that recall the organic materials and simple forms of Mediterranean villages.

The painstaking three and one-half year restoration process used all the extensive tools of modern preservationists. Floors were removed, re-milled, and refinished. Tiles were reproduced and restored. Original designs were meticulously retraced and repainted or appropriate modern designs were produced as were compatible furnishings.

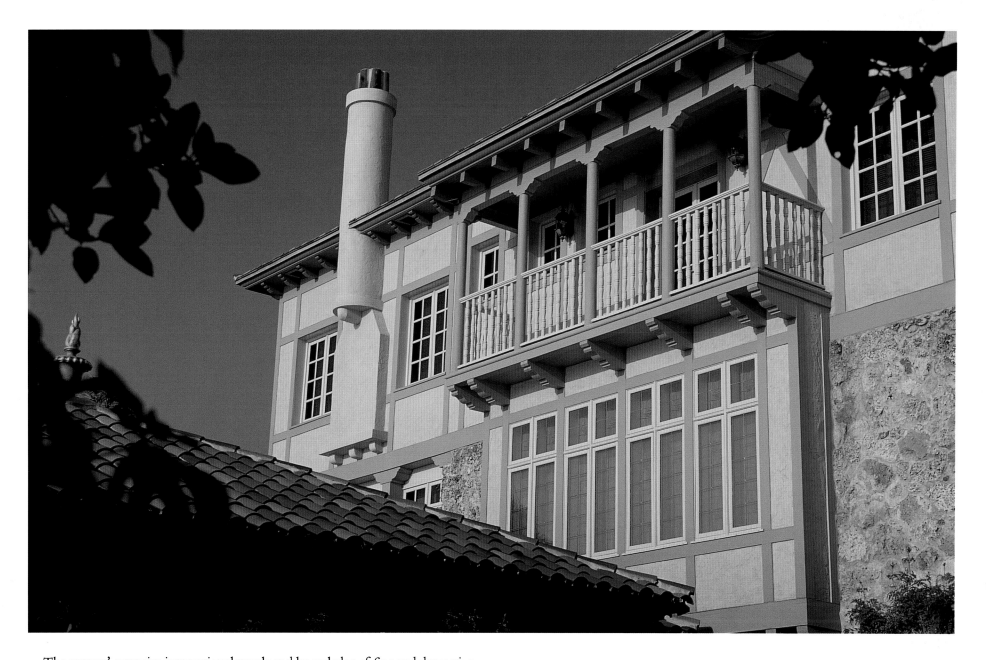

The owners' extensive international travels and knowledge of fine and decorative arts provided a vision for Collado Hueco's restoration. It was that vision that endowed the restoration with character and authenticity and allowed them to follow Mizner's path in expressing the story of the house. They worked to give the house, in their own words, "the look of centuries." In their efforts the restoration blended the old and the new in a timeless recreation of the best of Palm Beach architecture.

OPPOSITE John Volk's guesthouse addition repeats the theme of arches and a red tiled roof. ABOVE A detail shows the rich contrast of materials used at Collado Hueco: red clay roof tiles of different colors, stucco chimney, coquina stone, and half-timbering. The variety of building materials reinforced Mizner's story of a house that had grown over centuries. RIGHT Collado Hueco is unusual among Mizner designs for its lack of applied cast stone decoration. In describing the story of his architecture, Mizner said, "I sometimes start a house with a Romanesque corner (then) pretend it has fallen into despair...suddenly the great wealth of the world has poured in and and the owner has added a very rich Renaissance addition."

91

ABOVE The entrance hall at Collado Hueco viewed toward the iron entrance gate creates a feeling of romance and anticipation with its period furniture and lighting and massive tile floor.

LEFT Artwork contrasts with the severity of an iron-barred window.

OPPOSITE RIGHT Three views of pottery displayed in dining room niches.

OPPOSITE TOP FAR RIGHT Collado Hueco's entrance hall with appropriate period lighting fixtures.

OPPOSITE BOTTOM FAR RIGHT The grand stairway is decorated with an antique lighting fixture.

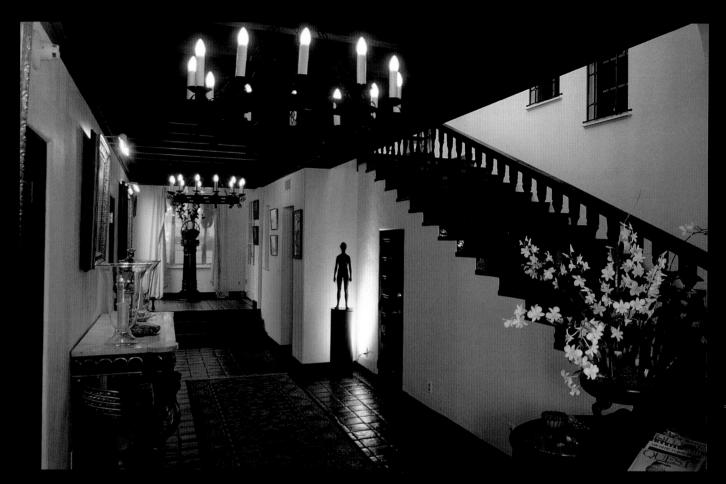

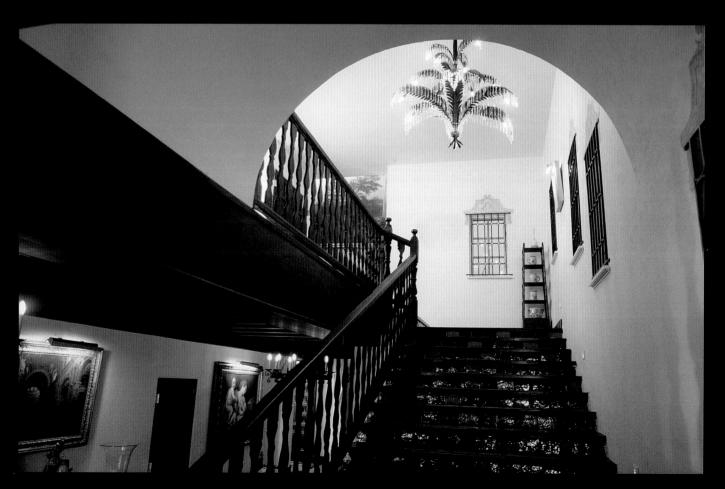

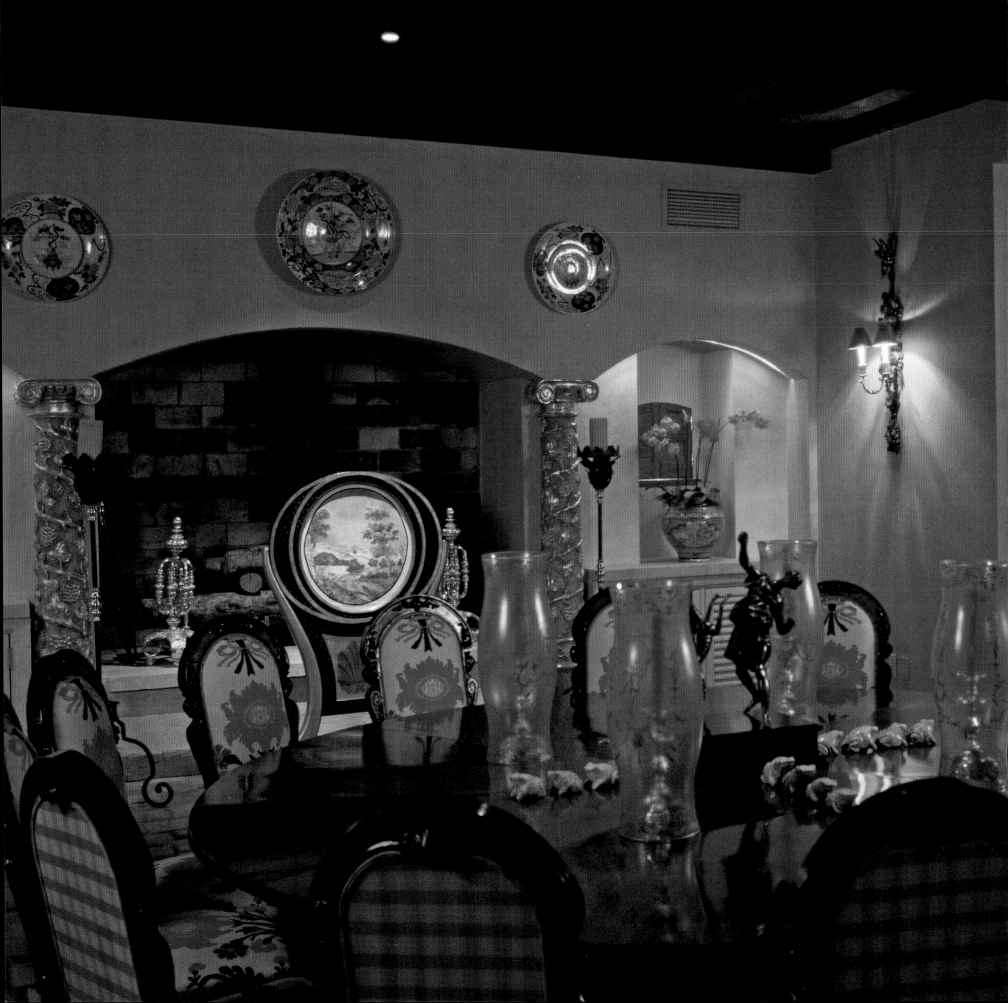

OPPOSITE AND TOP *A lengthy process of experimentation with colors in the dining room produced a blended pale yellow and a red color. The colors were laboriously sponged on by hand and then rubbed with steel wool.*

ABOVE *A historical photograph shows early furnishings at Collado Hueco.*

ABOVE *A coordinating theme of the restoration at Collado Hueco is the elaborate wood ceiling decoration. Frequently wood beams were painted to create intricate designs.*
RIGHT *Elaborate patterns in floor tiles echo the intricate designs shown on Collado Hueco's ceilings.*

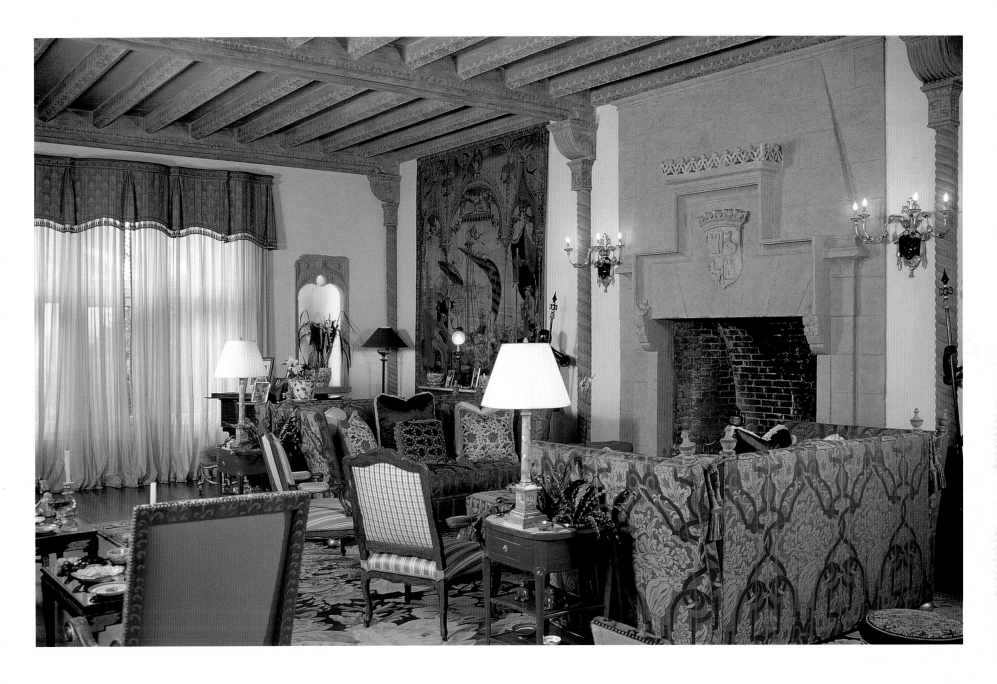

ABOVE *The restored living room focuses on the massive fireplace.*
RIGHT *The living room pictured in a historical black-and-white photograph.*

ABOVE Collado Hueco's west facade glows with light and contrasting shadows. A period shop sign forms part of the Mizner story on Collado Hueco's courtyard. It recalls Mizner's sense of how his homes grew, like Mediterranean villages, over time.

RIGHT Viewed from the pool terrace, Collado Hueco's grounds cascade down toward the lake. The west terraces, steps, and pool pavilion were modified during the restoration as was the guest house terrace.

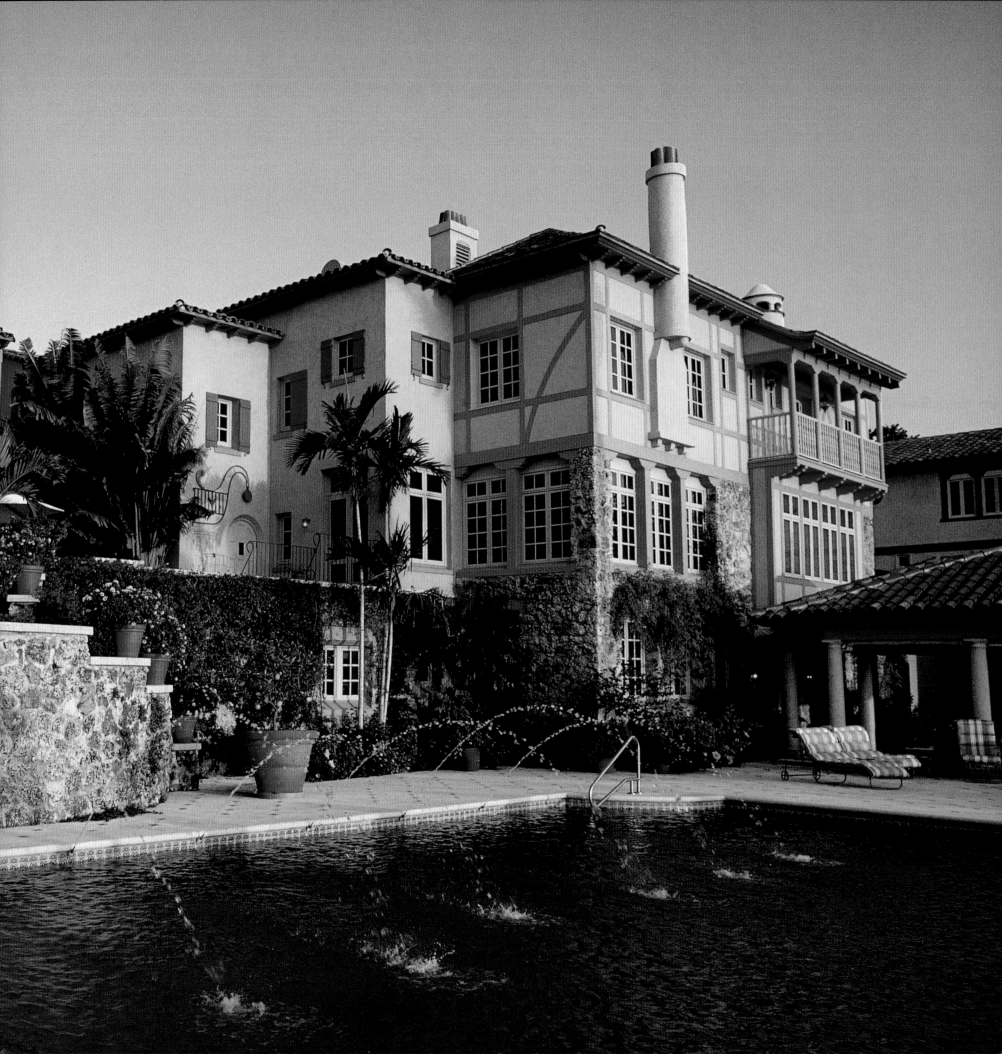

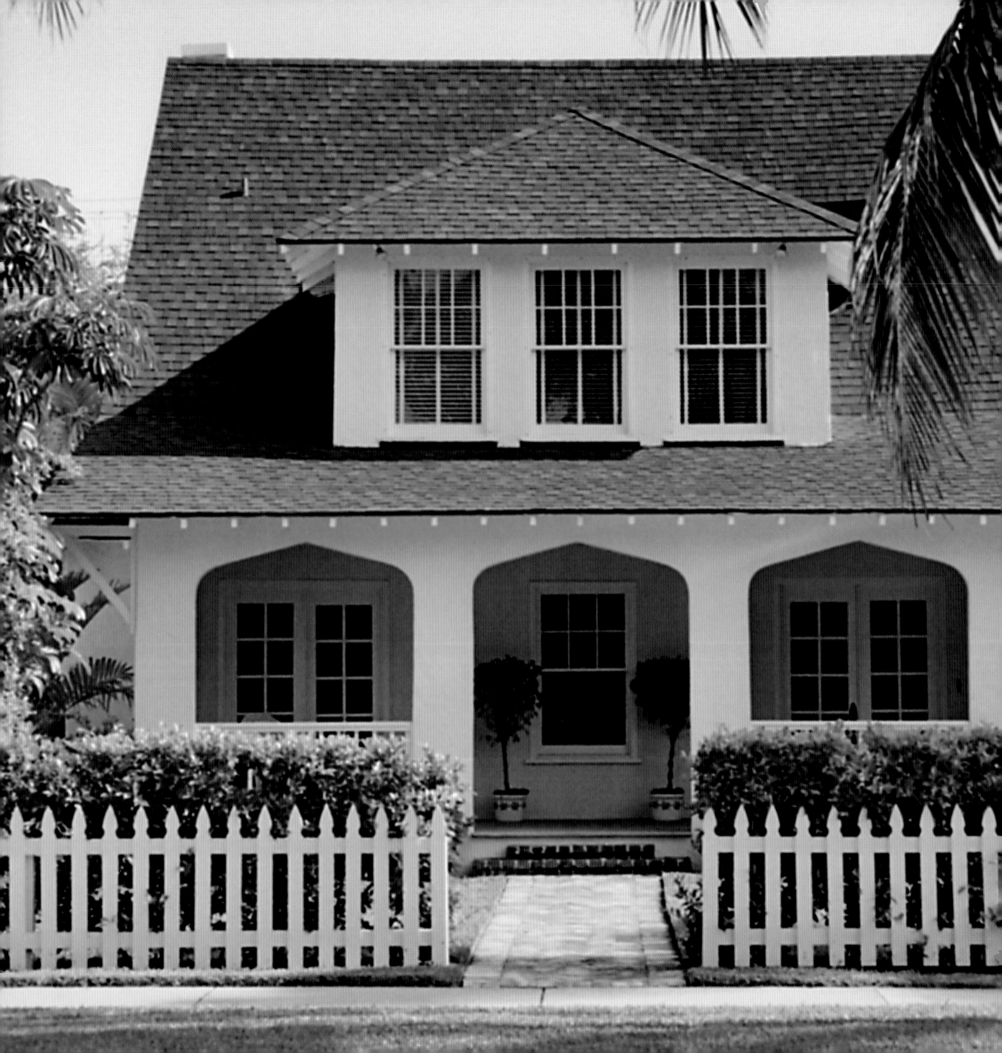

Brazilian Avenue Bungalow

While the bungalow form is not a distinctive American contribution to architectural history, in the United States in the early twentieth century, bungalows became the most popular architectural style in the country. The modest bungalow form of a low house with open verandas was elaborated, homogenized, and popularized as nowhere else. With breezy front porches, dormer windows for light and air, bay windows, exposed rafter ends, and broad eaves, bungalows were easily adaptable to resort life and gained a reputation as a universal house type.

The ultimate Americanization of the bungalow was found in the Sears Roebuck catalog where one could order a standardized bungalow to be shipped to any homesite. Palm Beach was no exception to the early twentieth-century bungalow craze, and the Ballinger Award in 1995 recognized Robert Deziel's efforts to restore and preserve one example of the town's bungalow heritage.

Bungalows in Palm Beach could be quite commodious, but they tended to be smaller than architect designed mansions and to occupy the cross streets in the center of town whose development began before the 1920s boom in Mediterranean Revival architecture. Often designed by knowledgeable craftsmen or construction firms, bungalows were anonymous but omnipresent in early Palm Beach. Since they tended to be built on small, intown lots, and represented relatively inexpensive redevelopment opportunities, they were among the first of Palm Beach's characteristic architectural forms to be attacked by the tear down phenomenon. By the 1990s when Robert Deziel restored his bungalow on Brazilian Avenue, what was once a typical Palm Beach style was a rare survival.

The Deziel bungalow was constructed ca. 1915 for L.D. Cowling by East Coast Builders. Its 1992 restoration, which was under the direction of Jeffrey W. Smith of the Smith Architectural Group, respected all the typical elements of the bungalow style. Additions were made to the rear facade of the house to expand the kitchen and a bedroom and to frame a new pool and patio. The rear walls were pushed out and the roof lines modified to create a master bedroom suite, dining and loggia area, and expanded kitchen. Newly constructed bookcases in the living room offered the opportunity to frame a traditional window seat, while the interior flattened arches repeat the shape of the house's exterior arches. The living room demonstrates the simple elegance of bungalow life style.

Recently sold to a new owner, Robert Deziel's bungalow is typical of the charming early bungalows found throughout Palm Beach. With different porches, sizes, colors, and degrees of restoration, these bungalows offer all the amenities of intown living, yet today they are the town's most rapidly vanishing architectural style. The Ballinger Award winner demonstrates how these bungalows can be rejuvenated through restoration.

OPPOSITE Restoration work revised Robert Deziel's bungalow into a balanced and comfortable home. Its triple arches in a flattened Gothic form create an understated contrast with the rectangular lines of the first floor and dormer windows.

ABOVE Shortly before its restoration in 1992, the Brazilian Avenue Bungalow presented an air of despondency.

ABOVE *A bay window expands the dining room, and the interior design repeats the arch motif found on the exterior. Reproductions of typical period windows were constructed with the smaller panes in the top half forming a decorative element. The reconfiguration of the back of the house allowed the dining room to open toward the outdoor view.*

LEFT *At one end the living room focuses on a period fireplace.*

OPPOSITE ABOVE *A view of the living room looking toward a traditional window seat, added in the restoration, shows a simple wood window framed by the relaxed arch above the window seat and the built-in bookcases flanking the window seat. Although the window seat here was added as part of the restoration, window seats were a typical feature of bungalow homes.*

OPPOSITE RIGHT *The master bath was provided with a traditional claw-footed tub.*

OPPOSITE FAR RIGHT *The upstairs master bedroom suite was enlarged through the rear addition that was included in the restoration work.*

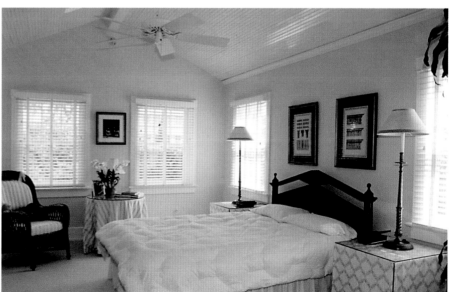

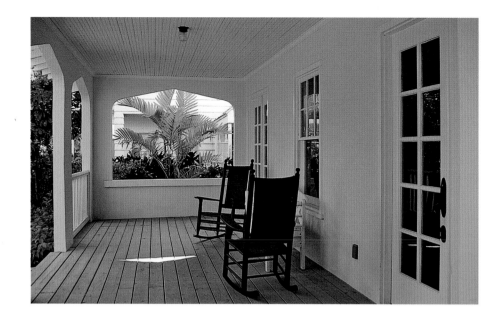

TOP The broad front porch cools the warm Florida air entering the home and provides a welcoming transition to the interior.

ABOVE The different angles and pitches of the roof lines add interest and variety to the side facade. The exposed wood rafters are typical of the bungalow style.

RIGHT The rear facade shows the new pool and patio and expanded areas of the house. While the expansion significantly increased the available square footage, it is not visible from the street or front facade. The sensitivity of Jeffery Smith's architectural plans is shown by the fact that the street facade retains its original scale and massing.

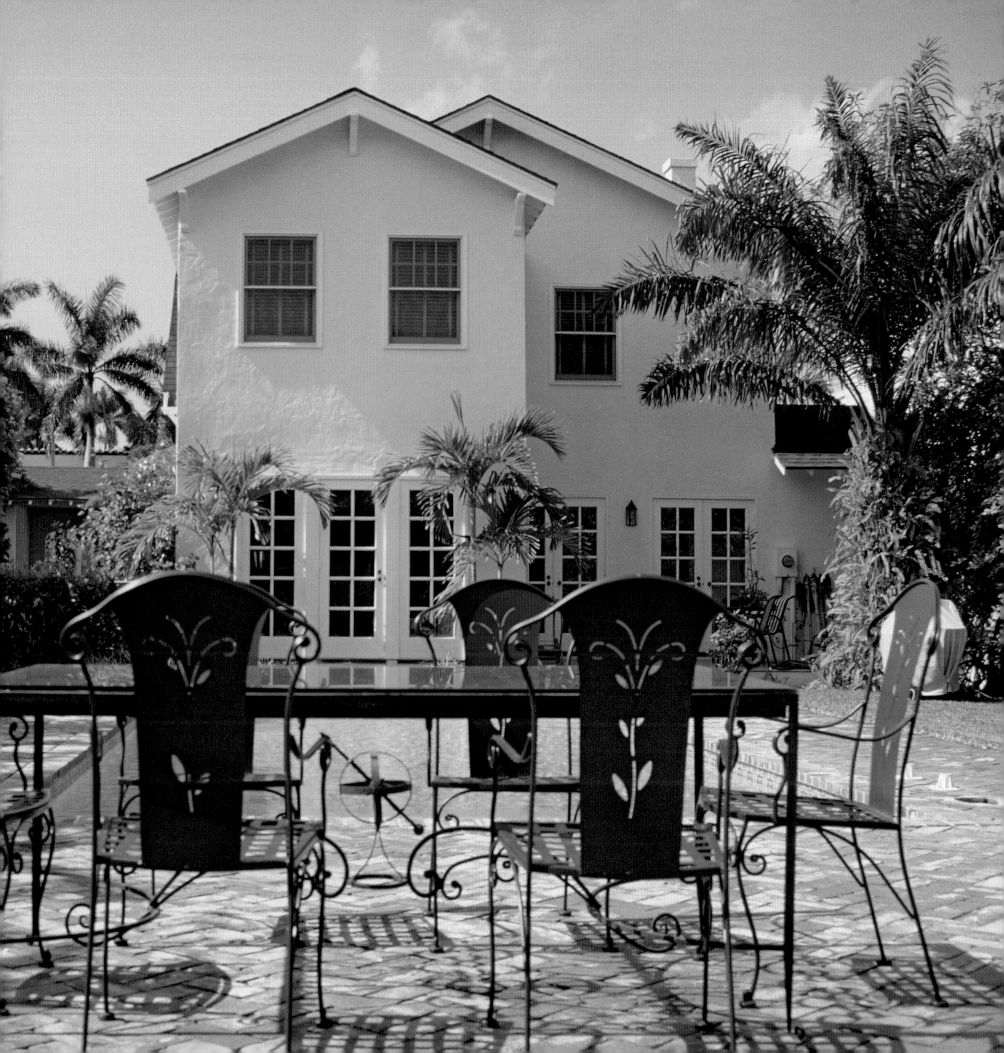

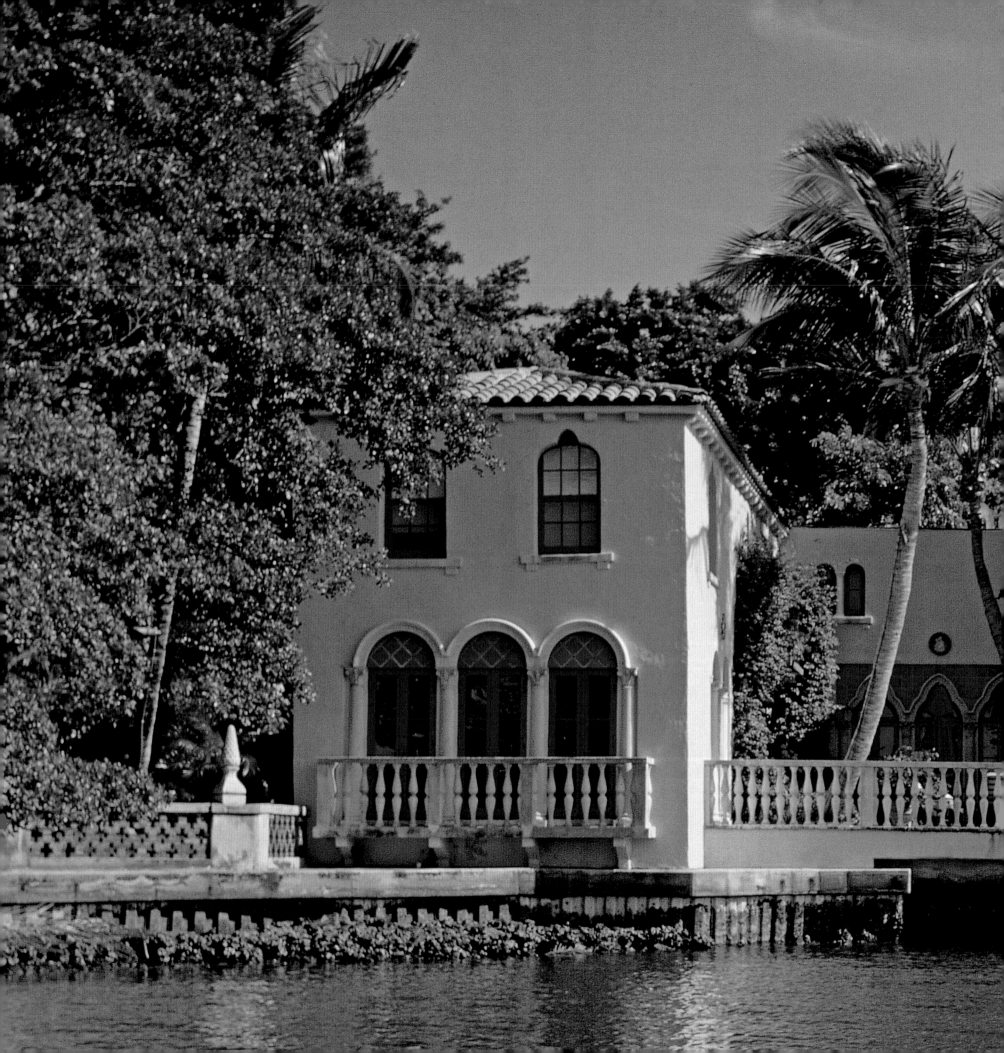

Casa de Leoni

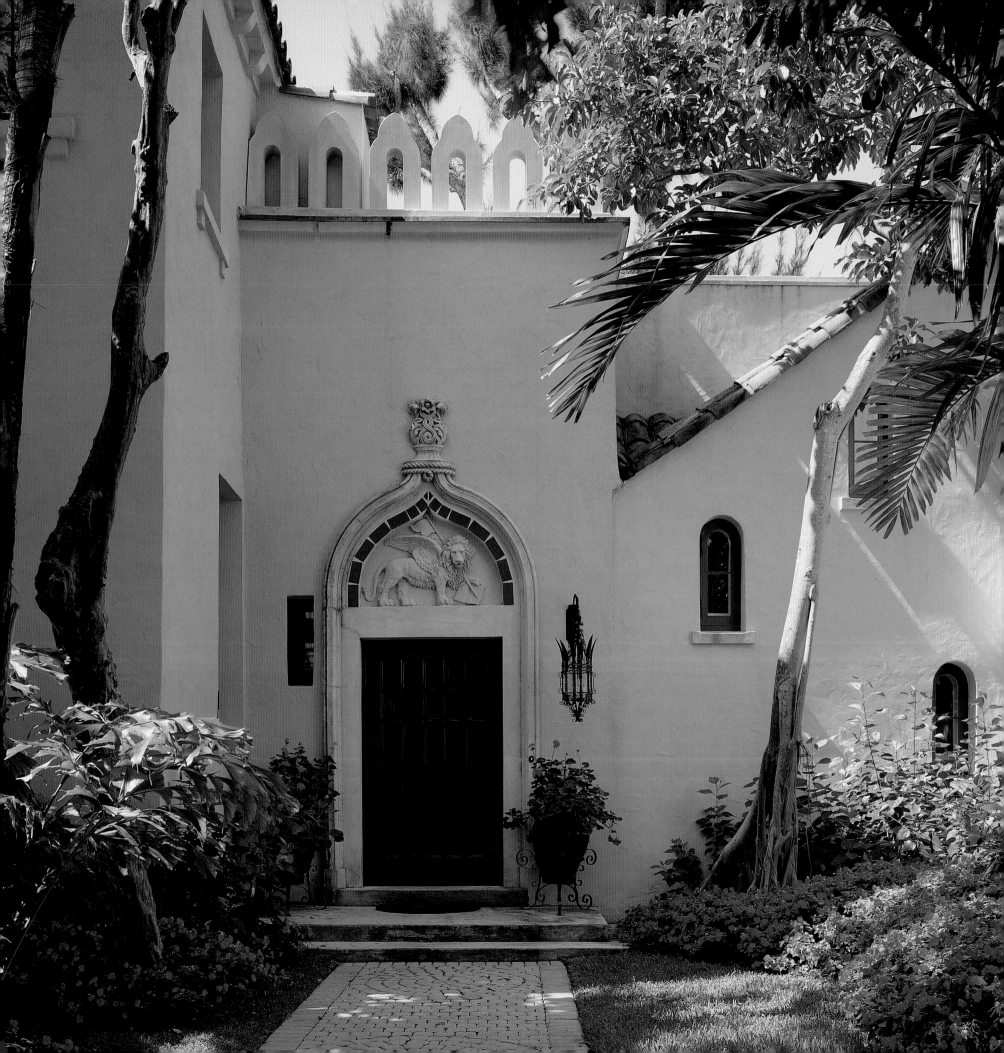

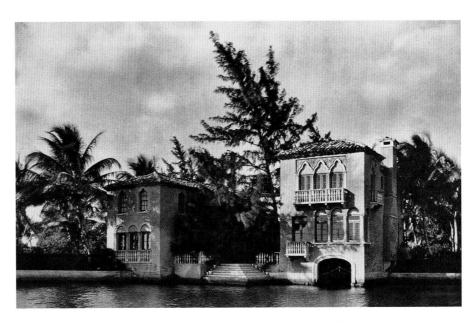

Casa de Leoni, one of Addison Mizner's most distinctive homes, received a second Ballinger Award presented in 1995. Built in 1921 for Leonard Thomas, Casa de Leoni was a departure from Mizner's trademark Spanish style. For Casa de Leoni's location at the very water's edge of Lake Worth, Mizner chose the Venetian Gothic style. In another departure from his more usual homes, Casa de Leoni was a relatively small house. With its intown location, limited site, and waterfront orientation, Casa de Leoni defined the essence of a Mizner town home.

From the water Casa de Leoni's outstanding feature was its water gate. Another prominent feature was Mizner's early use of trefoil-arched windows, a theme frequently found on his later homes. Casa de Leoni was designed in a u-shape with a waterfront courtyard between the two major wings of the house. The courtyard originally featured broad steps down to the waterfront, which were later replaced by a lakeside balustrade. From the land side Casa de Leoni announced itself with a pecky cypress door surmounted by an arch depicting the Lion of Saint Mark, from which the house derived its name. An addition by Marion Sims Wyeth in the

1950s provided a compatible pool wing and pool for the house. When Casa de Leoni was landmarked by the Town of Palm Beach, the documentation provided for Casa de Leoni called it "more innovative" than many of Mizner's larger homes and said, "Casa de Leoni in short, is a gem."

The exacting restoration was completed in 1992 under the architectural direction of Jeffery W. Smith of Smith Architectural Group. The interior design was created by Howard Slatkin of New York. Slatkin's exuberant, dramatic interiors resonate with Mizner's contrasts of light and shade and heighten the romance of Mizner's conception. The restoration relied on precise details such as the lion theme that appears in wood, cast stone, tile, and brass. In particular the brass hardware that was reproduced or newly designed is one of the glorious features of the restoration.

The two Ballinger Award winners in 1995, both intown homes on relatively limited sites, demonstrate the enormous potential of historic restoration. The Brazilian Bungalow and Casa de Leoni stand today as symbols of all the reclaimable homes in the heart of Palm Beach. They are a testament to their owners' vision of what these homes could become.

OPPOSITE *Casa de Leoni's restored front door.*
ABOVE *An early photograph of Mizner's entrance shows the Lion of St. Mark's ensconced over the doorway. Leonard Thomas, the first owner of Casa de Leoni, had diplomatic postings in Madrid and Rome. He planned, according to historian Dr. Donald W. Curl, to hire an Italian staff for Casa de Leoni and to import Italian furniture and even a gondola.*

TOP *An exterior plaque in a della Robbia style decorates a plain wall.*
ABOVE *As this historical photograph shows, originally Mizner's design provided broad steps descending to the waterfront.*

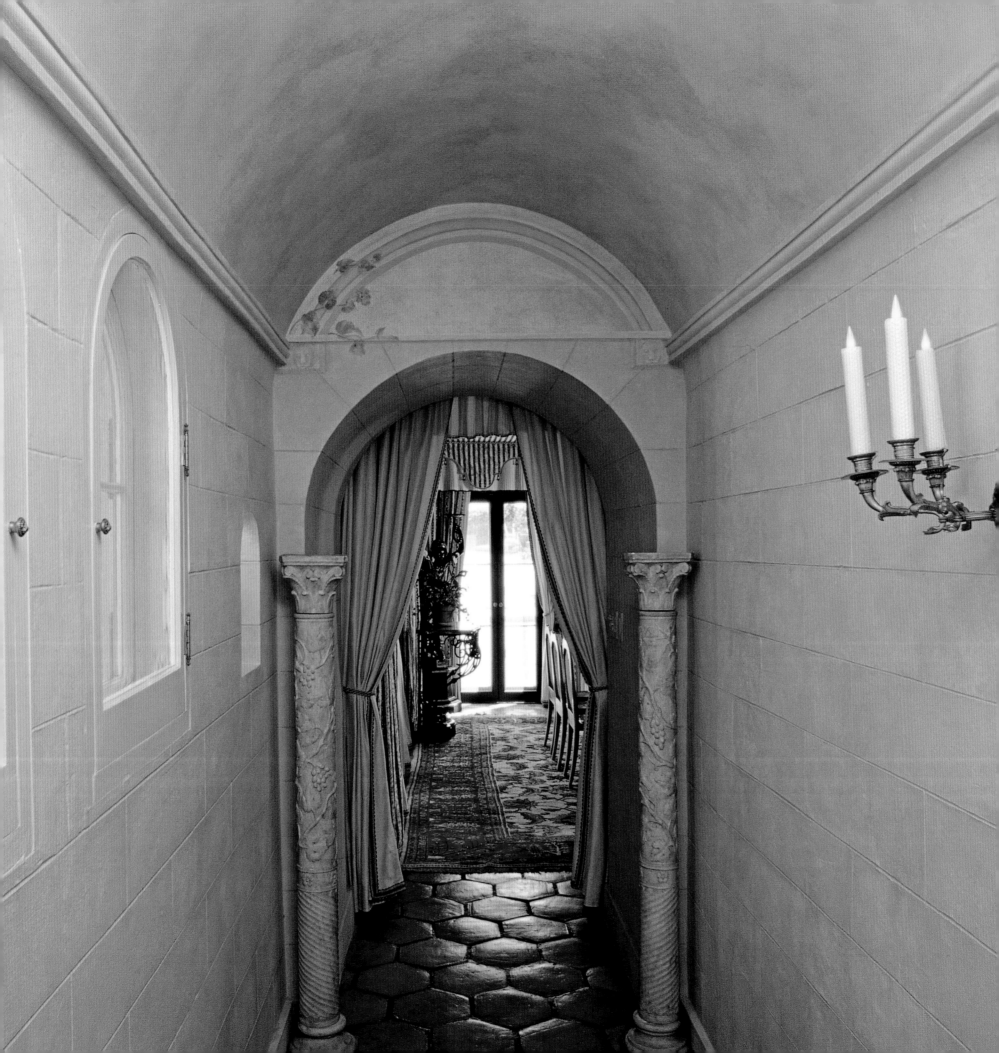

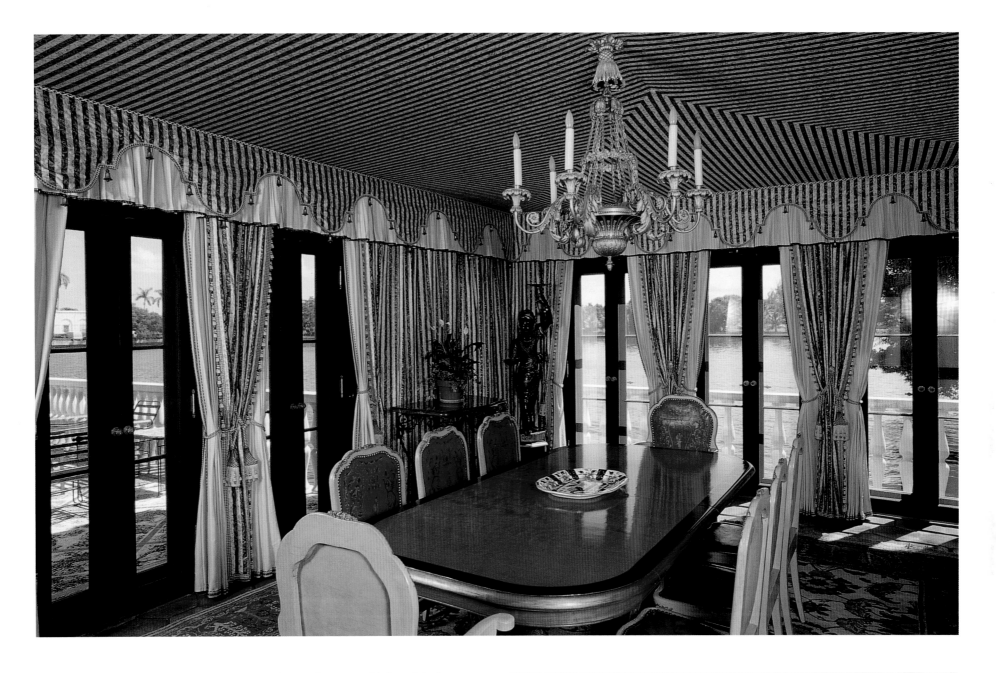

OPPOSITE *A corridor lit by arched windows provides a cool contrast of light and shadow.*
ABOVE *In the dining room at Casa de Leoni, Howard Slatkin draped the room with a tent of striped silk. The fabric was imported from Italy.*
RIGHT *Detail of tiny bells sewn onto the valance of the dining room drapes.*

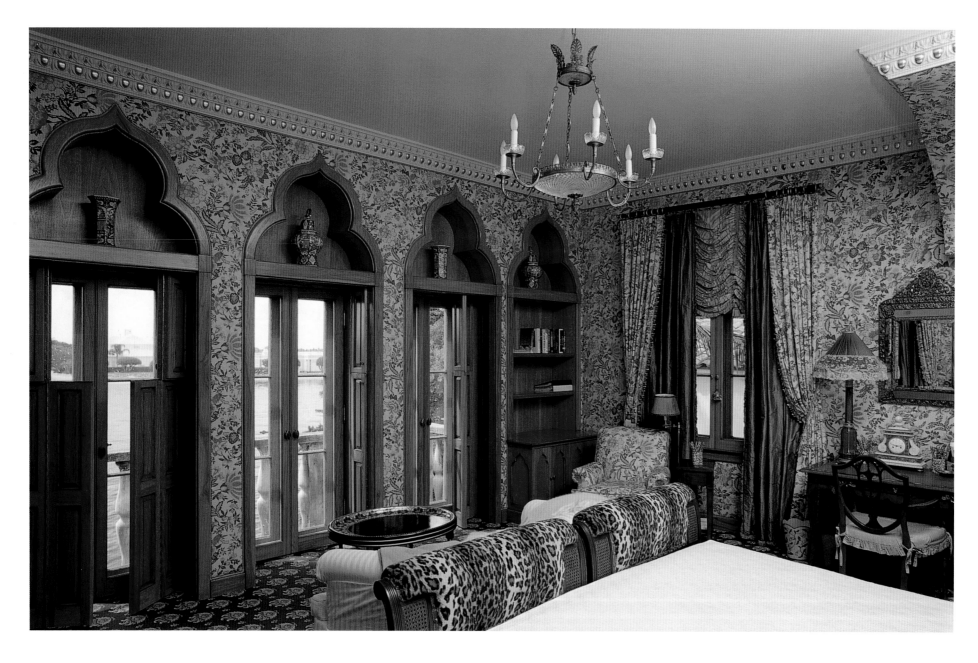

ABOVE AND (DETAIL) RIGHT *The master bedroom with its Moorish arches and gold egg-and-dart molding demonstrates Howard Slatkin's approach of patterns and more patterns everywhere throughout Casa de Leoni. A guest bedroom at Casa de Leoni shows architectural forms employed as a surface for decorative patterns.*

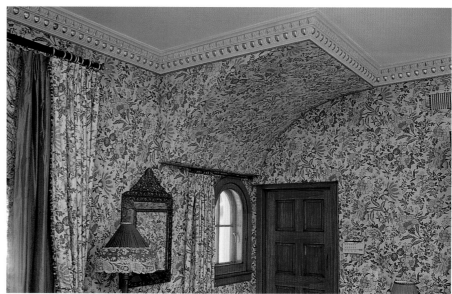

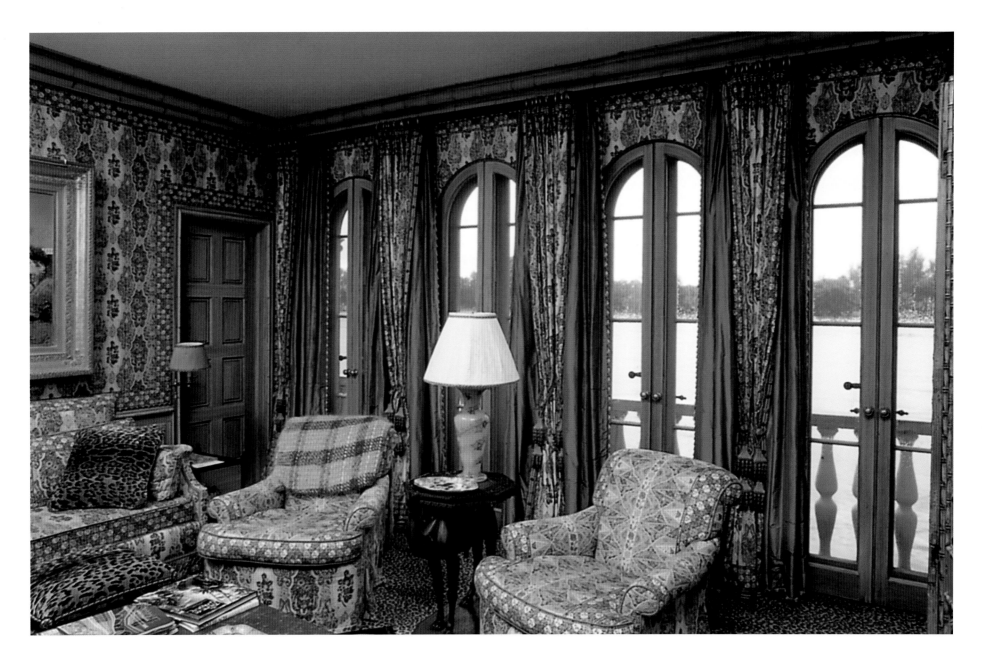

ABOVE *Vibrant patterns are a theme in a lakeside sitting room.*
LEFT *Delicate hand painting enhances a window view.*

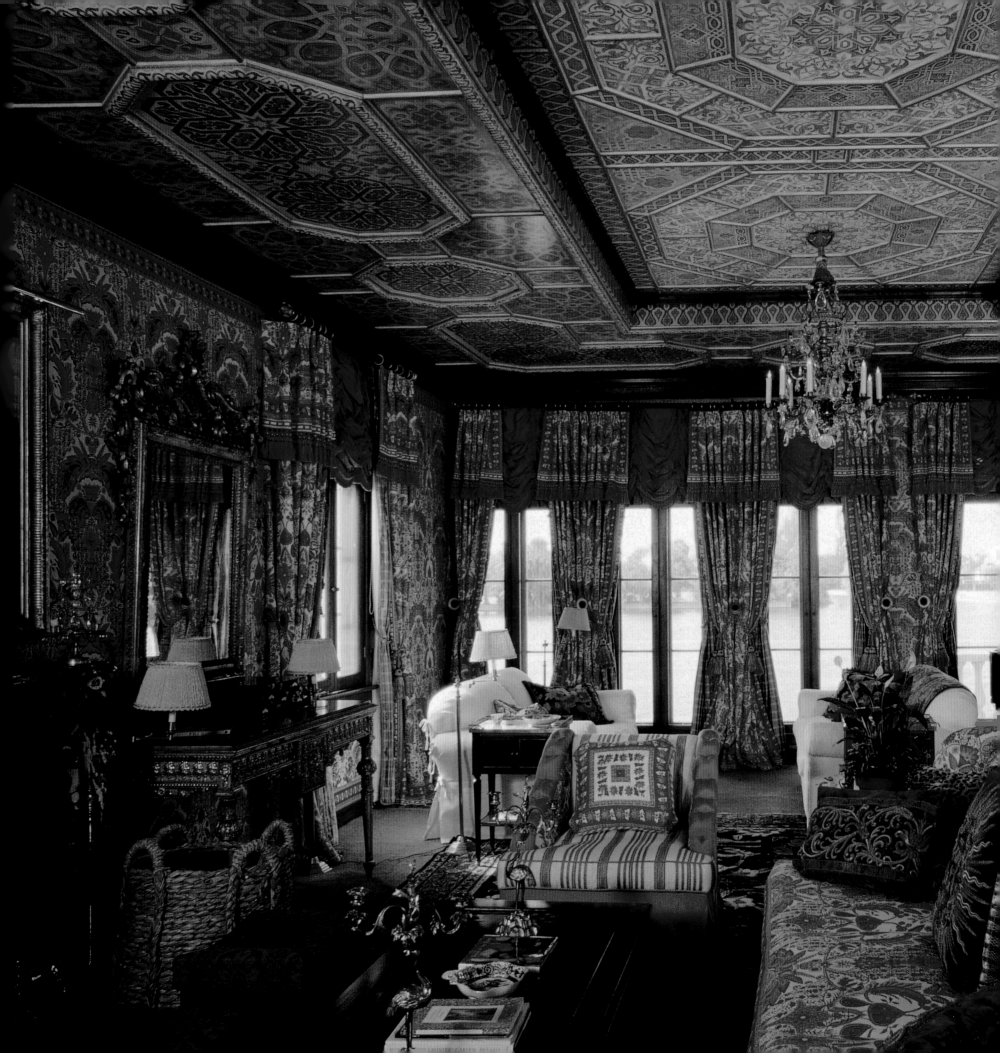

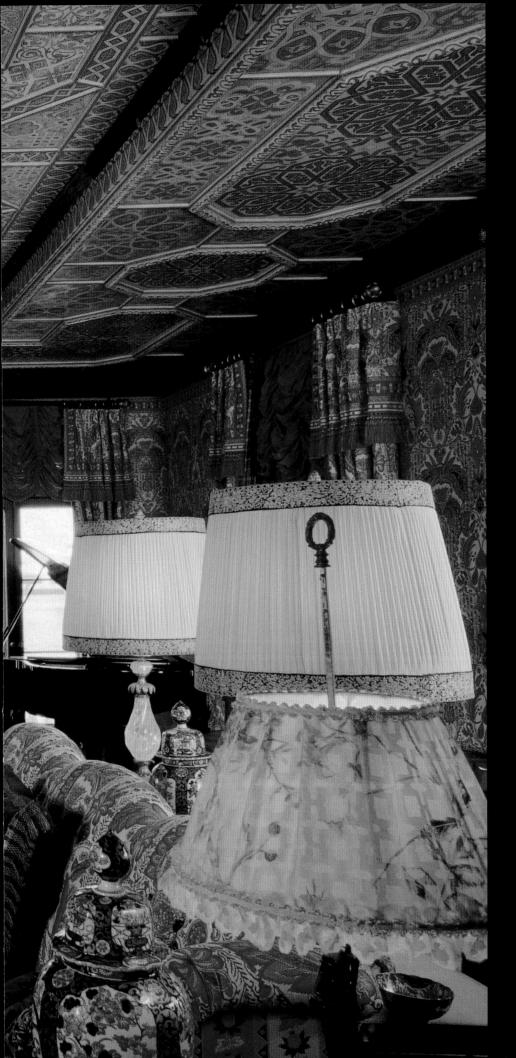

OPPOSITE Casa de Leon's living room, an incredible blending of texture, color, and pattern, with a remarkable stenciled ceiling, is a fitting stage for the glorious lake views outside.

TOP AND RIGHT Casa de Leoni displays a great variety of form in its hardware. It would have been only too easy to use standardized hardware, but the owner and decorator delighted in the diversity of many shapes and subjects. A starfish theme is frequently found in the intricately detailed custom hardware. Over 1500 brass hardware designs were created for Casa de Leoni. The lion's head motif is found throughout Casa de Leoni; brass lion heads were custom cast by P. E. Guerin.

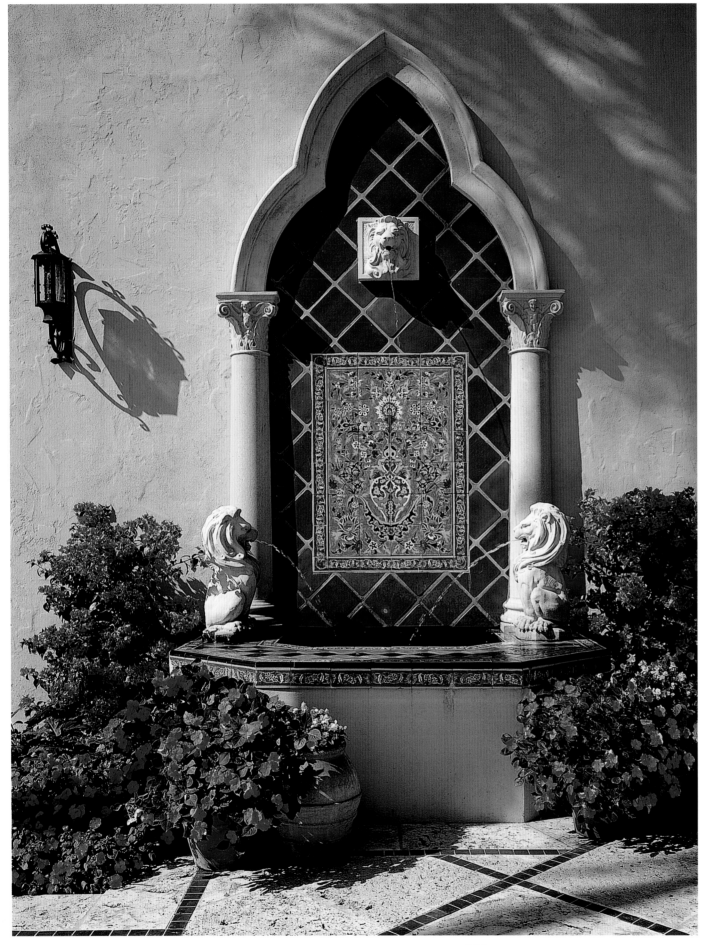

LEFT *A tiled fountain is a focal point for the central courtyard at Casa de Leoni.*
OPPOSITE *An inner courtyard relies for effect on both simple and complex arched forms.*

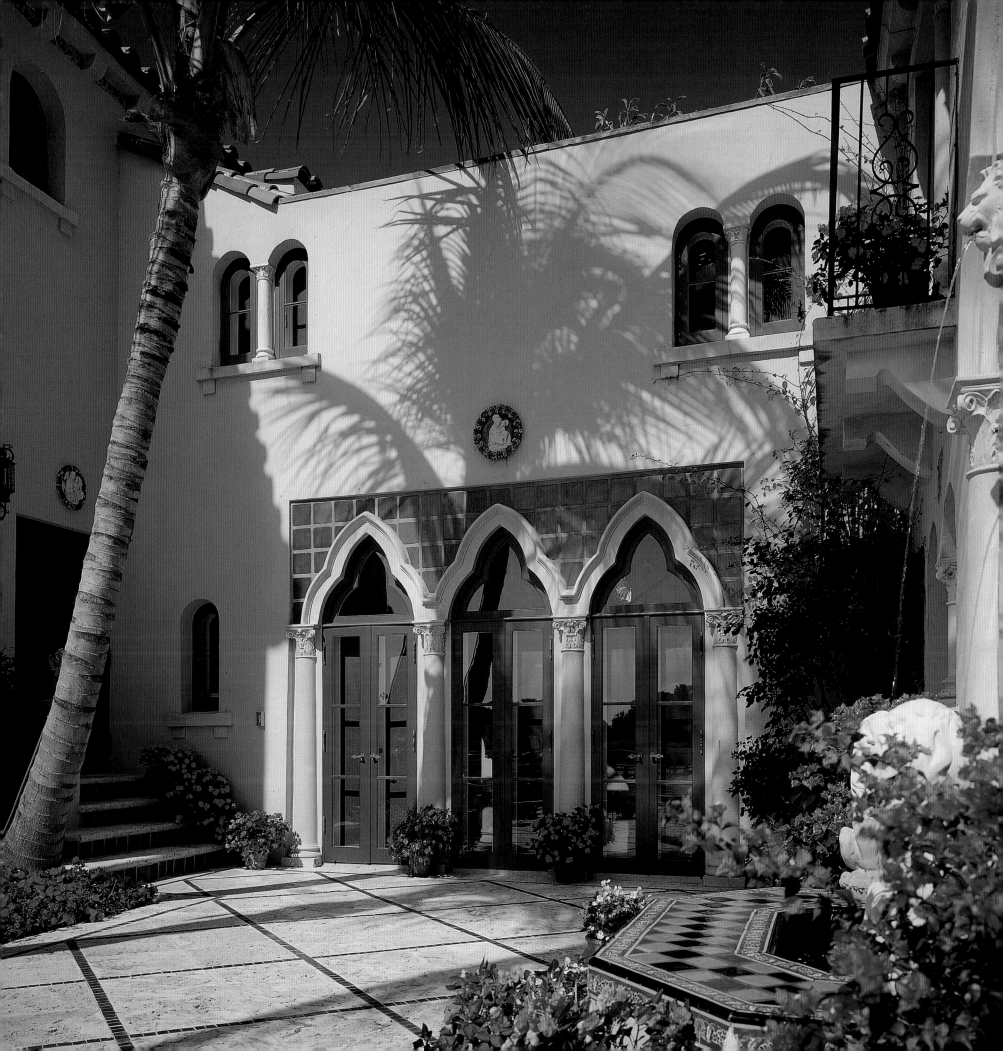

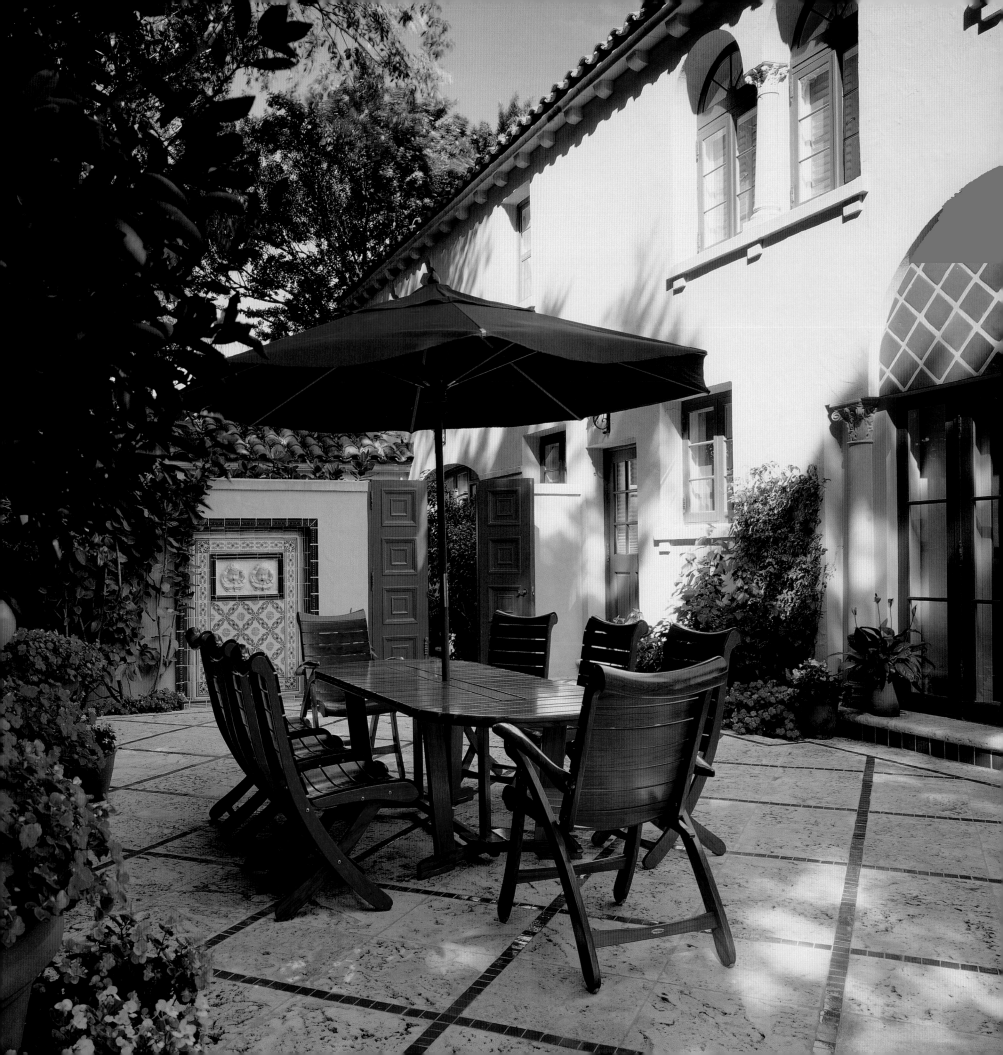

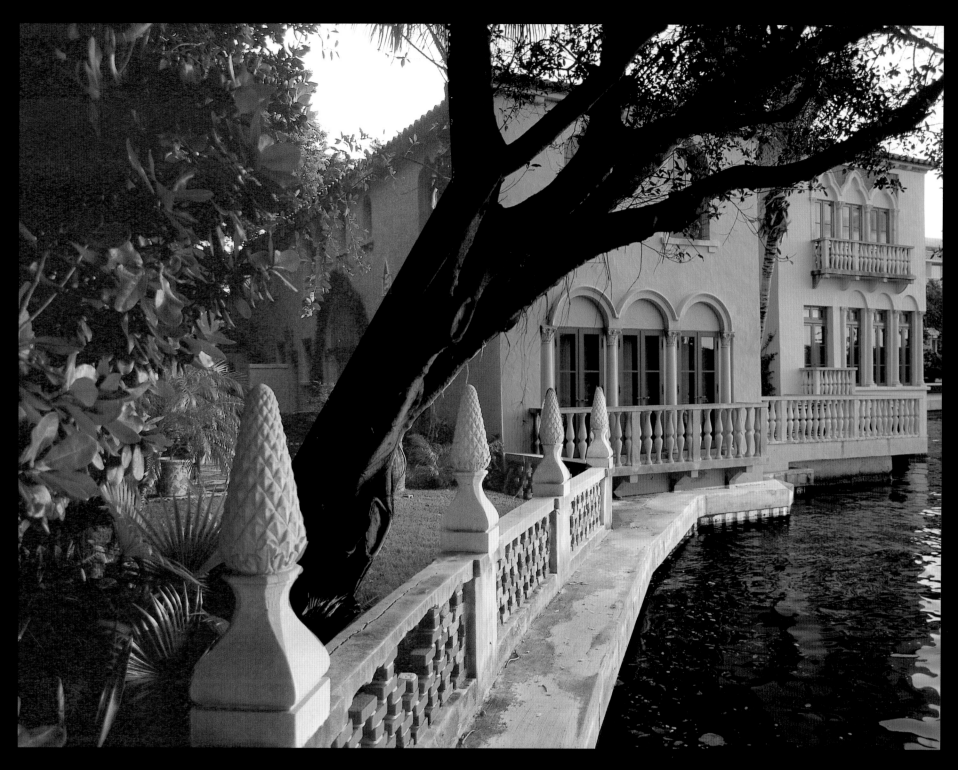

OPPOSITE *One of the three private courtyards at Casa de Leoni.*
ABOVE *Cast stone balustrades are an important design feature on*
the lakeside of Casa de Leoni.

Bethesda-by-the-Sea Episcopal Church

The first commandment of historic restoration is to do no harm. The restoration of Bethesda-by-the-Sea Episcopal Church is an outstanding example of how to manage a restoration, which was recognized with the Ballinger Award in 1996. The Bethesda restoration process, accomplished at a cost of over 3.5 million dollars, completed repairing the roof, cleaning and water proofing the exterior walls, repairing all the woodwork, repointing the stonework, and protecting the church's cherished stained glass windows. This accomplishment of restoration must be viewed through the history of the congregation from its first services held in the Little Red Schoolhouse, which was built by the pioneers on Lake Worth in 1886. Three years later the congregation moved to its own simple wooden building, constructed at a cost of six hundred dollars, which looked much like the Little Red School-house.

By 1895 the growing church needed a second home and built the now deconsecrated church on Lake Trail, whose picturesque Moorish influenced design has delighted Lake Trail travelers for the last century. The Bethesda of today, with its front entrance figure proudly holding a miniature Bethesda, was built in 1925-26 by the New York architectural firm of Hiss and Weeks. Its impressive Gothic style, which was much admired by contemporaries, testifies to the growing sophistication of Palm Beach in the 1920s.

Bethesda's outstanding restoration methodology began with a test wall on which all chemical preparations and paints were subjected to a rigorous trial and error analysis by the general contractor, Conkling & Lewis, and the painting contractor, Jerome Russo. Of particular note was the church's decision to adopt state-of-the-art technology to protect its glorious stained glass windows. Florida's prevalent hurricanes have damaged many fine buildings, and residents continually struggle to find effective and affordable means of protection. Forty-one of Bethesda's windows are now covered with a clear laminated double glass system, able to withstand a projectile at one hundred fifty miles per hour. The system allows the vivid colors of the stained glass to be enjoyed while the windows are protected. Despite the cost of the double glass system the congregation chose to provide the most effective hurricane protection available.

The completion of the Hiss and Weeks' Bethesda-by-the-Sea in 1926 can be viewed as a significant development in the maturation of Palm Beach as a town. Instead of architectural landmarks identified with entrepreneurs like Flagler or master architects like Mizner, the town now had a significant landmark created by the devotion and tenacity of a group – a congregation. Just as its 1925 Town Hall marked a coming of age for the government of Palm Beach, Bethesda-by-the-Sea,

and the 1926 construction of St. Edward Catholic Church, marked a social and religious coming of age.

The main tower of Bethesda rose to one hundred five feet in the air. Its cloister quadrangle enclosed a space eighty by ninety feet. Interestingly, all the cast stone for the walls and floors was cast on the site with great care exercised to ensure a range of color, size, and texture. The English Gothic design, the only prominent building in the style in the town, dominates a prominent corner.

In 1931 the church was further enhanced by the donation of the Cluett Memorial Gardens located behind the main building, which provide one of the most beautiful planted garden oases in the town. All Bethesda's details are lovely: its Della Robbia decorations, its madonnas, its gargoyles, its arches, and its brilliant Tiffany window, safely installed in an interior location. All of these details remind us of Bethesda's philosophy of restoration – that the goal of preservation is not to remove the look of age, just the damage.

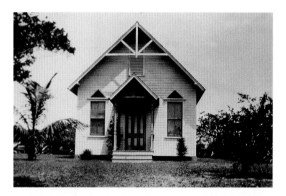

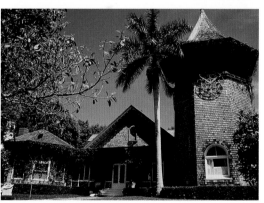

OPPOSITE *The third Bethesda-by-the-Sea is dominated by its entrance tower. The name means House-of-Healing-by-the-Sea and was suggested by Mary Cluett Mulford, wife of the first rector.*

TOP *The third Bethesda-by-the-Sea is decorated by stone gargoyles in fantastical forms which animate the Gothic style of the building.*

MIDDLE *The first Bethesda-by-the-Sea (1889) was a simple frame vernacular structure. It was similar to the 1886 Little Red Schoolhouse except for the pointed arches decorating its windows and doors.*

BOTTOM *The second Bethesda-by-the-Sea was a wood shingle building with a Moorish tower. The tower helped guide the many Sunday worshippers who came by boat to the lakefront church.*

The glorious com-pany of the Apostles

The noble army of Martyrs

HOLY HOLY
HOLY

thou didst humble thyself to be born of a Virgin

The goodly fellowship of the Prophets

The Holy Church throughout the World

WE ACKNOWLEDGE THEE

WE PRAISE THEE O GOD

TO BE THE LORD

To the Glory of GOD & sacred to the memory of FLORENCE FENTON

OPPOSITE *The Te Deum window behind Bethesda's high altar is the focal point of the interior of the sanctuary. It was constructed in England during World War II and shipped to the United States on three separate vessels.*

RIGHT *A view of the wood beam ceiling inside the colonnade bordering the quadrangle.*

BOTTOM RIGHT *View along the Gothic colonnade at the front of the church. The pillar illustrates the variety in color and size of the cast stone blocks.*

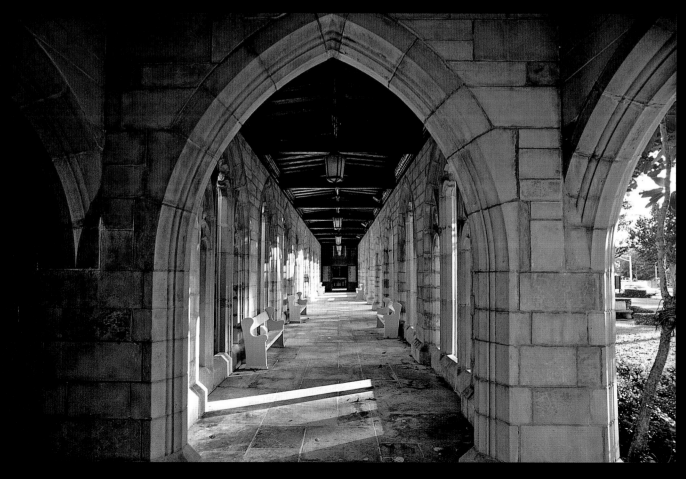

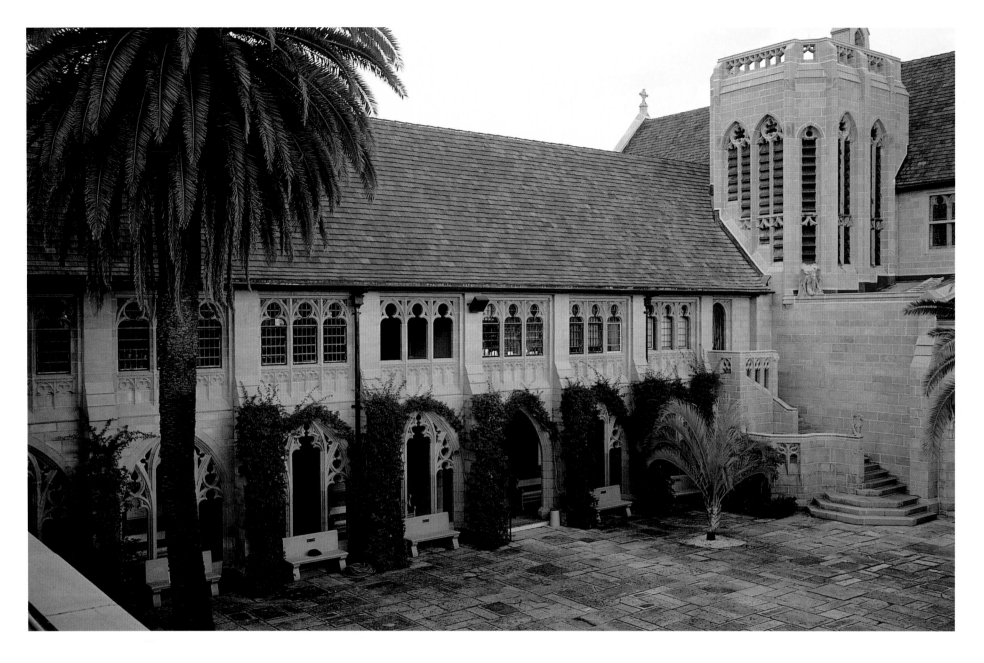

ABOVE *The north facade of the church's spacious quadrangle.*
LEFT *The entrance to the church offices is a modestly scaled depiction of the Gothic style.*

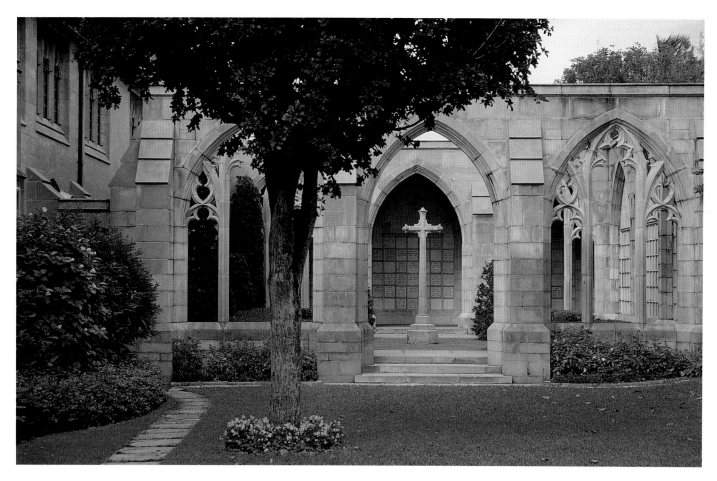

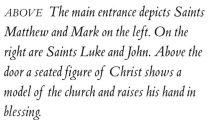

ABOVE *The main entrance depicts Saints Matthew and Mark on the left. On the right are Saints Luke and John. Above the door a seated figure of Christ shows a model of the church and raises his hand in blessing.*

TOP RIGHT *The stonework approaching the columbarium.*

BOTTOM RIGHT *View inside the quadrangle.*

THIS WINDOW IS ERECTED TO THE HONOR AND GLORY OF GOD BY
ISABEL NEWLANDS GOSS
AND YE ARE CHRISTS AND CHRIST IS GODS

Junglewood

Junglewood, the second Ballinger Award presented in 1996, has been a labor of total involvement for its owners Barry and Cindy Hoyt. In fact it has been the labor of a lifetime since Junglewood has been owned by the Hoyt family since its present owner was a child.

Junglewood was designed by Julius Lee Jacobs, an architect whose propensity for drama and whose talent for combining all the evocative elements of the Mediterranean Revival style, such as elaborate windows, arches, decorative outside stairs and asymmetric massing fully rivaled Mizner's. Jacobs, one of the most gifted architects to work in Palm Beach, came from New York City. Although he practiced with Mizner and another early architect Bruce Kitchell, he is largely a man of mystery.

Jacobs designed three houses of outstanding presence in Palm Beach. The first, on South Ocean Boulevard, was formerly the home of Sumner Welles, the diplomat. The second, nearby on South Ocean Boulevard, is a magnificent barrel vaulted palace its impact now somewhat diminished by the loss of its entrance terrace and flamboyant balustrade. The third, Junglewood, built in 1927, speaks eloquently to the development of Palm Beach as a community of artistic and theatrical importance by the 1920s. Junglewood's first owner, Stanley Warrick, was well-known on the island as early as 1916 when he created the first non-Flagler inspired shopping area in Palm Beach, the Fashion Beaux Arts. As a Mediterranean Revival themed shopping destination, the Fashion Beaux Arts foreshadowed Mizner's use of the Mediterranean Revival in the town centers of Palm Beach and Boca Raton.

Stanley Warrick was Palm Beach's own pioneer entertainment mogul. He opened the first movie theater in 1922 at the Beaux Arts. The theater, which was said to seat one thousand people, was located on the roof of the Beaux Arts building and took full advantage of its Florida setting. Shows started after dark, and the doors were opened wide to provide natural air conditioning. Warrick built a second theater a year later, backed the development of the Paramount Theatre in 1926 along with E.F. Hutton and A.J. Biddle,

Jr., and opened the first night club, the Colony Club, in 1928. In an era before television, Palm Beach was supporting three movie theaters.

In keeping with Warrick's theatrical enterprises, Julius Jacobs created a grand theatrical setting for Warrick's home. Jacobs's proclivity for Mediterranean Revival drama in his houses is not surprising. When he first came to Palm Beach, Jacobs worked as one of Mizner's principal draftsmen. Junglewood was described by contemporaries as "palatial," with a great tower, a winding staircase, and remarkable tiles. It was reported to have cost one hundred thousand dollars in 1927. Its interiors both historically and today complement the drama of its exterior. Jacobs's exuberant blending of Mediterranean Revival features, arches, towers, pecky cypress, cast stone, cast iron work, and even half-timbering offer visual delights from every vista. Restoration architect Eugene Pandula provided sensitive adjustments, for example to the front entrance. He also designed a new pool pavilion, which both continues the original architectural theme of the house and dramatizes the interior courtyard. Even Junglewood's renewed landscaping, designed by the Lang Group and executed by Hadden Landscape, added dramatic emphasis. The beauty of Junglewood's landscaping has been recognized with an Award of Excellence from the Florida Nurserymen and Growers Association.

As with the best theatrical productions, Junglewood presents a mystery and a challenge. Who was this Julius Jacobs, who left three masterpieces, but little other evidence of his work, although some sources say he worked in the area as late as the 1940s. Are there other undiscovered masterpieces or have they been demolished? The challenge for historic preservation is to work through architectural history to uncover the missing pieces of our past in order to make it a part of our future.

OPPOSITE Junglewood is a landmark of the Town of Palm Beach. It is notable for its tiled doorway with a cast stone motif of a rope surrounding the door. Above the doorway is a tiled Madonna and child plaque surmounted by a cross.
LEFT A detail of the outdoor stairway shows how Julius Jacobs took every opportunity to incorporate interesting details at Junglewood. The stairway's cast stone support is a monk's figure.
TOP Detail of decorative ironwork at Junglewood.

TOP *Garden statuary at Junglewood.*

ABOVE *The sudden slash of a crimson accent in the landscaping contrasts with the serenity of a Madonna.*

RIGHT *The north facade of the pool courtyard demonstrates Jacobs's mastery of combining a curving motif — the outdoor stair — with vertical architectural accents.*

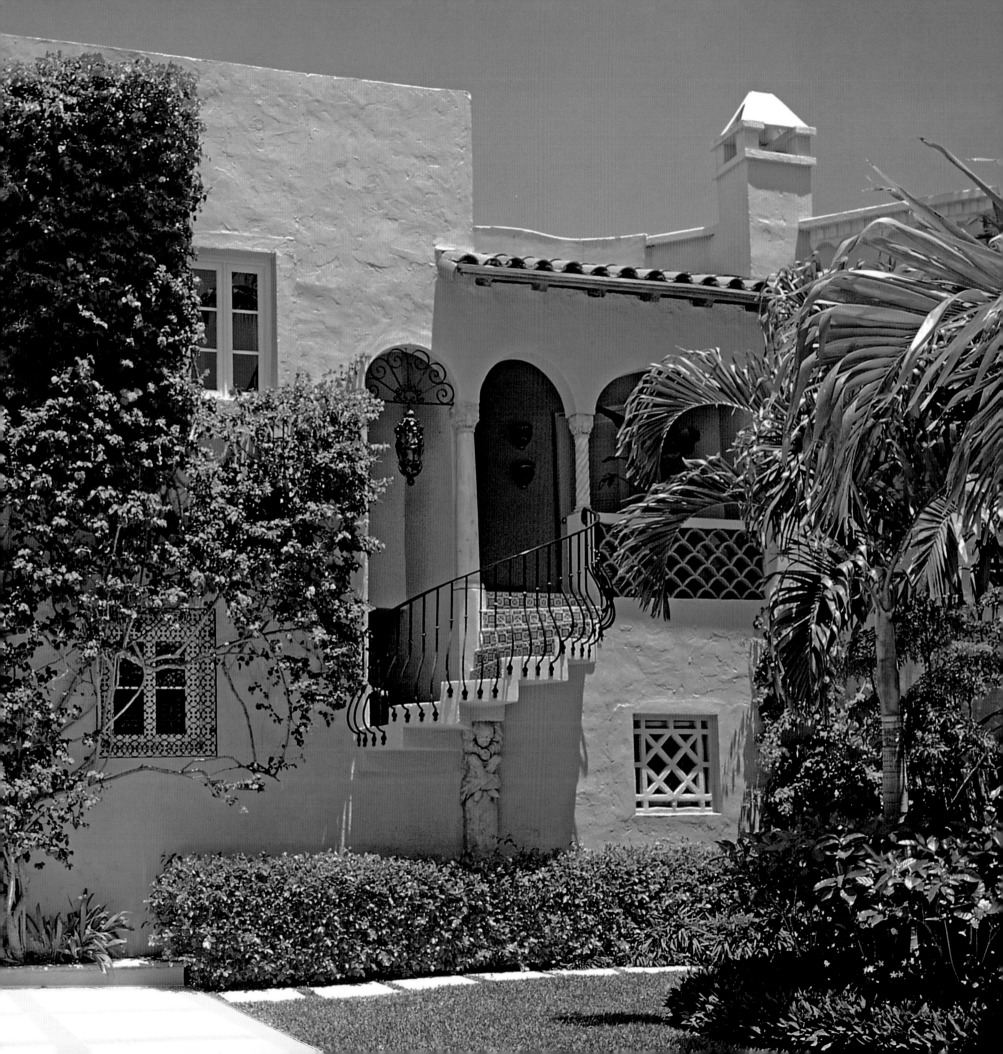

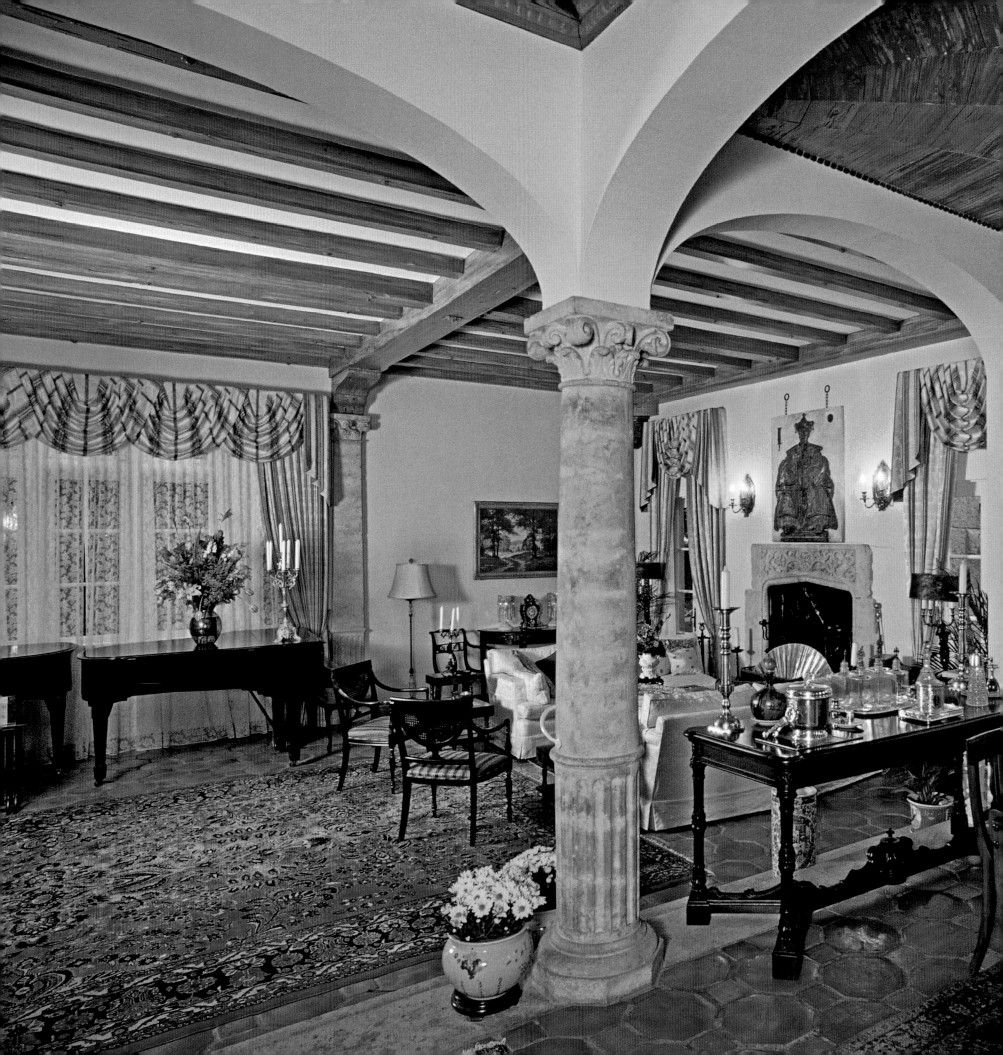

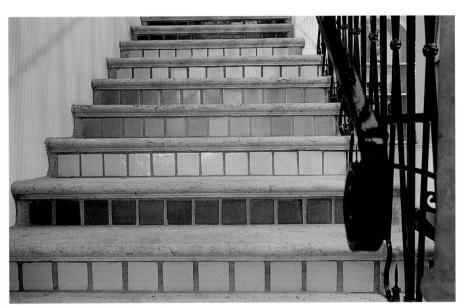

LEFT The spacious living room is defined by pillars with decorated capitals and an arched entrance. Details include a pecky cypress ceiling and stone fireplace. The Warricks, the original owners, were mentioned frequently in the Palm Beach newspapers as entertaining in grand style in their "palatial" home.

TOP The grand stairway at Junglewood focuses on a colored glass leaded window with a cross motif. Jacobs employed many religious themes in Junglewood's decoration. Local newspapers also noted the stone stairway was intended to imitate "travertine stone."

ABOVE Detail of multicolored tile risers on Junglewood's grand stair.

ABOVE *The dining room features two leaded glass windows.*
RIGHT *The entrance to the pergola area was carefully modeled with an arch and Spanish door in the restoration.*

OPPOSITE TOP *Junglewood's luxuriant landscaping lends itself to secret shadowed views like this glimpse of a gate.*
OPPOSITE BOTTOM *Junglewood's grounds include a variety of handsome fountains. Strong patterns are a feature of the fountain at Junglewood.*

FOLLOWING PAGES:
TOP LEFT *An antique lighting fixture is framed in an arch in this view from the pool pavilion toward the north facade.*
BOTTOM LEFT *The open second floor balcony provides a view toward the pool pavilion.*
RIGHT *The pool pavilion, designed by Eugene Pandula for the restoration, complements the historic architecture and completes enclosing three sides of the pool courtyard.*

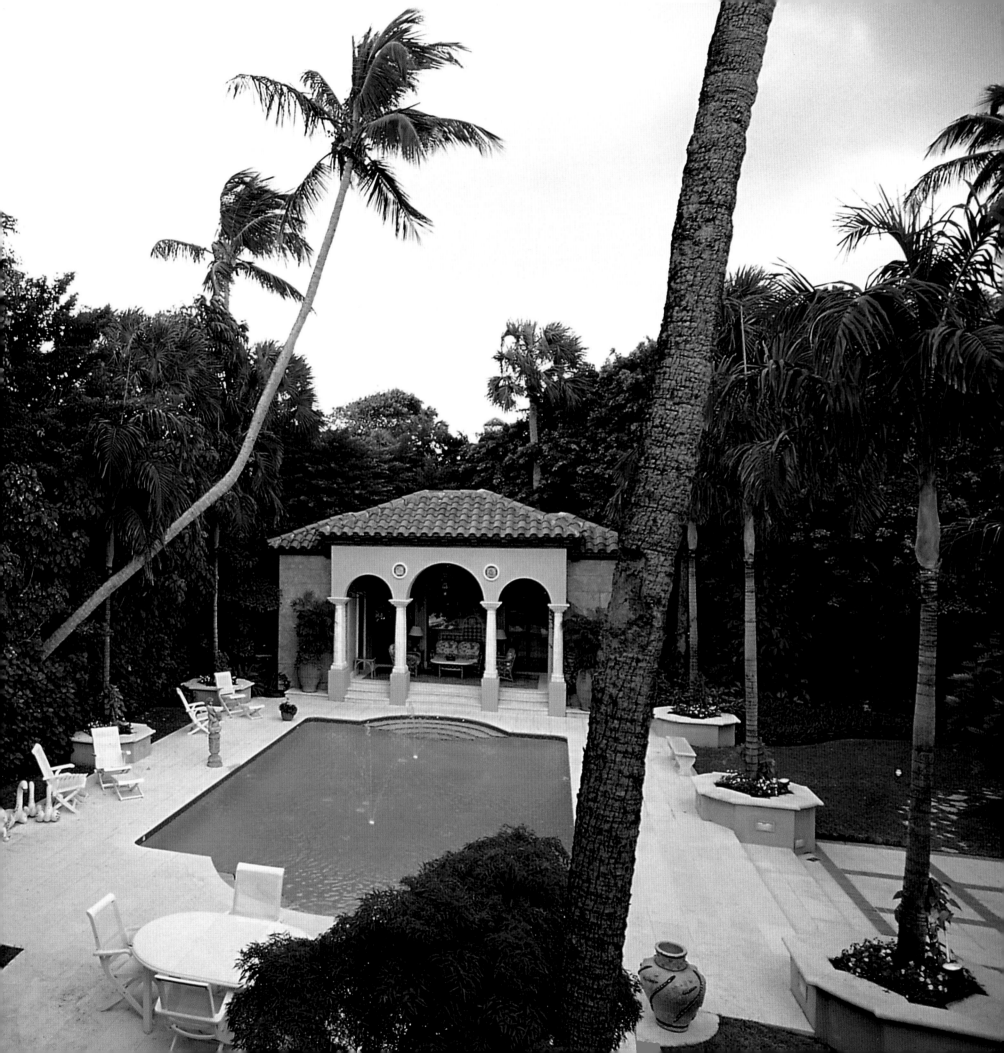

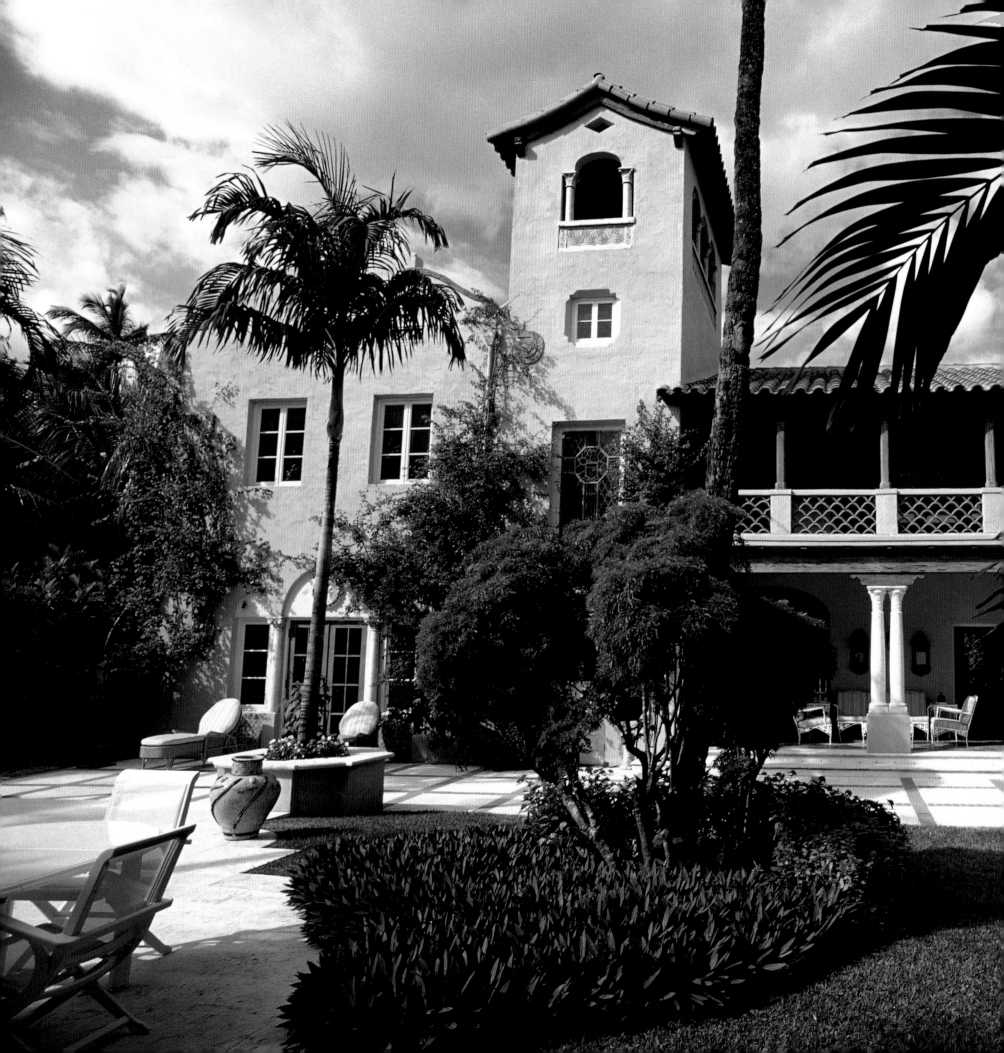

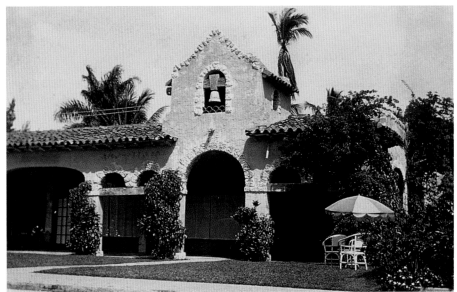

OPPOSITE *Junglewood's courtyard facade displays the somewhat unusual combination, for Palm Beach, of stucco construction on the first floor with half-timbering (obscured in the view) on the second. Julius Jacobs exploited to the fullest extent contrasts of horizontal massing, flat walls, shaded balconies, and a dramatic tower in his design for Junglewood.*

ABOVE *The Fashion Beaux Arts Shopping Center was built in 1916 by architect August Geiger. An addition was constructed by the architect Maurice Fatio in 1928. Before building Junglewood, the Warricks wintered in a cottage on the Beaux Arts grounds.*

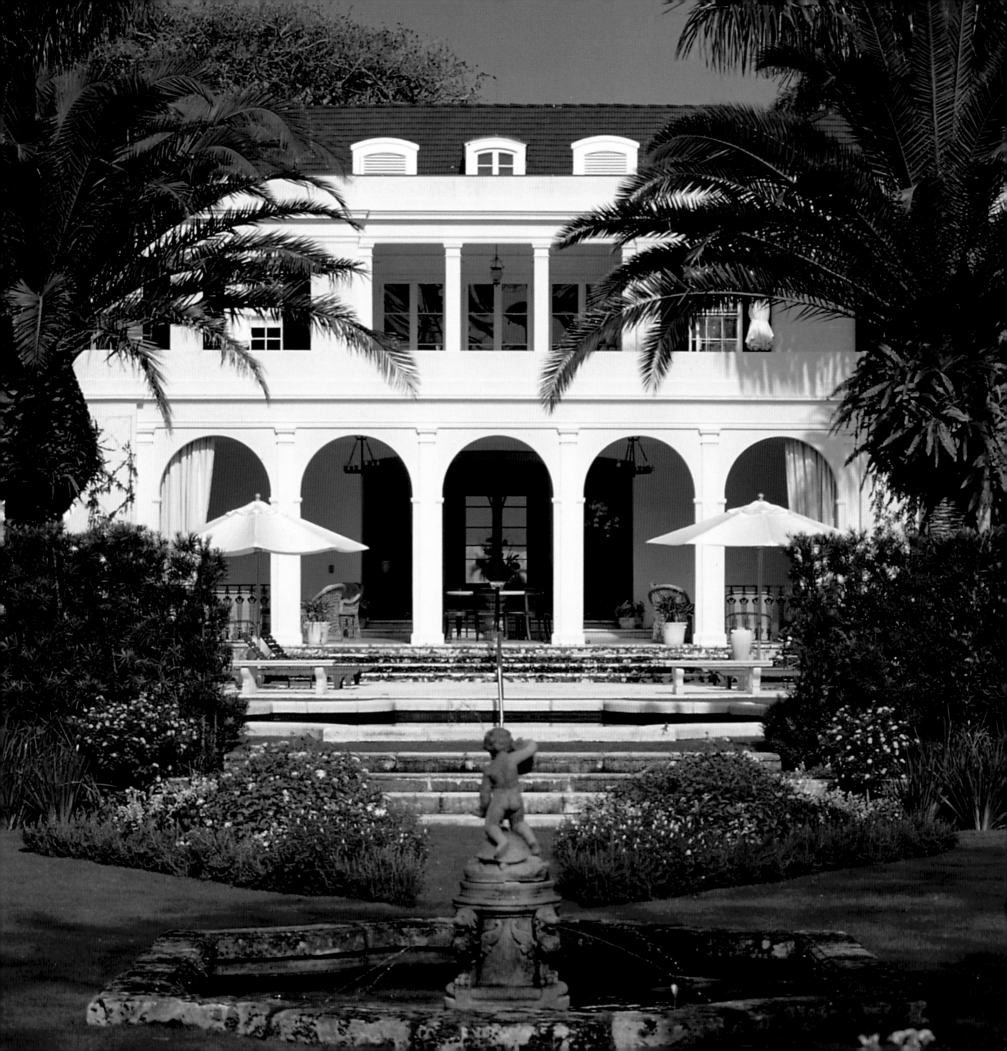

South Lake Trail House

The 1997 Ballinger Award to a house on South Lake Trail reaches back in time to the earliest beginnings of Palm Beach. Instead of the exuberant excesses of Mizner's era, the South Lake Trail house recalls the simplicity of pioneer years, a simplicity epitomized in the cool elegance of the 1938 John Volk neoclassical design that was honored with the Ballinger Award.

The Volk home contains within its walls remnants of a much earlier home, Primavera. Through Primavera the property traces back to one of Palm Beach's earliest pioneer families, the Dimicks. If any single spot in Palm Beach could be said to be the focal point of early settlement, it would be South Lake Trail in the center of town. Here the pioneer Geer family located their homestead, which was sold to R.R. McCormick, who built Sea Gull Cottage, the town's oldest house. The Geers' intermarried with the Dimicks, and "Cap" Dimick's homestead, Cocoanut Grove, was expanded into Palm Beach's earliest hotel. It was the pre-Flagler destination of choice for the sportsmen who came to Lake Worth to revel in the area's abundance of fishing and wild game.

In 1892 another Palm Beach pioneer, Charles S. Clarke, a Pittsburgh businessman, having sampled the delights of Lake Worth on a yachting vacation, purchased the Cocoanut Grove. After a disastrous fire destroyed the hotel, Clarke built his family home, called Primavera, on the property. Located directly on the Lake Trail, Palm Beach's preauto artery of transportation, Primavera, and the other Clarke homes that soon joined it, witnessed the transformation of Palm Beach from a jungle paradise to a world famous resort. Until the opening of Flagler's famous Royal Poinciana Hotel in 1894, pioneer Palm Beach had no roads, no shops except the Brelsford general store near the Clarke home on Lake Trail, no bridges, no civic buildings except its one room schoolhouse, and no religious edifices except the earliest simple Bethesda-by-the Sea Episcopal Church.

The Charles J. Clarke home, which is believed to be the original Primavera house of approximately 1893-94, occupied the site of the Ballinger Award. This commodious family home commenced the illustrious architectural history of the site. Despite its rambling bungalow features with a nod to the Spanish Mission style, it is listed among the commissions of the Carrère and Hastings firm who later designed Whitehall. Today more restrained early Mission style homes are sometimes dismissed as lacking the high drama of some later Mediterranean Revival designs. But the Bungalow and Mission styles that predominated in early Palm Beach were a significant architectural influence and are sadly under-represented in landmark efforts to preserve the record of the town's architectural history. Quite possibly some

of the original walls of Primavera exist within John Volk's creation. What is known for certain is that Volk designed one of his finest neoclassical homes for Mr. and Mrs. Charles S. Davis. Davis was the president of the Borg Warner Company.

John L. Volk, who came to Palm Beach in 1925, touched every facet of Palm Beach's visual history through his long and prolific career. Volk was born in Austria and emigrated with his family to New York City in 1910. His father's career as a designer and craftsman of ornamental architectural woodwork resulted in commissions for important clients, such as

OPPOSITE The garden facade is one of the most distinguished elements of the South Lake Trail house. Classical arches on the first floor are set off by a string course and rectangular windows above. Even the air conditioning equipment was given an architectural treatment in the restoration by being hidden behind dormers on the third floor. The original Ludovici roof tiles were also restored in the eighteen months of work on the house.

TOP The expansive ceiba (Kapok) tree at South Lake Trail is over one hundred years old. It is one of the finest specimens of its type in Palm Beach and is listed on the town's roster of Historic and Specimen Trees.

ABOVE John Volk's original design relied on a wonderful long vista made possible by the extensive property.

William Randolph Hearst, for whom he crafted wood interiors at San Simeon. Volk's boyhood exposure to drafting and design work led naturally to a career in architecture after he studied at Columbia University School of Architecture and the École des Beaux-Arts. With his background in European design, craftsmanship, and the building trades, Volk was a worthy addition to the group of master architects working in Palm Beach. In the 20s he designed Mediterranean Revival masterpieces to rival the most extravagant of Mizner's creations. By the 30s he had turned much of his effort toward quieter styles more in keeping with the depression years. He is widely credited with popularizing neoclassical and British Colonial designs as popular alternative styles in Palm Beach. Volk completed over two thousand commissions during his long career, which included outstanding work in the Bahamas, in Wyoming, on the west coast of Florida, and

elsewhere. His versatility marks every area of Palm Beach from its residential streets to its commercial thoroughfares. Of particular note is his wonderful arcaded block just east of the Everglades Club. His gateway to Palm Beach next to the north bridge, the Royal Poinciana Plaza and Playhouse, is, like the South Lake Trail home, a presentation in the cool elegance and precise detail of the neoclassical style.

With the South Lake Trail house, the Volk tradition of classicism, balance, and attention to detail found full expression in the restoration. With the help of their contractors, Brennan Custom Homes and Beach Building Associates, the owners approached their task of restoration as a renewal and chose to let the house speak for itself. In their words "The house has a language of its own, all you have to do is copy it." Mark Hampton's sensitive collaboration on the interior design preserved the cool spaciousness and clean lines of Volk's design. Every room displays the meticulous detail that characterizes the house.

Volk's own words describe the cool, calm presence of the house—"I designed

for them a two-story residence in the Style of the Adam Period. . . . Mr. Davis was a perfectionist and wished every room to reflect the elegance of an English Manor House." Volk goes on to say, "the result was very fine cornices," and the restoration of the wood details throughout the house bears out the self-effacing quality of both the owner's and Mark Hampton's approach. Only a total clarity of architectural design and restoration vision can produce a collaboration that submerges individual egos and allows a house to truly speak in its own voice. Volk continued to describe of the house's fireplaces, beautiful floors and freestanding stairway.

The South Lake Trail house, with the history of Palm Beach embedded in its surroundings, cannot be appreciated in isolation from its site, which is reminiscent of the grand estates of earlier years. Volk consciously designed the home to gain a view of the lake from almost every room. Unlike many homes with more limited properties in Palm Beach, the South Lake Trail house possesses glorious gardens, which Volk deemed to be "the most extensive in Palm Beach." The garden

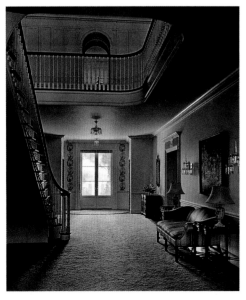

restoration, by the firm of Sanchez and Maddux, recreated much of John Volk's garden design with reflecting pools and parterre plantings through painstaking excavation of the original garden foundations. These extraordinary long garden vistas demonstrate why all its owners have cherished this site, for its privacy, its views, and its beauty.

In the late 1800s Louis Clarke, the son of Charles, hand carried a young ceiba tree from Nassau to the Clarkes' lakefront property. In the garden restoration this tree has been given a sculptured effect through underplantings of African Violets. It has its own proud history, for its claim as a parent the famous "Hanging Tree" that still stands in the Fox Hill settlement in the Bahamas. Louis Clarke's seedling, today a giant, over one hundred years old, and a historic and specimen tree of the Town of Palm Beach, links the historical roots of the exceptional South Lake Trail property with the vibrant future ensured by its award-winning restoration.

ABOVE As restored the grand stairway's elegant Georgian balance and curves have been exactly preserved.
LEFT The grand stairway in a historical view.
OPPOSITE Doorways between the entrance hall, dining room, and living room frame a table and magnificent orchid display.

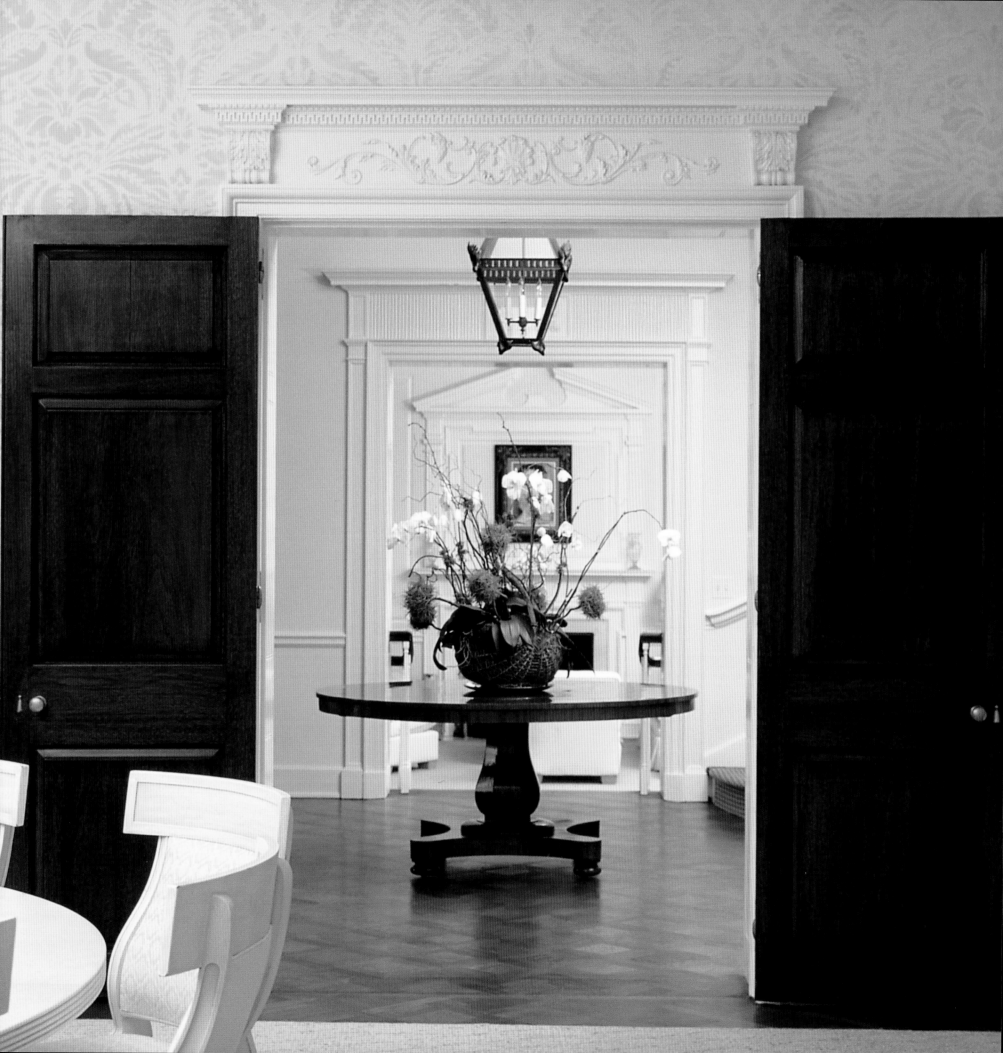

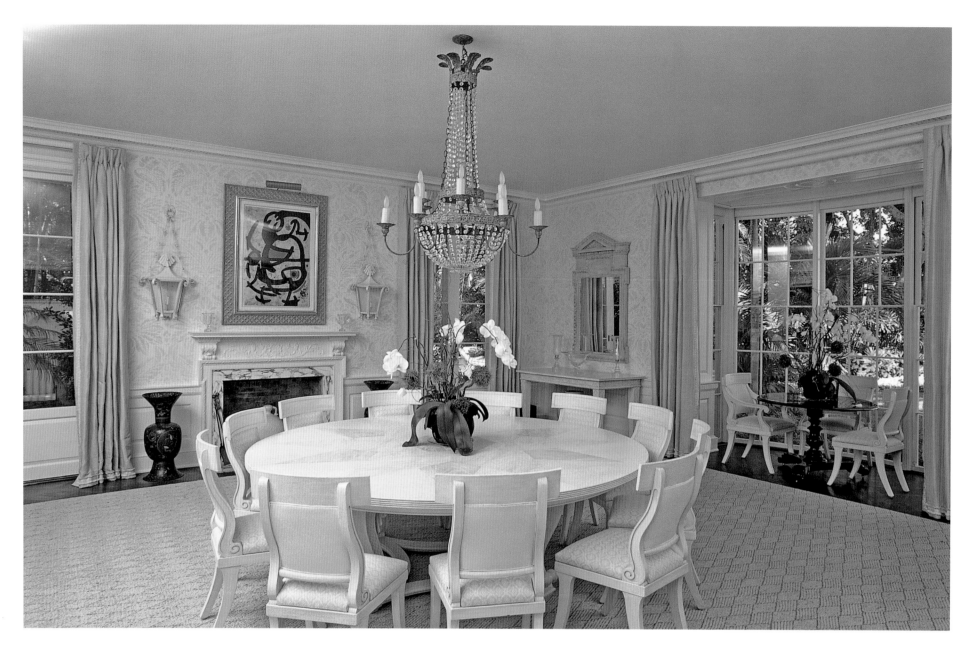

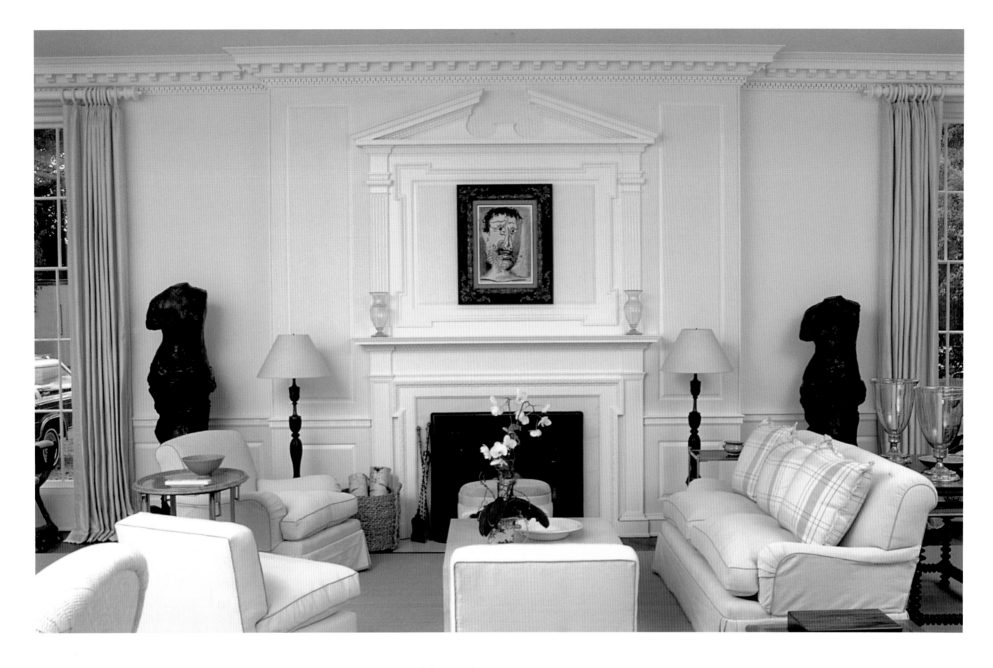

OPPOSITE TOP *The dining room's restrained classical decor emphasizes the cool elegance of Volk's classical architecture and Adamesque woodwork details. In the dining room Mark Hampton used Lee Jafa fabric backed by raw silk on the chairs. The grass cloth carpet has an original stenciled design. The chandelier is by John Rosselli.*

OPPOSITE BOTTOM LEFT *A living room alcove offers a view across Lake Worth toward West Palm Beach.*

OPPOSITE BOTTOM RIGHT *The dining room alcove provides space for a small dining area.*

ABOVE *The living room's balanced arrangement frames the modern art displayed.*

RIGHT *The restoration plan called for many different shades of white on the walls of the main rooms as a neutral background for the owners collection of museum-quality art.*

ABOVE Mark Hampton's goal at the South Lake Trail house was to preserve Volk's taste through restoring the home in a "refined American Regency style" adapted to the "mood" of the "tropics." The cachepots on the étergére are by John Rosselli.

RIGHT The living room in a historical photograph shows the fine Adam-style details of the doorway moldings.

ABOVE In the library rich dark wood paneling is offset by lighter colors in the upholstery.
RIGHT Details of delicate wallpaper at the South Lake Trail house.

TOP LEFT *A cherub atop a turtle adds a playful touch to one of the pools in the main garden vista.*

MIDDLE LEFT *A ram's head urn in the garden.*

BOTTOM LEFT *Classical ornamentation and hidden pools create a mood of romance and mystery in hidden areas of the garden.*

ABOVE *A historical view shows the extent of the gardens at South Lake Trail that frame the lakefront house.*

OPPOSITE *In a garden view showing the historic ceiba tree in the left background a classical gate stops the vista where the earlier greenhouse and conservatory stood.*

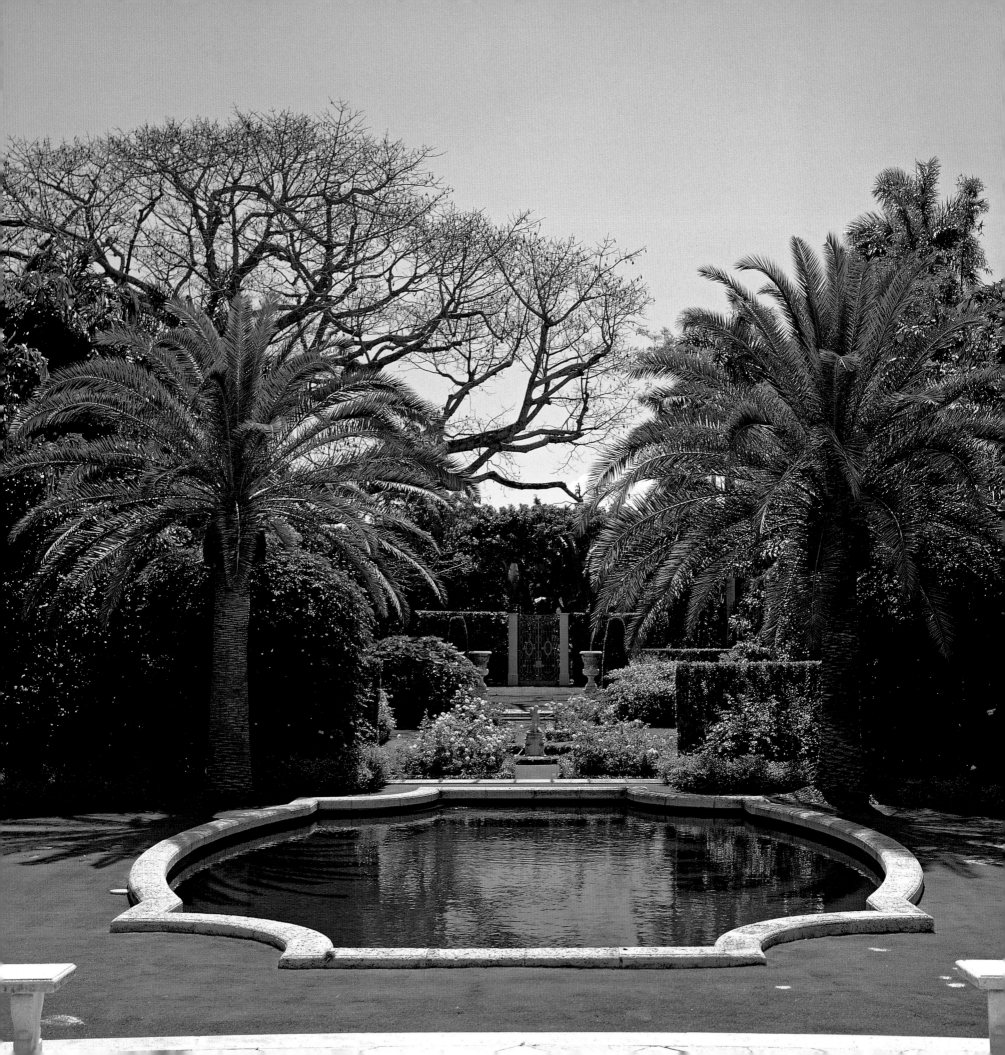

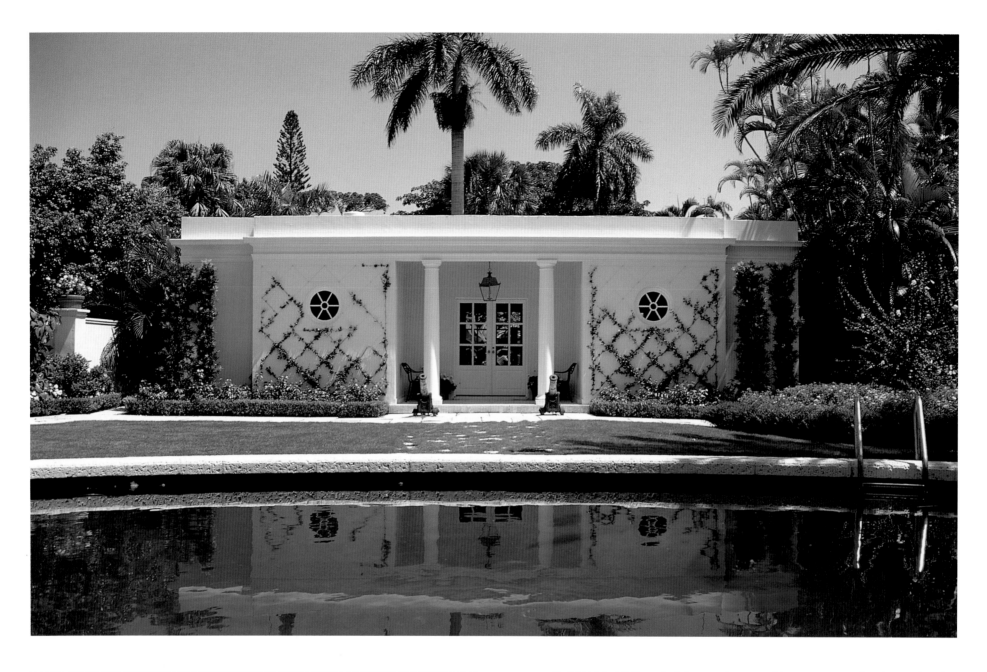

ABOVE In 1974 John Volk received the commission to add a swimming pool at the South Lake Trail house thus ensuring that the addition would be compatible with the original house. The poolhouse carries on the neoclassical theme in an understated way without competing with the architectural elaboration of the main house.

LEFT The gate onto Lake Trail displays graceful urns and iron tracery reminiscent of the Adamesque influences Volk acknowledged in his commentary on the house.

OPPOSITE For the west or lakefront facade of the South Lake Trail house Volk relied on a three-bay organization with bay windows and a center pediment.

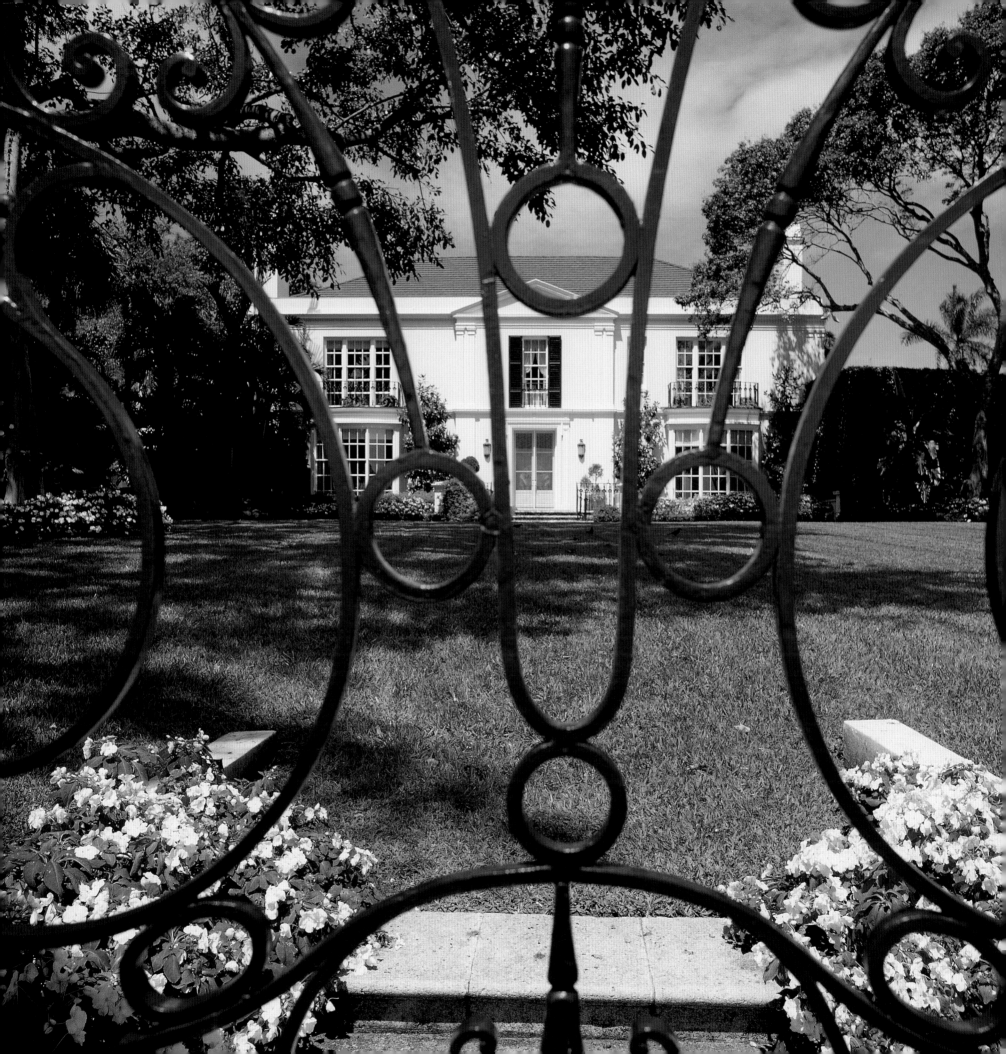

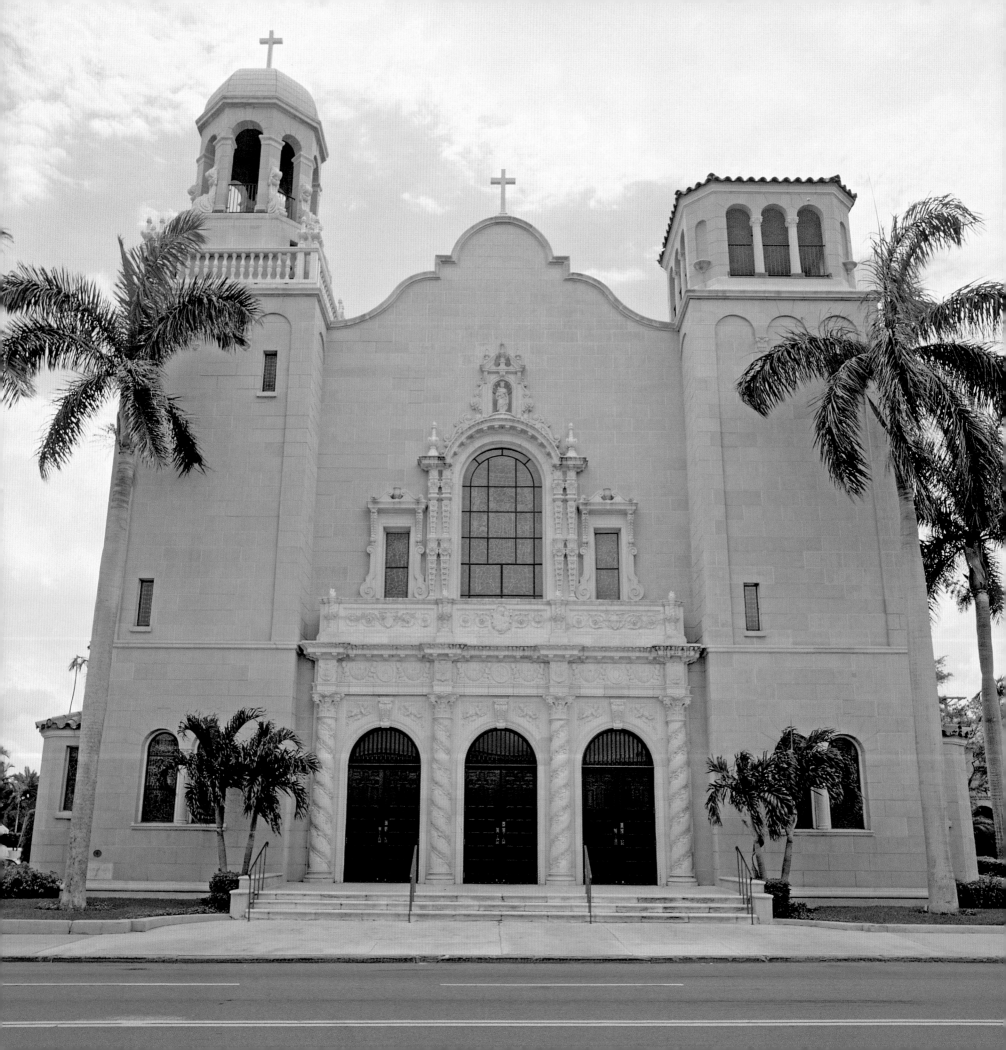

St. Edward Catholic Church

In the mid-1920s, despite the Paris Singer–Addison Mizner development of the Everglades Club and the commercial beginnings of Worth Avenue, the original northern part of the island was very much a vibrant business center for Palm Beach. Major hotels, Bradley's Beach Club, and the Beaux Arts shopping center, which clustered at the foot of the Flagler railway terminus, all gave impetus to new building projects that competed successfully with the beginnings of Worth Avenue.

Colonel E. R. Bradley, a friend of Flagler's, an avid sportsman, and the proprietor of Bradley's Beach Club, was also a leading philanthropist in early Palm Beach. One of Bradley's enduring contributions to Palm Beach was the land on which St. Edward Catholic Church was constructed. In 1998 St. Edward received the Ballinger Award for a painstaking two year restoration which cost over $1.2 million.

Palm Beach's finest example of Spanish Colonial Baroque architecture, St. Edward was designed in 1926 by the notable New York architect, Mortimer D. Metcalfe. Metcalfe, like John Volk, a graduate of Columbia and the Beaux Arts Institute, brought his experience working on the Cathedral of St. John the Divine, Grand Central Station, and the Ritz-Carlton, Belmont, and the Biltmore hotels in New York City to his Palm Beach projects. Later commissions executed by his New York firm included buildings at Vanderbilt and Florida State Universities, the Church of St. John in Jacksonville, and residences for August Belmont and H. P. Robbins.

Originally built at a cost of five hundred thousand dollars, St. Edward reflects the adaptation of the Spanish Colonial style to Palm Beach by a truly eminent architect. Just to the west of St. Edward in 1925 Metcalfe had designed the Palm Beach Hotel, the first major Palm Beach hotel not located on the waterfront. For the hotel he employed the same motif of twisted Spanish Baroque columns used so effectively for the triple arched entrance of St. Edward Church. Metcalfe completed the design for the St. Edward complex with a parish house and cloistered courtyard.

The $1.2 million restoration included the repair of water damage so severe that over half of the building's stucco had to be stripped off revealing that the core of the church was hollow clay tile with a covering of stucco scored to depict stone. The restoration returned the church's roof to its original variegated colors of Spanish tile. Its cast stone decoration and arches were repaired or recast from molds made of the original decorative elements.

The restoration plan was formulated by architect James Anstis and the skilled construction work of the restoration was directed by Martin Seras of Seras Construction. As part of the restoration, foundations were repaired with a steel pin piling system that corrected two inches of sagging. Water damage from driving rains was repaired. New flashing and stucco preserve the church's glorious interior, which rises to a height of sixty-five feet with a magnificent coffered, barrel vaulted ceiling, patterned in octagons and squares of painted plaster. With all of its interior details meticulously restored, from its wood carvings to its endowment of over forty stained and painted glass windows, the sanctuary at St. Edward glows with reflected light. All the church's windows, which were repaired and resealed in the restoration, were created in the Munich, Germany, studio of Franz Mayer in 1926.

Its restoration complete, today St. Edward Catholic Church reaches out with renewed grandeur to its community. In the words of one parishioner, Tierney O'Hara, "It looks heavenly."

OPPOSITE The church's main entrance is recognized in the Palm Beach Landmarks Designation report as one of "the finest churches constructed in the early south Florida period of development." The main facade is symmetrical with two towers balancing the triple-arched doorway. The contractor estimated that over sixty percent of the deteriorated stucco on the exterior had to be replaced.

ABOVE The dome of the bell tower was completely rebuilt in the restoration.

ABOVE A detail of the Marion windows, which form one of the most outstanding features of St. Edward Church. The windows tell the story of sixteen major events in the life of the Virgin Mary. These arched windows, like all the others in the church, were originally constructed from hand blown glass.

BELOW A detail of nave level stained glass shows a scene from the life of Jesus. The church's windows follow the Munich style of easel paintings and emphasize rich colors and elaborate dress.

RIGHT The interior of St. Edward Church is designed with a simple nave and an apse behind the altar. Looking towards the nave, the sixteen arched clerestory windows provide a powerful axis directing the organization of the interior.

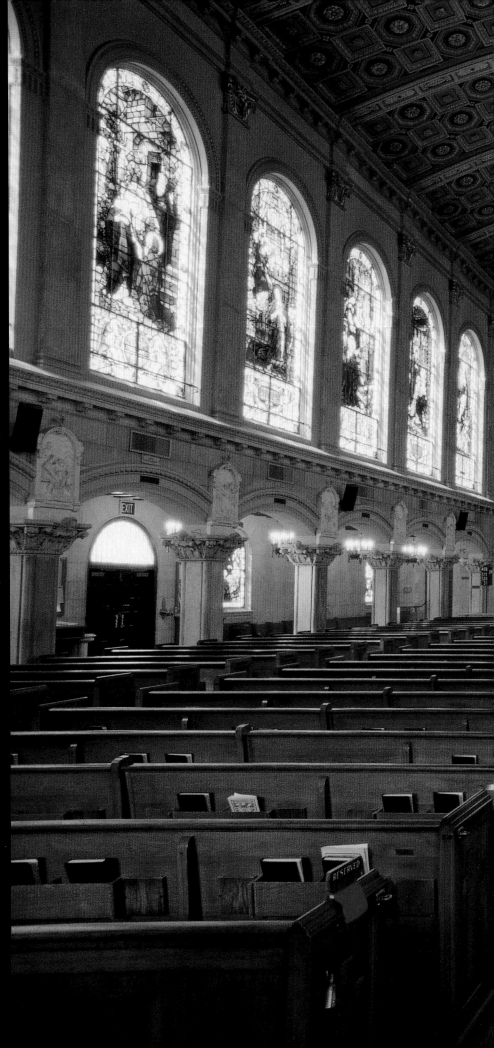

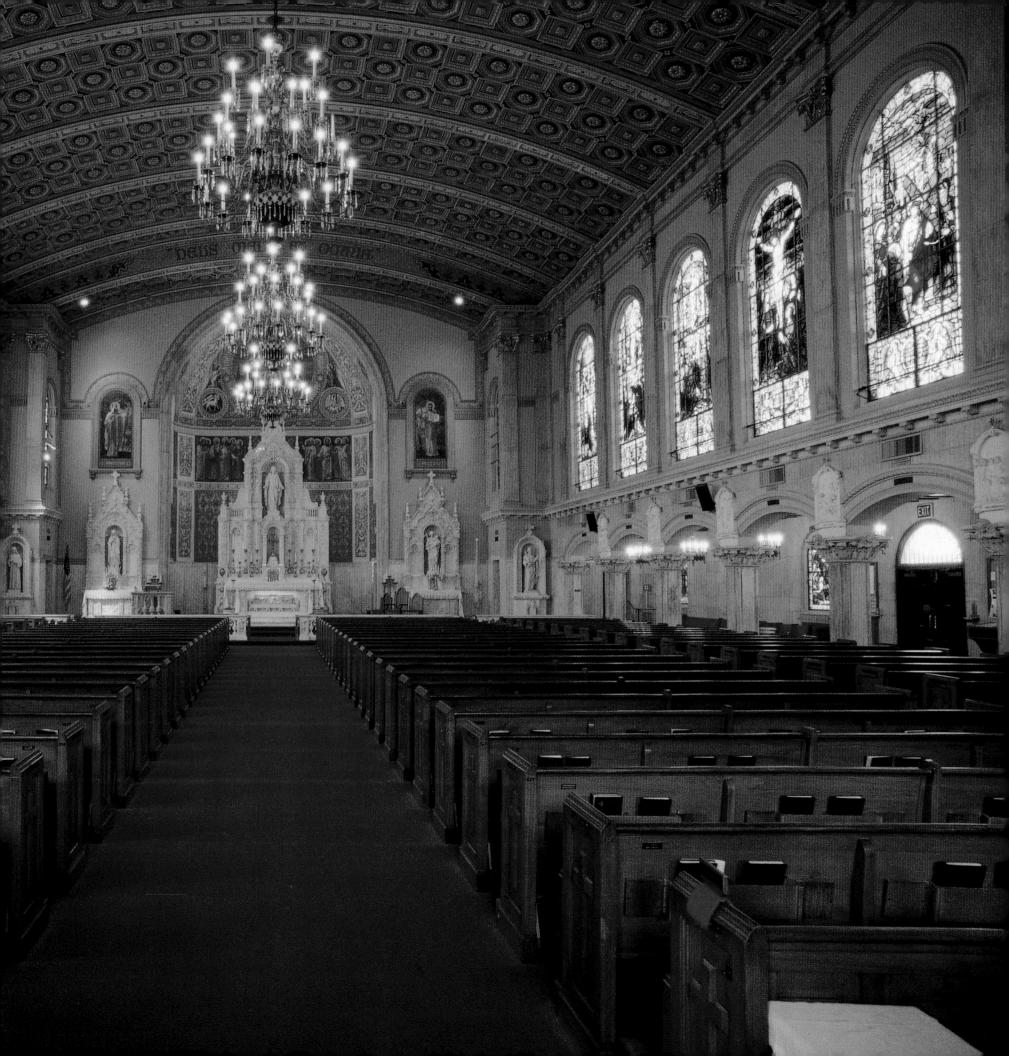

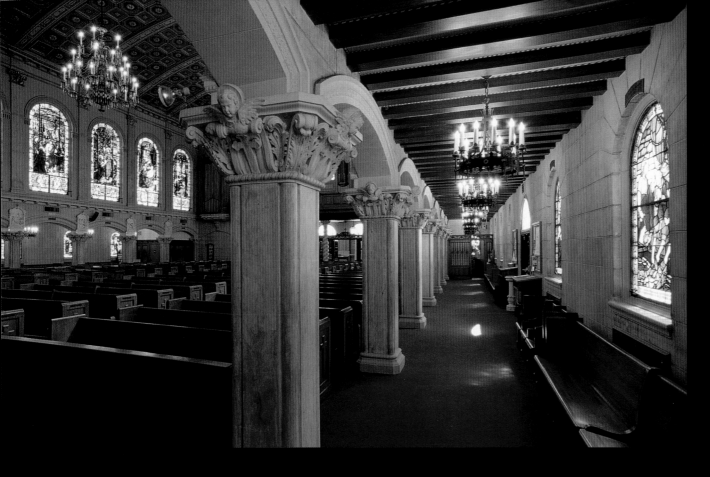

TOP LEFT Arched stained glass windows
along the two aisles flanking the nave depict
Jesus's seven miracles and parables from the
Gospels. The pews are made of carved rose-
wood. In the original architectural design,
the windows were all placed to enhance the
effect of direct and indirect light in the nave
and sanctuary. The restoration protected the
church's rich endowment of stained glass
with re-flashing and hurricane-resistant
glass. Marble pilasters with gilded acanthus
capitals support the nave.

BOTTOM LEFT The confessional is
enclosed by a screen of carved rosewood.

ABOVE Richly carved walnut grills
depicting angels and cherubs divide the
nave from the vestibule.

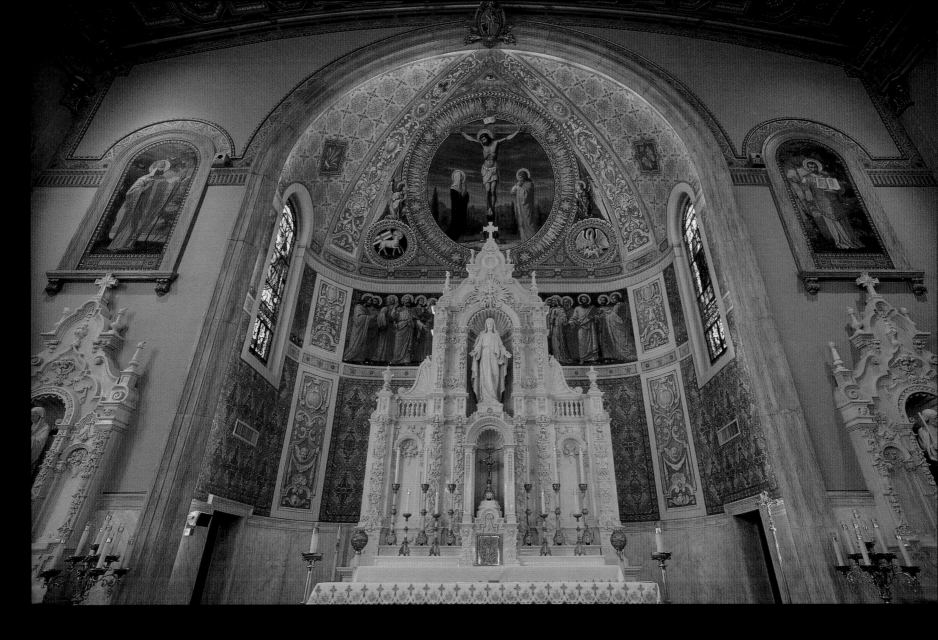

ABOVE The altar and sanctuary are constructed of alabaster. The central statue depicts
the risen Christ.

RIGHT The barrel-vaulted ceiling with its pattern of octagons and squares adds richness
and elaboration to the interior.

OPPOSITE TOP *Details of the lavishly decorated cast stonework above the entrance.*

OPPOSITE BOTTOM LEFT *Cast stone braces were recast around fiberglass rods, instead of the original steel, to prevent deterioration from the elements.*

OPPOSITE BOTTOM RIGHT *Although the principal contributor to the fundraising drive to establish St. Edward was Edward R. Bradley, proprietor of Bradley's Beach Club in Palm Beach, the church takes its name from Edward, King of England from 1042 to 1065, who was known as Edward the Confessor. He was canonized in 1161.*

ABOVE AND RIGHT *Metcalfe's design for the church cloister evokes a reflective, almost romantic area. The simple cloister columns contrast with the monumentality of St. Edward Church viewed through the cloister arches.*

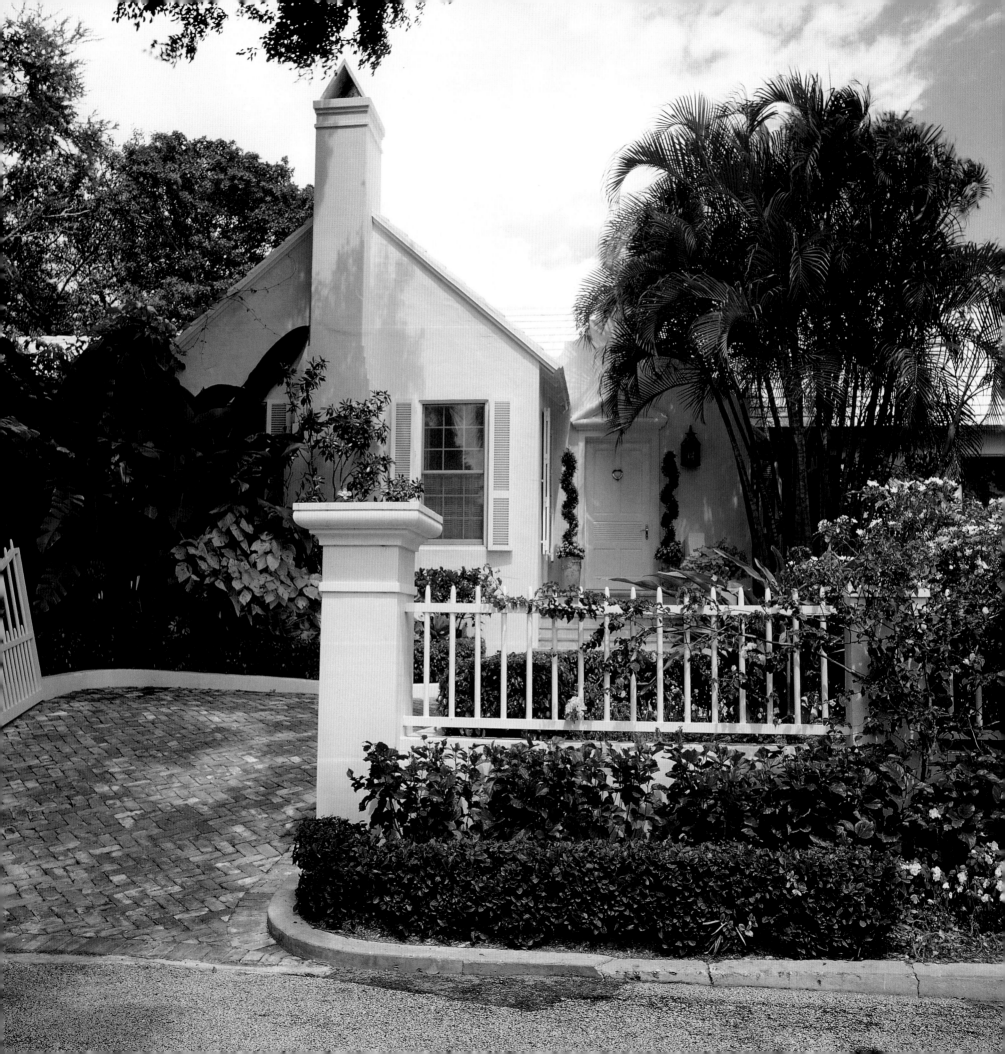

Hi-Mount Road House

In the 1930s Palm Beach architectural taste accepted a new vocabulary of classical revival styles, such as the neoclassical designs of John Volk and the British Colonial influenced work of Howard Major. Major made the Bermuda style one of his trademarks with a series of homes that reflected the more subdued, restrained taste of the depression decade of the 1930s in America. Nowhere was his characteristic gift for understatement better expressed than in the house on Hi-Mount Road that won the 1998 Ballinger Award for its restoration.

Major felt the Bermuda style was more appropriate for Florida than the Mediterranean Revival. In the Hi-Mount Road house, constructed in 1939, he embarked on a journey away from the monumental and returned to the tradition of Palm Beach homes scaled to complement their neighborhoods. In this remarkable restoration and rehabilitation the owners not only expanded their home by approximately a third, they also gave it new architectural character by drawing on the best of both traditional and modern styles. Yet the redesign was accomplished without altering the calm civility with which the house faces the street. The very quiet traditional street facade remains in scale and in harmony with its original neighborhood. All the dramatic changes that enhanced the Florida character of the house by providing a series of soaring indoor and outdoor rooms occur on the garden side and are not visible on the street.

In the Hi-Mount home Howard Major presented one of his most fully realized and firmly controlled Bermuda creations. The design included a typical capped chimney and Major's trademark octagonal window. The Hi-Mount Road house exhibits a gentle, understated face to the passerby and reserves its embellishments, as in the study and the living room, for the privacy of its owners. The restoration was designed by architect Eugene Pandula. In his interpretation the traditional reticence of the Bermuda style has been enhanced with a trellised loggia that reaches for the sky and allows the house to flow into its setting, while the landscape in return frames the house.

In an era of massive redevelopment, Palm Beach contends with the same problems as other areas of the country. Many claim that modern zoning regulations and oversight requirements deter the creation of gracious open spaces, yet in the Hi-Mount Road project, accomplished in strict compliance with current rules, Eugene Pandula was able to restructure interior volumes to blend dramatic modern forms with traditional features.

In the landscaping plan, the owners created their own magic so the outdoors and the indoors of the home frame each other through views of light and shade. Color and control alternate their impact, and all vistas lead to the house. By combining the best of the tradition of Bermuda architecture with an innovative new design, the Hi-Mount home's owners have accomplished what they most desired, "a house of clouds."

OPPOSITE *A capped chimney shows off one of Major's typical Bermuda style embellishments. The understated street facade retains a typical Bermuda style character.*
ABOVE *Another Howard Major trademark was the use of an octagonal window as a grace note in a prominent facade.*

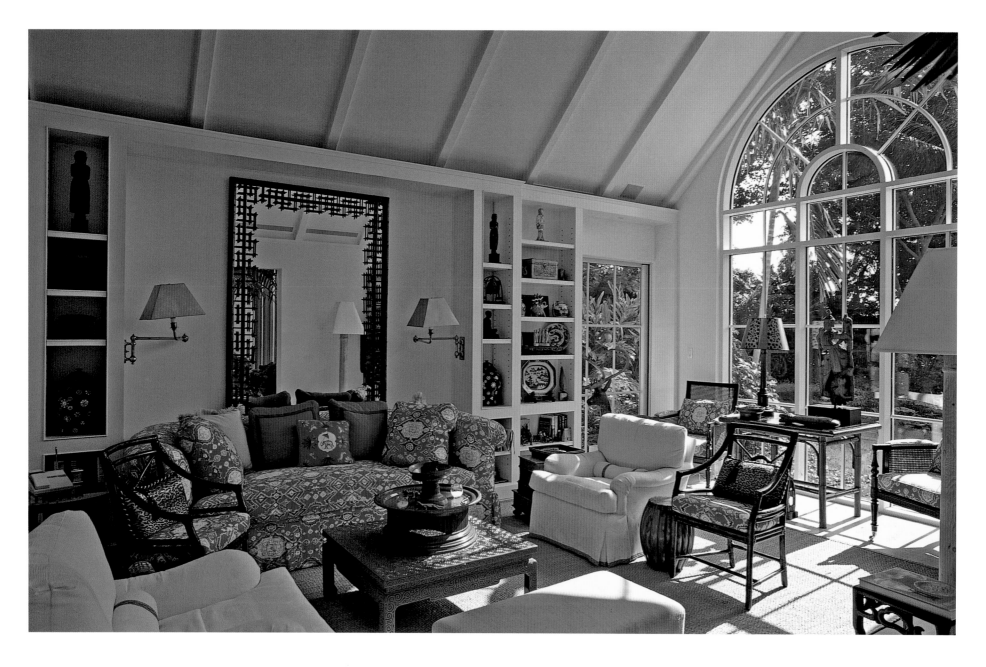

ABOVE The arched window at the back of the sitting area beside the loggia demonstrates how the entire garden side of the house has been opened out to its surroundings.

LEFT Alterations by Eugene Pandula provide a spacious loggia room that also functions as a passageway.

The dining room at Hi-Mount Road balances the sitting room on the other side of the loggia with a similar arched window-wall.

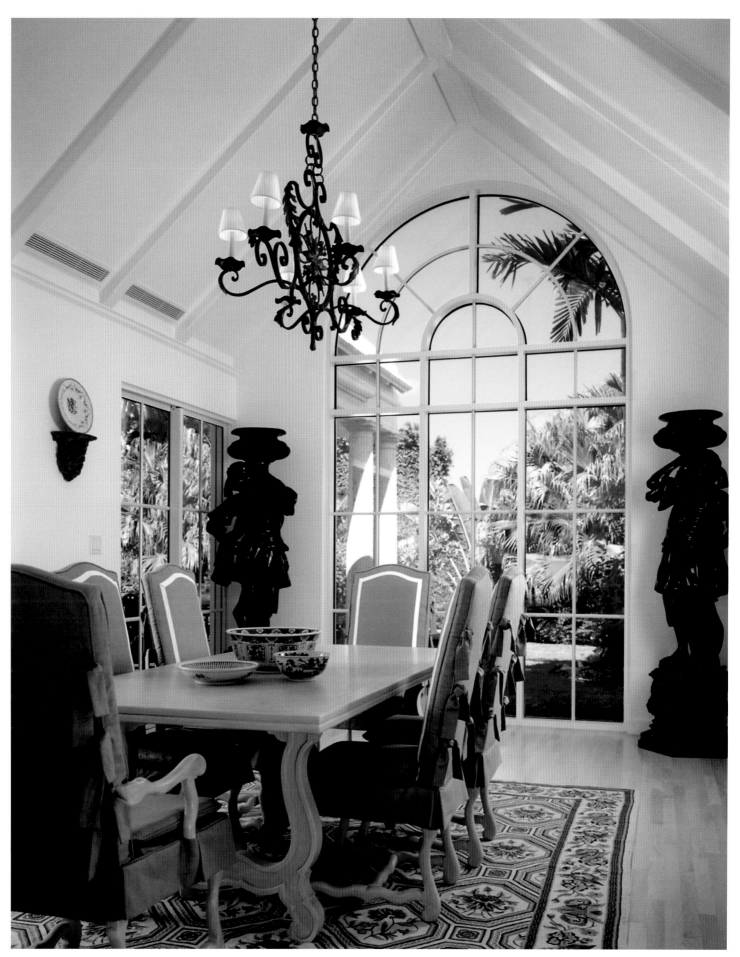

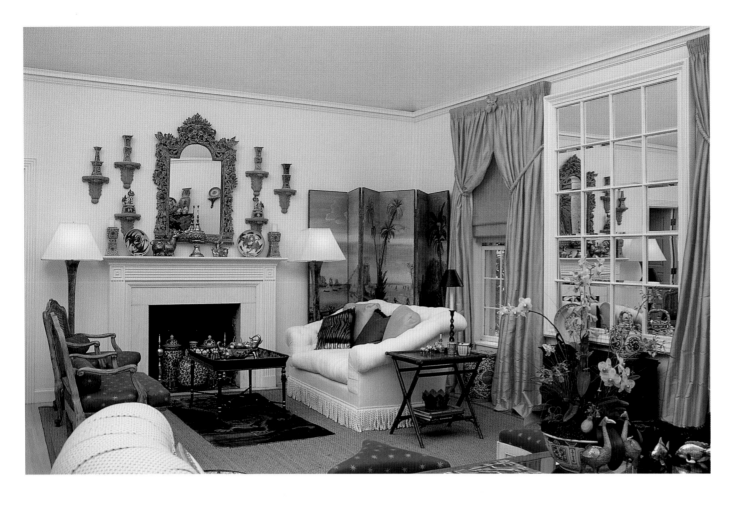

ABOVE *An interior passage to the re-designed guest wing is entered through a door with a charming faux painting of a child reaching for a butterfly.*

TOP LEFT *The mirror inset into the living room wall reflects the glorious explosion of light with which the restoration alterations by Eugene Pandula gifted the house.*

BOTTOM LEFT *The oak paneling in the library retains the dignity of a library area while providing a lighter setting than traditional dark paneling.*

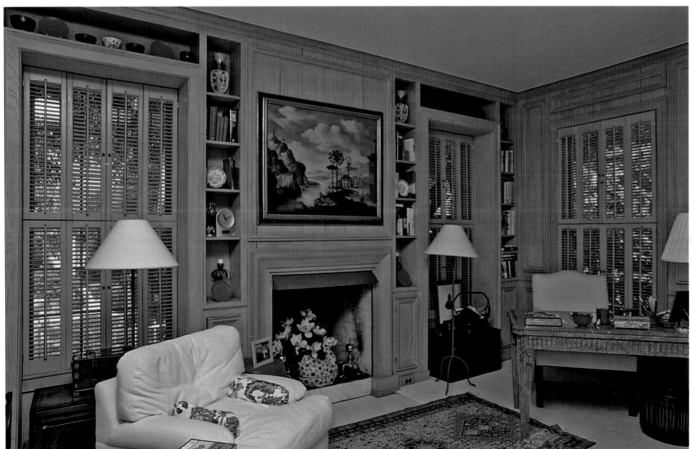

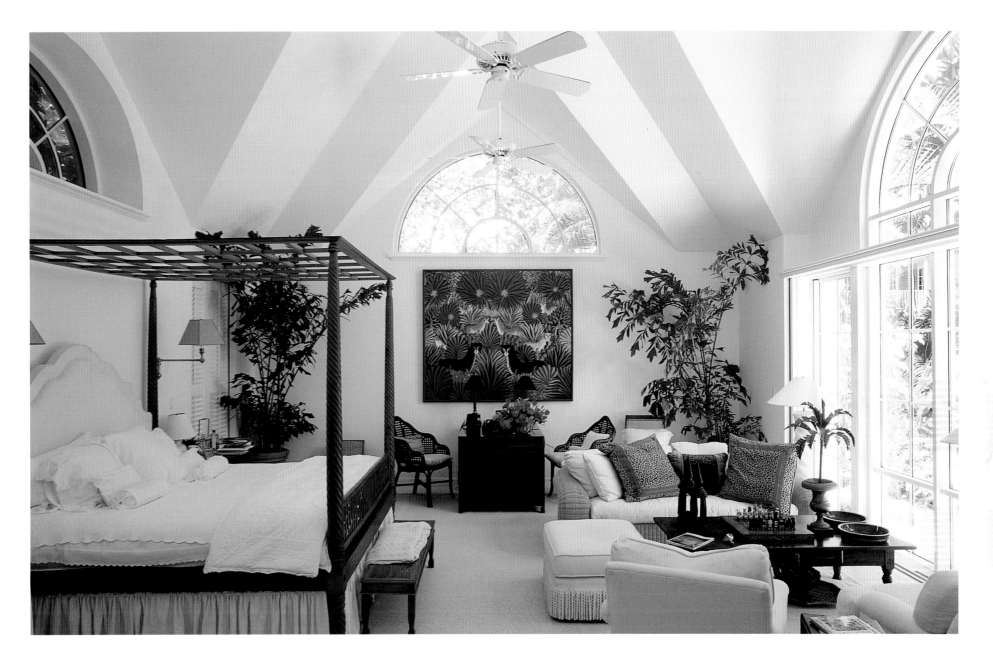

ABOVE *The strong architectural character of the master bedroom is defined by its soaring window arches and peaked ceilings.*
RIGHT *Another view of the master bedroom shows how a wall has been opened to become an arched window.*

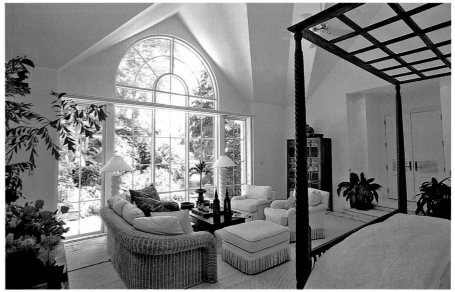

TOP *Every structural detail contributes both to architecture and to function; in this case the beamed ceiling contains air conditioning ducts. The loggia ceiling becomes a functioning part of the Hi-Mount House that continuously joins the house to its outdoor surroundings.*

ABOVE *A series of open panels provides light as well as an intricate shadow pattern for the new enclosed loggia space.*

OPPOSITE *The lush landscaping surrounding the Hi-Mount Road house frames the series of gables created to contain the arched floor-to-ceiling windows. The gables both link the house to its Bermuda style roots, and at the same time, provide a modern interpretation of the historical style.*

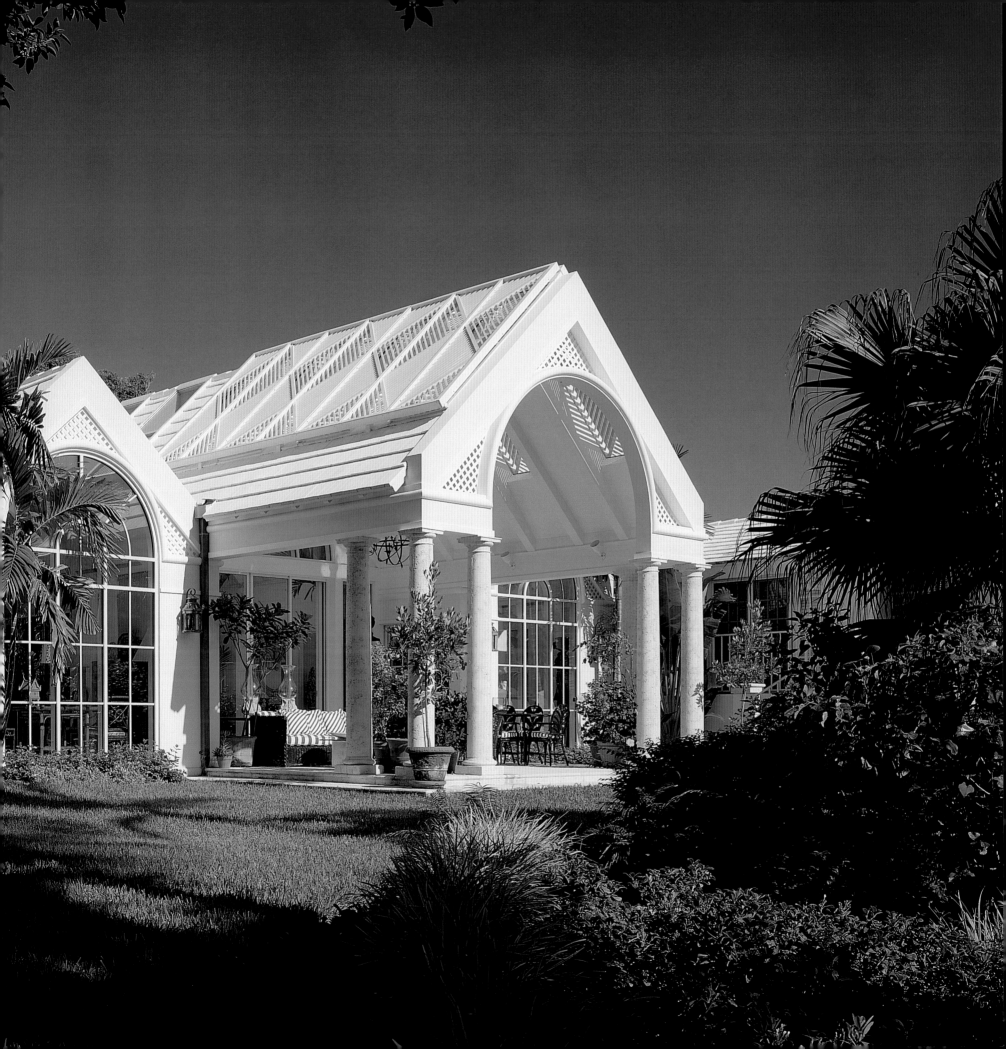

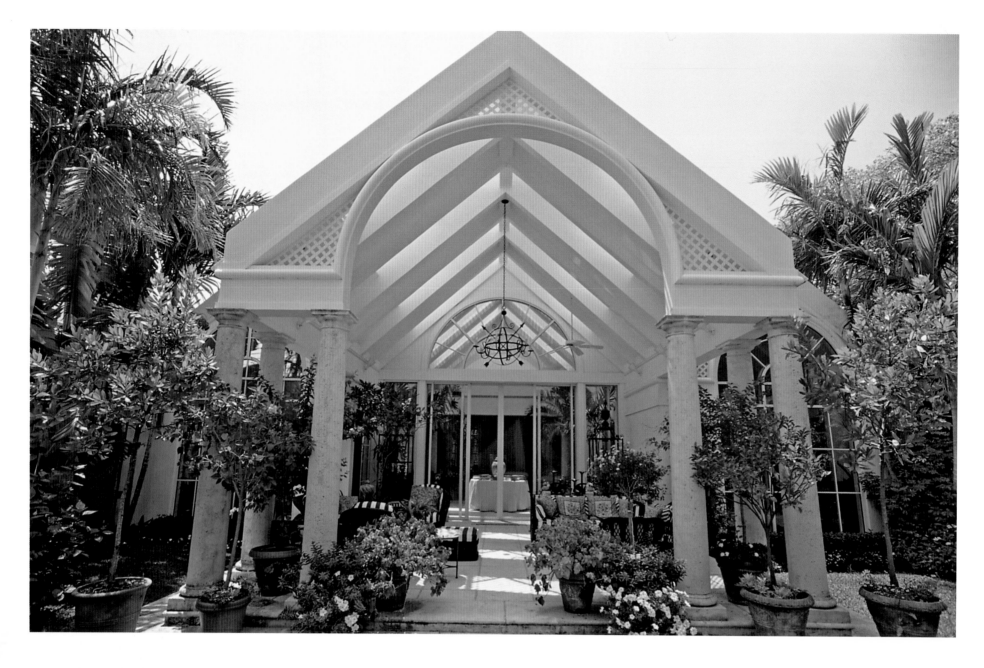

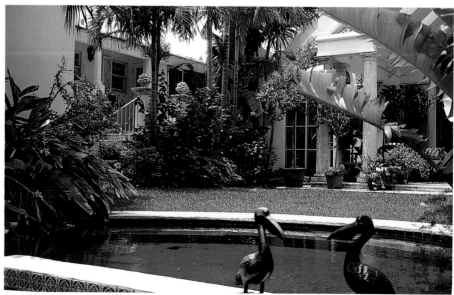

OPPOSITE TOP *A view of the open loggia Eugene Pandula designed highlights the transition between architectural space and landscaped spaces.*

OPPOSITE BOTTOM LEFT *A series of pools provides a water feature integrated with the landscape.*

OPPOSITE BOTTOM RIGHT *Pelican statues decorate one of the sides of the lavishly tiled pool.*

RIGHT *A view of the garden and pool from the outdoor loggia. The property occupies one of the highest points in Palm Beach.*

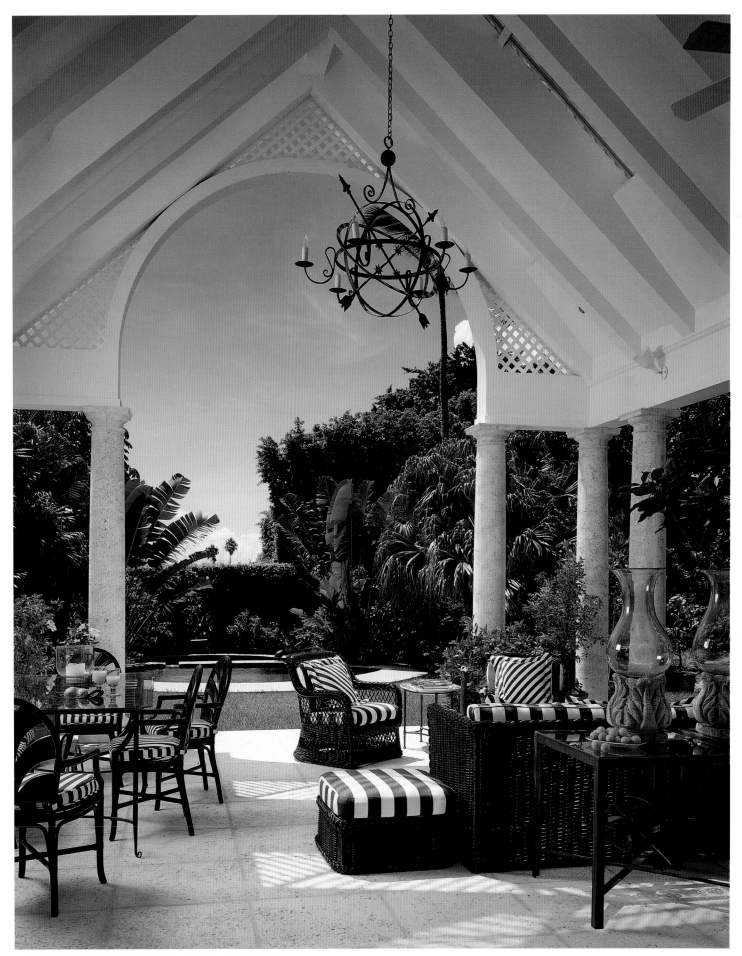

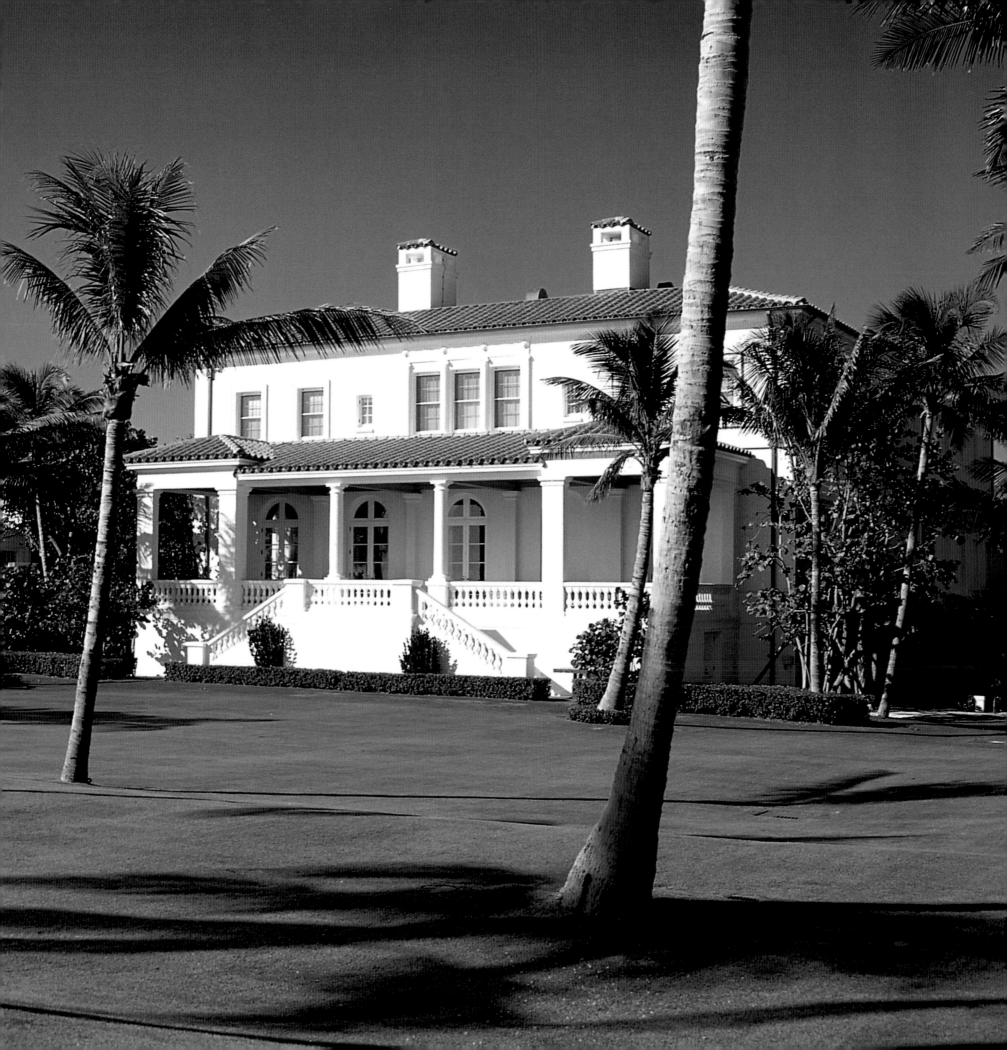

Flagler Drive House

In 1999 the Preservation Foundation recognized two homes originally designed by Marion Sims Wyeth with the Ballinger Award for outstanding restoration. Wyeth's 1924 design executed for Clara D. Frazier was a Spanish style home with strong architectural accents in its interior. In an oral interview taped shortly after his retirement, Marion Sims Wyeth recalled how Mizner's Everglades Club launched the vogue for Spanish houses in the 1920s. Wyeth called the cycle of demand for such homes the "Spanish itch . . . because it broke out all over Florida," but in his design for Clara Frazier nonetheless showed his mastery of the form.

Wyeth's homes were frequently designed in a U-shape. His skills at integrating architectural form with a patio or courtyard were seldom surpassed by the Palm Beach architects of his generation. As Wyeth remarked he wanted his designs to "make the outside part of the house." The restoration of the Flagler Drive home by Jeffrey W. Smith of Smith Architectural Group maintained the importance of Wyeth's patio design while resolving some of the architectural contradictions introduced by a series of owners and alterations. For many years this home was used as a vacation retreat for distinguished visitors, including King Hussein of Jordan and Vice President Spiro Agnew.

The restoration moved an oceanfront pool to the west of the house and restored the patio on the west which had been filled in by earlier alterations. Curiously when the pool was on the oceanfront, there was never an oceanfront door to the pool. Bathers had to exit the house from a side door. The Smith restoration enhanced the importance of the patio and the new pool area with classical balustrades that recalled Wyeth's use of the same form.

The restoration allowed the architectural character of the home to speak for itself on the interior through a series of arched spaces. Severe plain walls were enlivened only by original applied cast stone decoration. The interior decoration dared to let the mass and volume of the spaces speak for themselves while creating a simple palette of spare forms and clear colors reminiscent of the south of France. The owners' desire for a beachfront, barefoot life style is underlined by the disciplined simplicity of the interior settings.

On the oceanside the restoration provided a spacious veranda to emphasize the ocean setting and added simple classical columns to create a traditional Florida porch that looks as if it could always have been a part of the ocean facade. The theme of the Flagler Drive home speaks of a house whose interior style has changed but whose thoughtful restoration has maintained its character and grandeur.

OPPOSITE *The ocean facade of the Flagler Drive home after restoration shows a simplified Spanish approach relying on elemental statements of repeating columns and a red barrel tile roof. Scott Sloane of Sloane Construction was the restoration contractor. The restoration design for the oceanfront veranda (see following page) repeats the same strong horizontal balustrade found on the west side of the house and unifies the oceanfront with the courtyard on the land side.*
ABOVE *A detail of the cast stone decoration.*
RIGHT *Wyeth's original design for the prominent arched front door of the 1924 Clara Frazier home shows a strong Spanish influence. The original contractor was Cooper Lightbown, a well-known builder of the 1920s who also worked with Addison Mizner and served as mayor of Palm Beach from 1922 to 1927.*

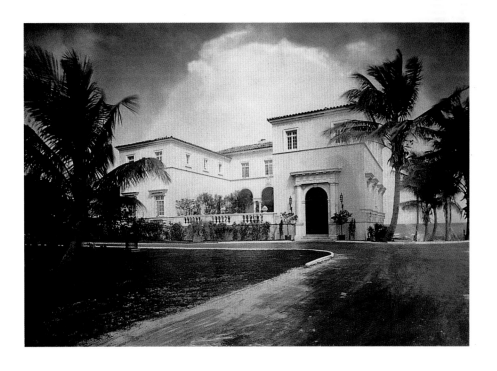

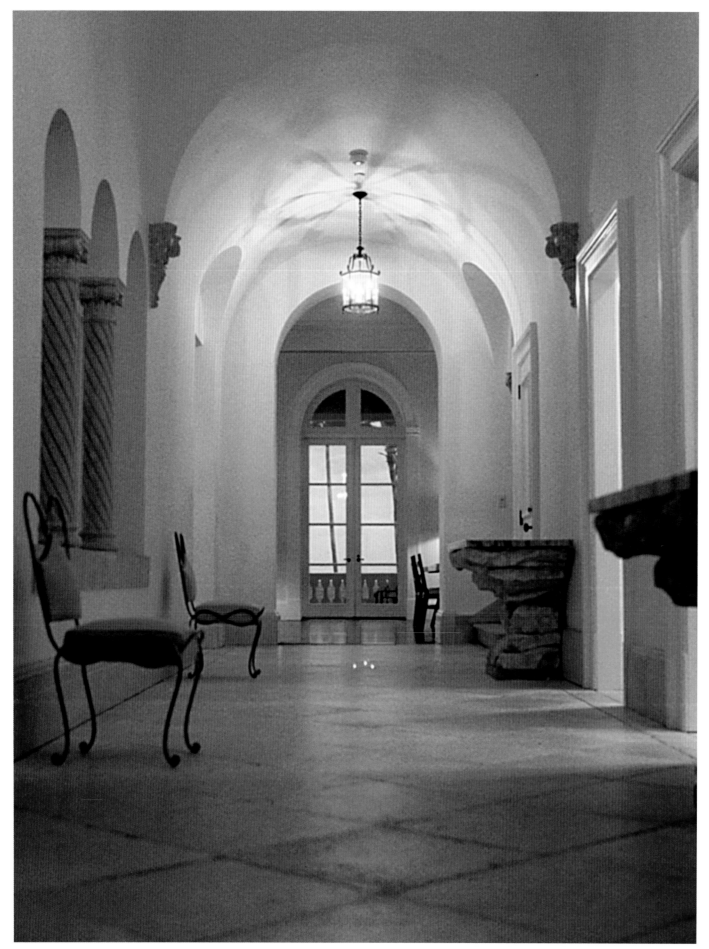

ABOVE *The arched volumes of the entrance stairs frame a solitary leaded glass window.*

LEFT *Plain walls are highlighted by isolated examples of applied cast stone decoration while arched volumes and high ceilings provide a strong axial direction in the interior.*

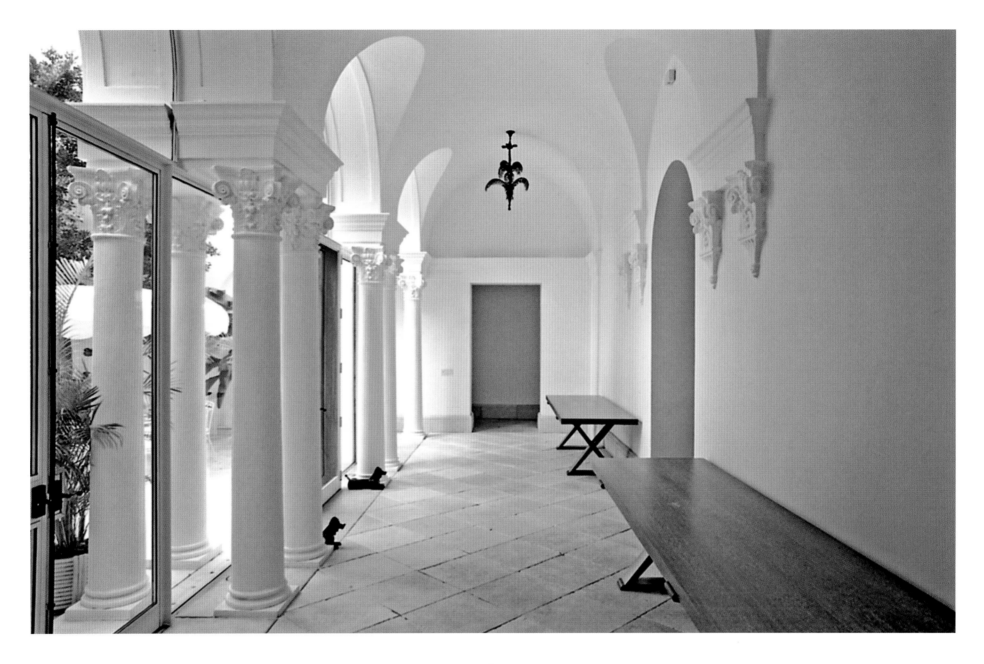

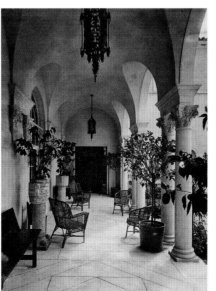

ABOVE *The original open loggia was enclosed by alterations designed by architect Ames Bennett in 1962.* LEFT *A historical photograph shows an early view of the open loggia.*

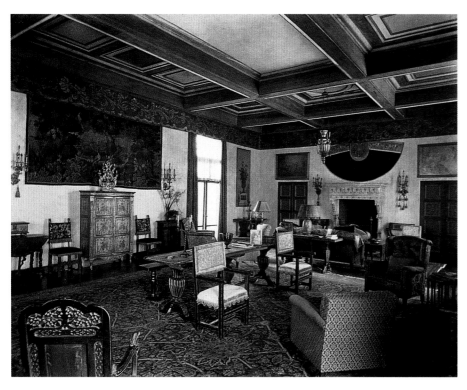

ABOVE *A historical view shows the original living room.*

RIGHT *Simple forms of furniture and lighting in the living room emphasize a beachfront life style. At the same time the arched windows, coffered ceiling, and stone fireplace provide a powerful architectural setting.*

BELOW *An arched window accents the straightforward presentation of the dining table.*

OPPOSITE *The simple presentation of the drawing rooms relies on the impact of sun and light from the ocean, an effect enhanced by the pure white lacquered floor.*
ABOVE *Period lighting fixtures provide a playful contrast to vibrant colors and simple, spare furnishings.*

TOP AND BOTTOM RIGHT *Guest bedrooms at Flagler Drive rely on simple and clear colors with period furniture and simple Venetian blinds.*

OPPOSITE TOP *Interior changes resulted in merging the kitchen with a family breakfast room decorated in vibrant colors.*

OPPOSITE BOTTOM LEFT *Numerous teapots, Fiesta ware, and a display of Russell Wright pitchers animate the family kitchen.*

OPPOSITE BOTTOM RIGHT *A likeness of Marilyn Monroe presides over the kitchen.*

ABOVE *The color and style of the French Riviera are evident in the new kitchen at the Flagler Drive home.*

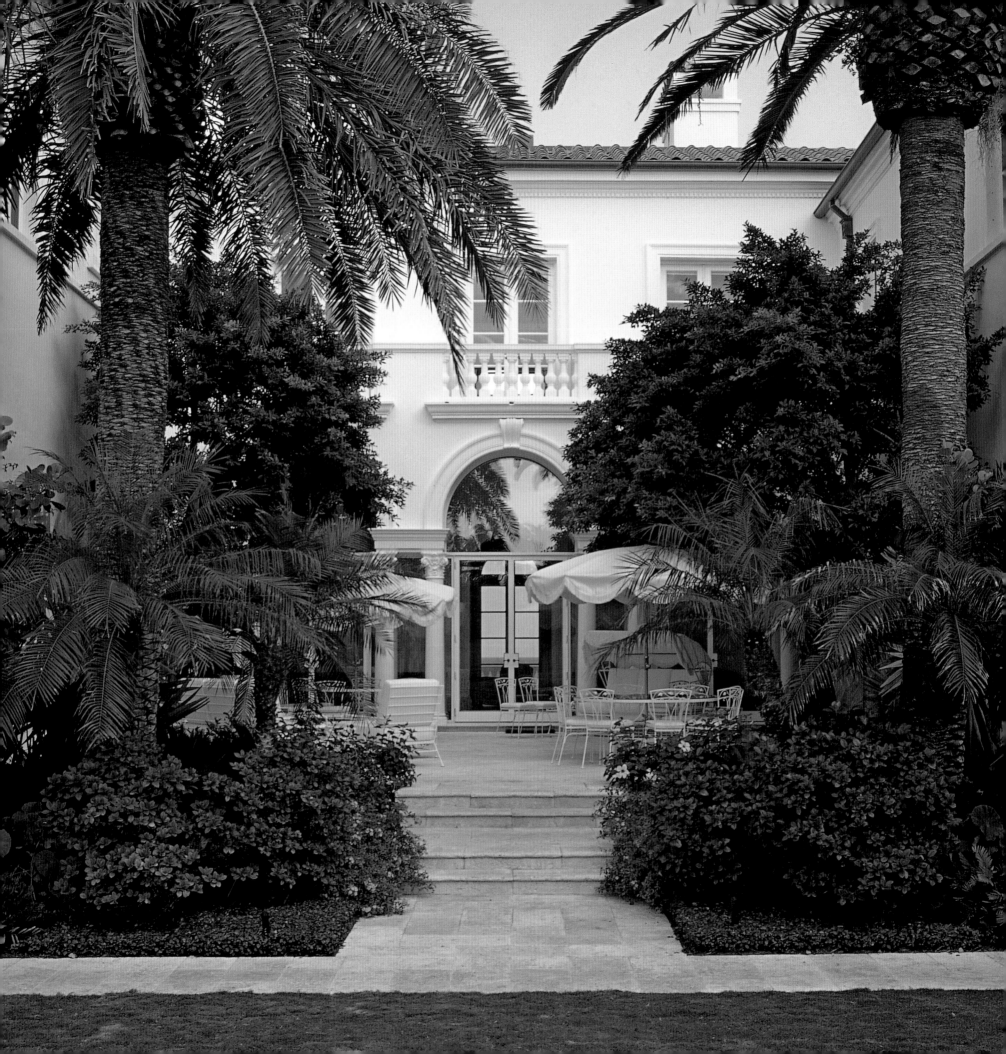

OPPOSITE *A view toward the courtyard and patio emphasizes the balance of Wyeth's original design.*

ABOVE *The original patio was a private area set off by a baluster. The use of balusters in the restored courtyard defines pool and patio areas and underscores the importance of the outdoor area.*

RIGHT *A historical photograph of the patio.*

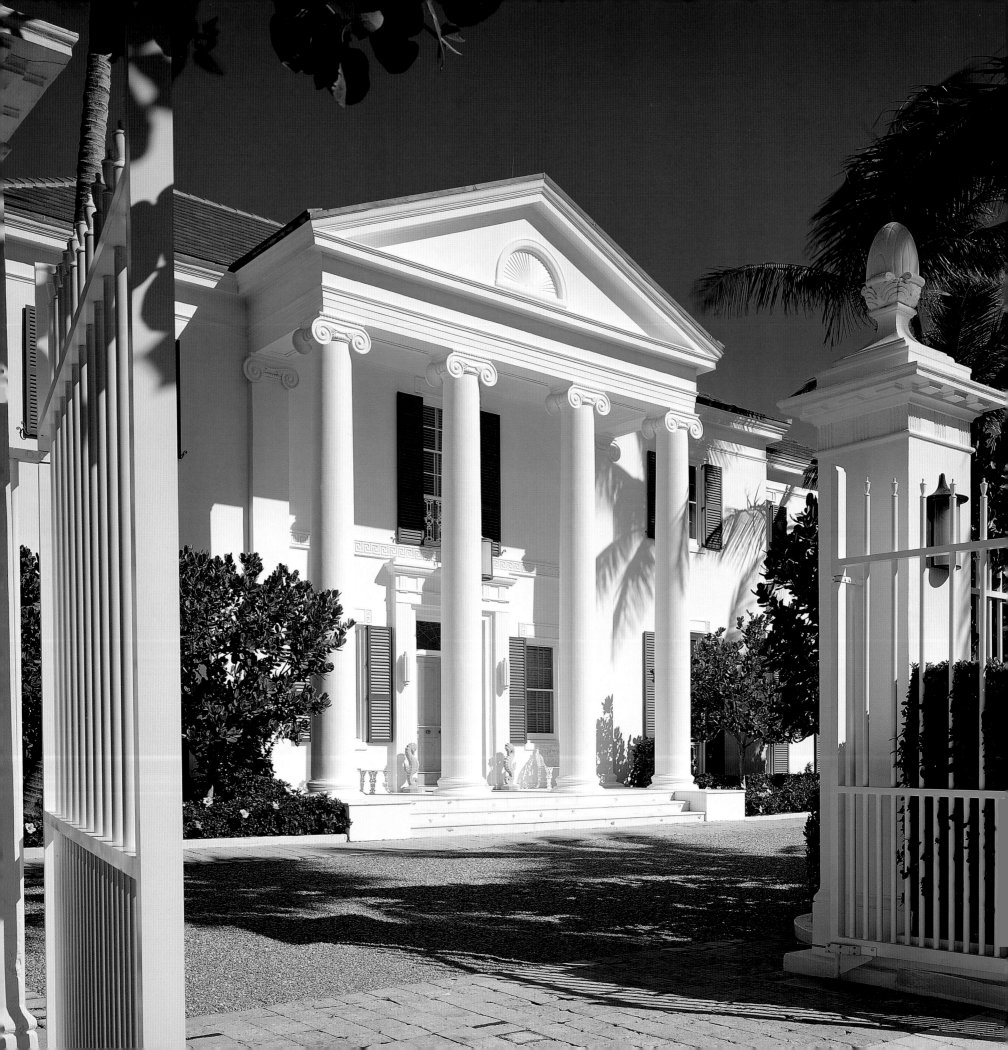

South Ocean Boulevard House

The 1999 Ballinger Award for the restoration of a Marion Sims Wyeth home on South Ocean Boulevard, constructed for Mrs. Edward Swanson in 1938, highlights Wyeth's skills as a master architect. His ability to speak through different architectural styles, in this case the neoclassical style, in the vocabulary of luxury and graciousness demanded by the Palm Beach environment, underscores the breadth and depth of his familiarity with differing architectural traditions and his understanding of how architectural form may be manipulated to produce character.

The annals of Palm Beach architecture honor two very different types of architects. Architects like Mizner and Urban flashed across the scene creating dramatic masterpieces that enthused and inspired observers. Architects like Wyeth and Volk, over the long span of their careers, created an inventory of accomplishments in many styles that responded to different social and cultural conditions. Which approach has influenced Palm Beach's architectural heritage more? Both approaches have had enormous influence. Certainly, in its ultimate impact on the viewer the controlled grandeur of Wyeth's outstanding neoclassical home on South Ocean Boulevard rivals the expansive exuberance of Mizner's designs.

The Swanson home was purchased by the family of its present owners in the 1960s. It was restored by Jeffery W. Smith of Smith Architectural Group working with Scott Sloane of Sloane Construction as the restoration contractor.

The restoration plan expanded the wings of the u-shaped house, and a room was added on the ocean facade. The goal was to orient the house more strongly toward its oceanfront site while respecting the basic neoclassical plan and details such as ionic capitals and Greek key ornamentation. The pool and tennis court on the landside became an enclosed family compound with the expansion of the garage, also in the neoclassical style, to the rear.

Since the house is a landmark of the Town of Palm Beach, the exterior restoration was strictly controlled, but preservation of interior features was not required. The owners' innate sense of history took them beyond the requirements to the preservation of the interior plan as well as many of its decorative features and even pieces of original period furniture. In an additional theme of the restoration, the owners aimed to create a family setting for all ages based on ease and comfort.

Decorative details drew on family collections and were presented with humor and imagination. The interior design was accomplished with the collaboration of Thad Hayes and project manager Donald Blender who attempted to "respect the

grace" of the period home while introducing a new feeling of family values.

Marion Sims Wyeth, in an oral interview, spoke about the kind of architecture that was not a "fad" but the natural evolution of the classical styles, Greek and Roman into English Classical and American Colonial. With his 1938 South Ocean Boulevard house he created a classical masterpiece that was readily adaptable to changing tastes in life style and in interior design. Its owners believed restoration, to be successful, must "resolve contradictions." Their restoration succeeded in creating a unity of grace and style in its interiors and its exterior.

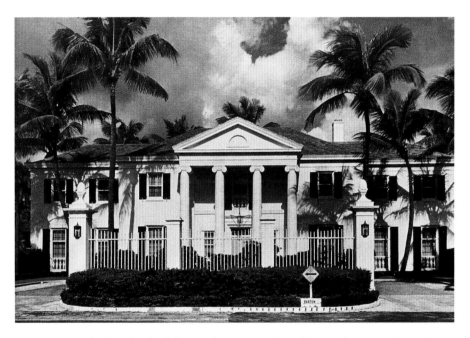

OPPOSITE The front facade of the South Ocean Boulevard house relies on neoclassical-Georgian elements, including a Greek portico surmounted by a pediment with a fanlight. Four ionic columns define the porch.

TOP Classical ornament carries through to the ocean terrace with a Greek key design for a baluster.

ABOVE A 1960s black and white picture shows the almost identical appearance of the front facade before restoration. The South Ocean Boulevard home was constructed during the period when Marion Sims Wyeth and Frederic Rhinelander King were partners.

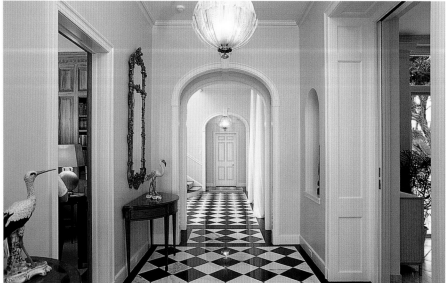

ABOVE On an upper-level landing twin niches for statuary provide a classical balance to a doorway.

LEFT An arched doorway carries the neoclassical theme down the hallway.

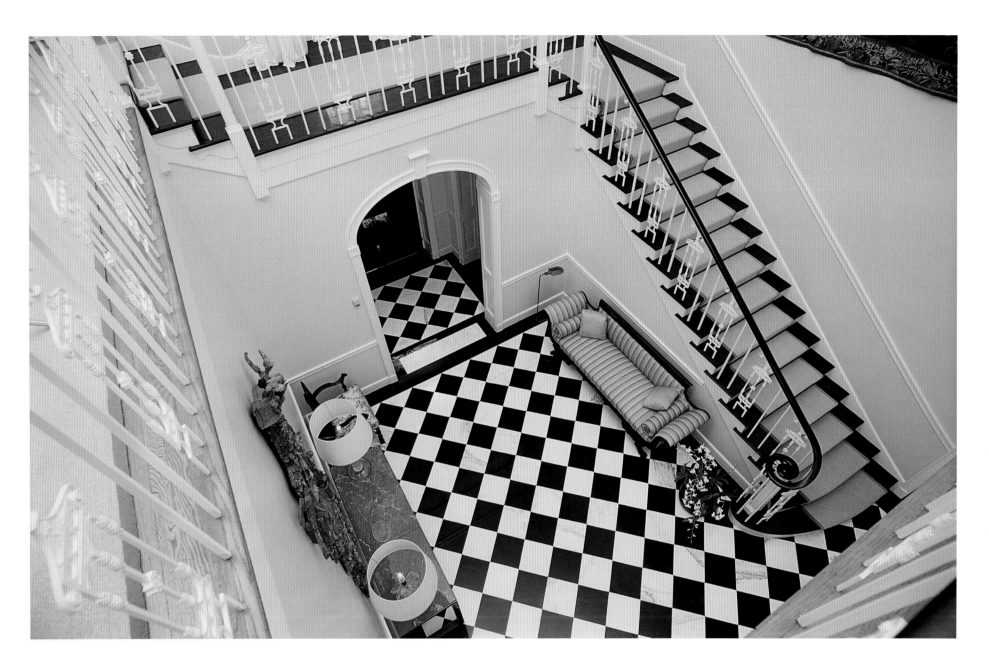

ABOVE The restored entrance hall contrasts the original diamond pattern floor with a sun-burst of yellow walls. The staircase railings and landings seen from above provide an intricate pattern.

LEFT Original furniture displayed in the entrance hall of the Swanson home before its sale. The original colors were severe tones of grey and white. When the home changed hands in the 1960s many pieces of original furniture, like this Empire couch, were part of the sale and have remained with the house.

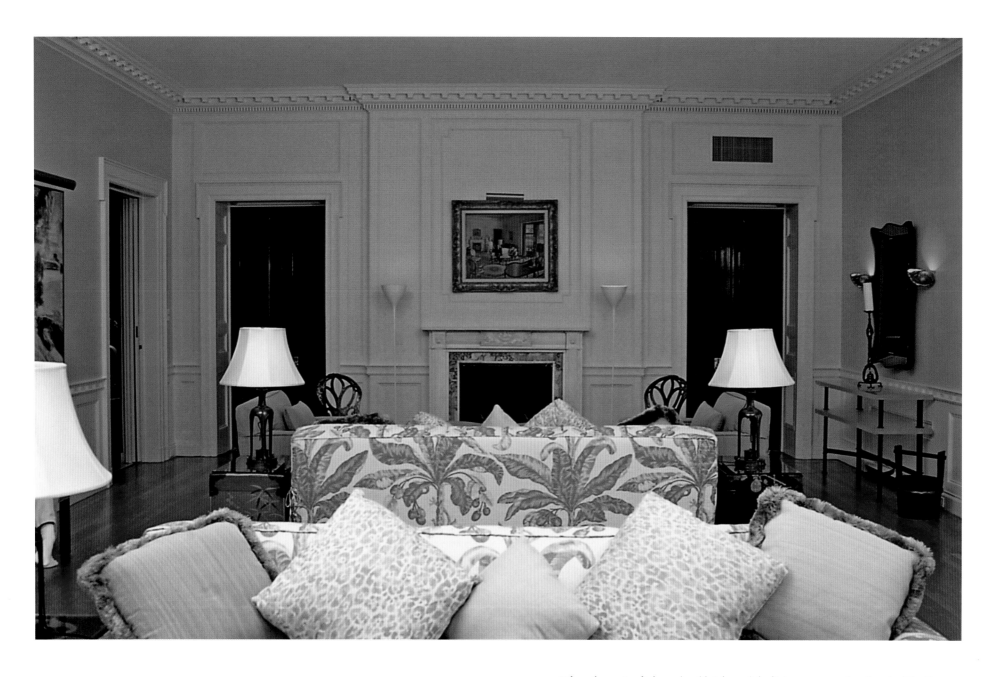

ABOVE The redecoration lightened and brightened the living room to relate it to its Florida setting. A Schumacher pattern was used on the sofa.

OPPOSITE TOP After the restoration the formal dining room displays a reproduction of the original wallpaper re-created in a slightly different shade.

OPPOSITE RIGHT A historical photograph of the dining room shows original furniture and wallpaper.

OPPOSITE FAR RIGHT A detail of the dining room wallpaper frames the view toward the living room. In the restoration, all the walls in the house were re-plastered and repainted. When work began some walls were found to be insulated with a layer of old newspapers.

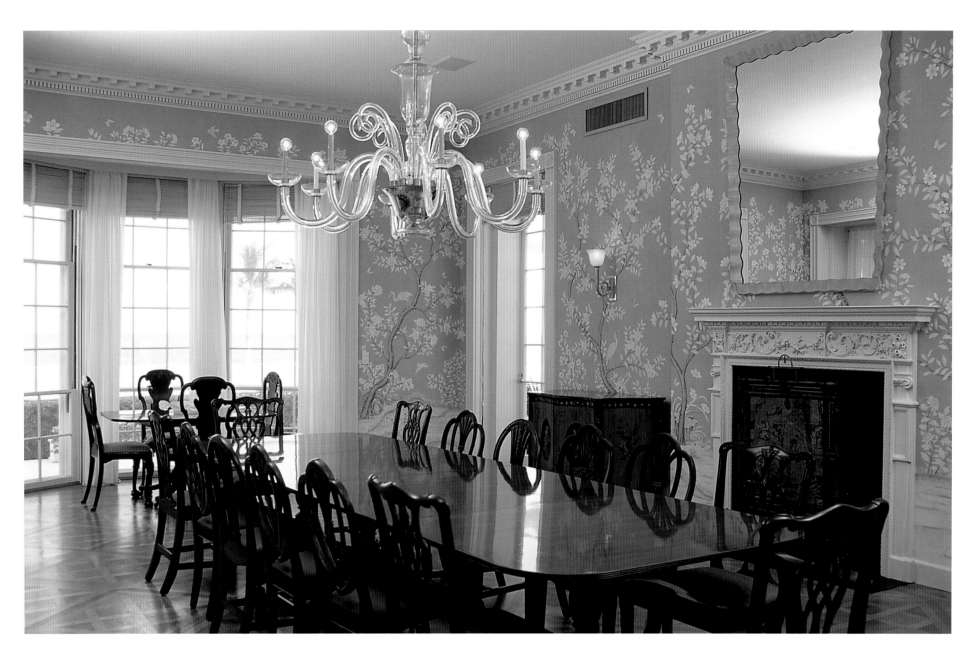

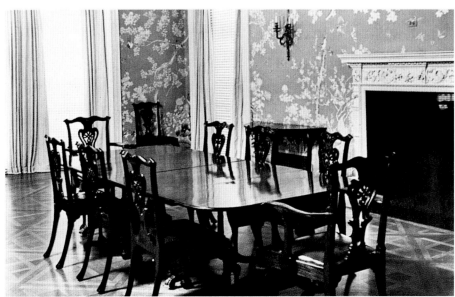

189

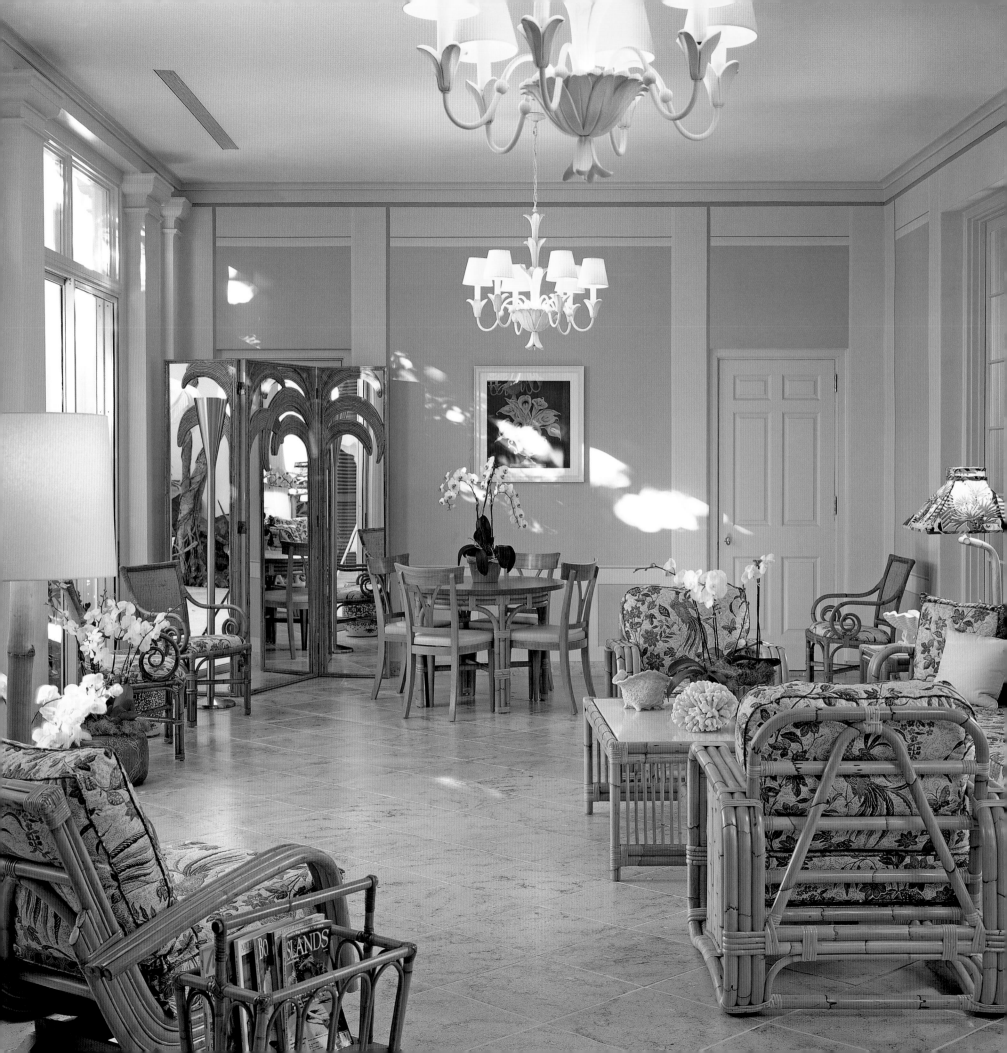

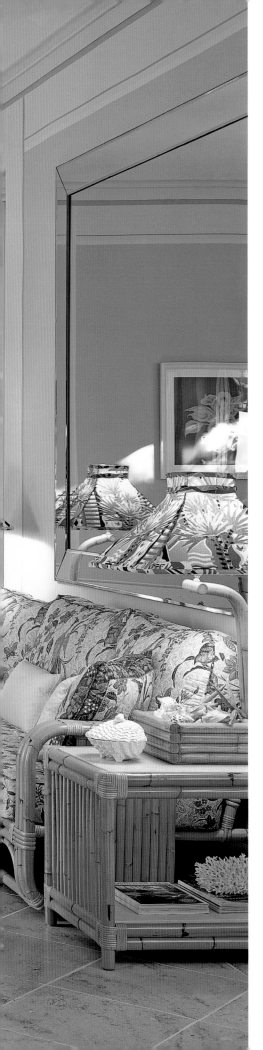

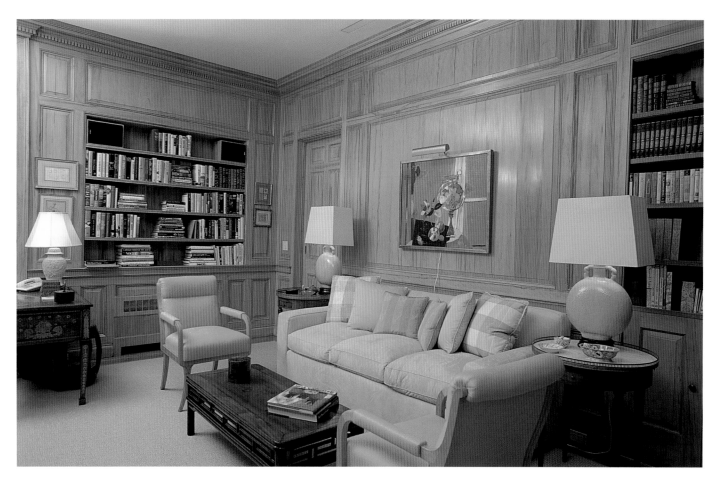

OPPOSITE *An upstairs loggia recalls a traditional 1930s Florida room.*

ABOVE *In the library original cypress paneling was cleaned and lightened. The simplicity of a sisal carpet complements Manuel Canoras fabric, Robsjohn-Gibbings chairs, and Lee Jofa fabric on the sofa.*

BELOW *The bamboo furniture in the loggia designed by Thad Hayes suggests traditional Florida furniture of the 1930s. The fabric is by Brunschweig and Fils.*

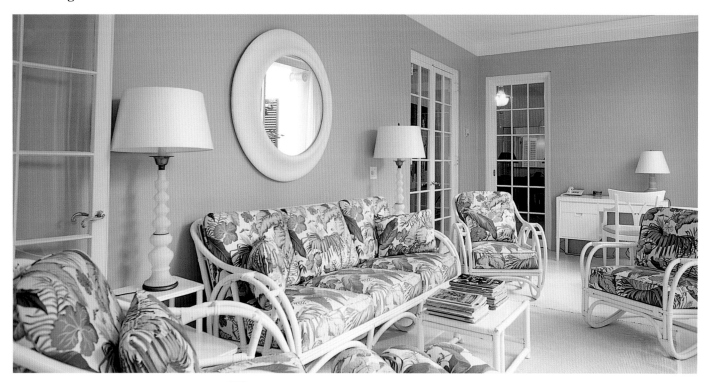

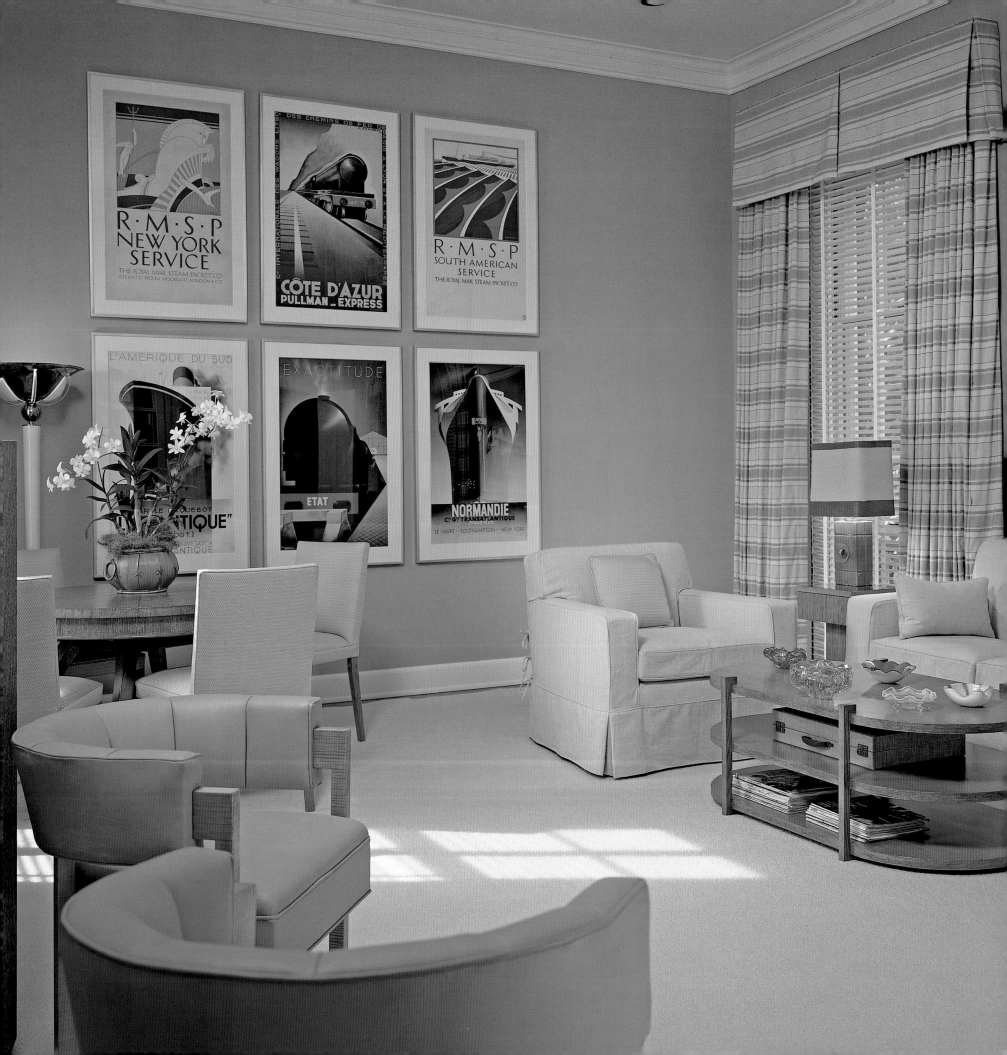

OPPOSITE *Modern posters and relaxed furniture underline the owners commitment to provide a relaxed life style.*

RIGHT *The details combine to create the perfect period bathroom. In many of the baths 1930s Crane fixtures were refurbished and reused.*

BELOW RIGHT *Period wallpaper and a mirrored chest decorate a bath.*

BELOW LEFT *Small details add charm to the bathroom displays.*

ABOVE *The original kitchen fixtures, a six-door refrigerator and a six-burner stove, were all restored for modern use. The stove alone took over a year to repair.*

OPPOSITE *The restoration added a new room for family dining which opens to the kitchen and links the home to its oceanfront surroundings.*

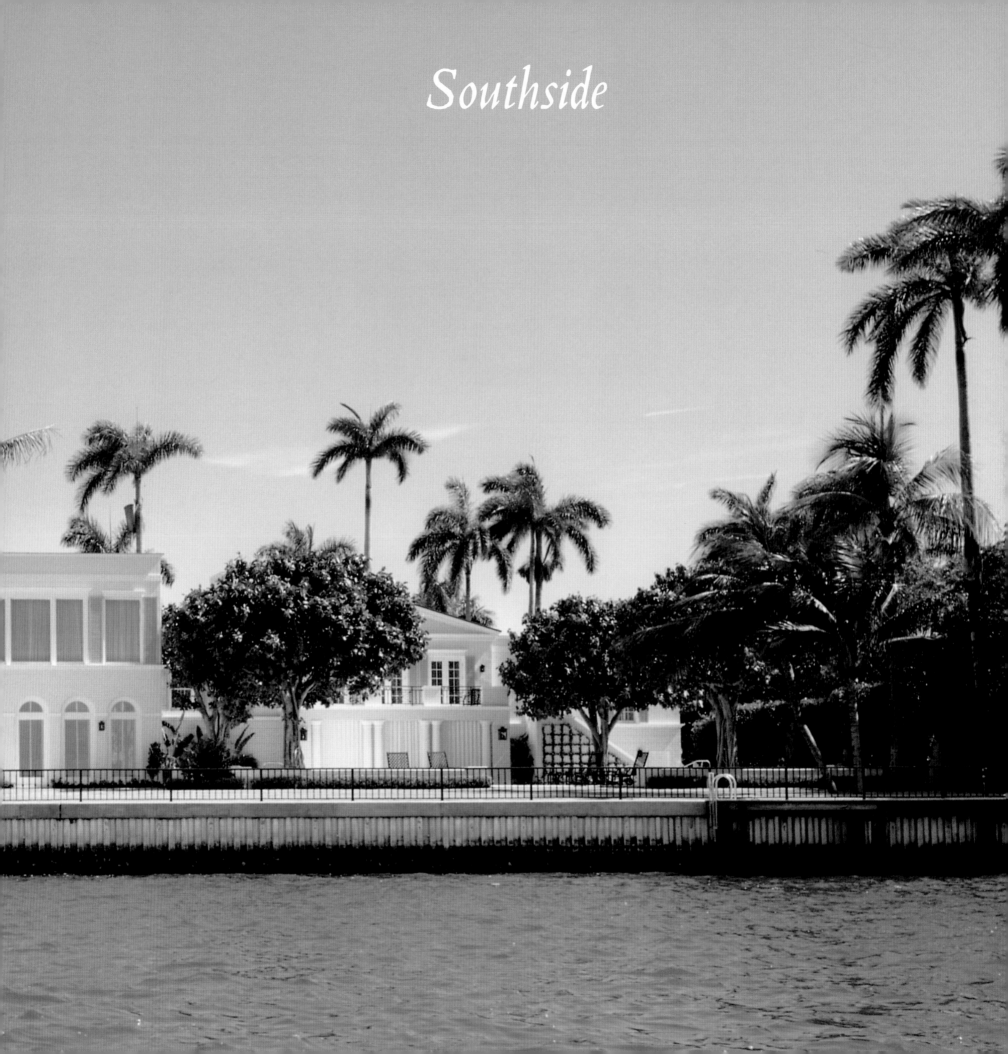

Southside

In 2000 the restoration of a fine older home allowed the Preservation Foundation the opportunity to recognize an architect hitherto largely unmentioned in the history of Palm Beach's architectural development. Along with the town's six early eminent architects, Mizner, Urban, Wyeth, Fatio, Volk, and Major who established their reputations in the 1920s, Palm Beach's architectural heritage owes a significant debt to architects such as Henry Harding, Belford Shoumate, and Clarence Mack. These architects' designs began to be influential in the 1930s. Although the 30s decade is often cited as a time of quiet architecture, a time of avoidance of architectural excess in recognition of troubled economic times, Clarence Mack's neoclassical designs yielded nothing to earlier Palm Beach mansions in their elegance and grandeur.

Mack, who lacked professional training as an architect, grew up and practiced in Cleveland where he designed homes for Midwestern industrial leaders. He moved to Palm Beach in 1935 after the 1929 stock market crash. Like other Palm Beach architects he was heavily influenced by his travels in France and England. In Palm Beach he designed homes in classical styles from Regency to Georgian to British West Indies. His synthesis of classical elements in a Florida setting has been variously called "Tropical Empire," "Caribbean Georgian," or "Palm Beach Regency."

Southside, 1936, owned by Jesse and Rand Araskog, was both restored and recreated from the architecturally compatible changes included in the restoration. Southside is sited on a very special tongue of land with a lake view that faces south. On this location Mack designed no less than five large homes that clearly demonstrated his taste for monumental neoclassical design, yet each home maintained its distinct individuality. At Southside, as the restoration evolved to meet the needs of its new owners, a sensitive interplay developed between Mack's historical classicism and its modern interpretation at the hands of Scott Snyder of Scott Snyder Inc. and his architectural designer, Virginia Dominicis.

Mack's original classic conception was strongly established through restrained classic detailing. These details were restored and repeated on an extended new wing. This elaboration and enhancement of the original themes links the historic wing to the new. Snyder planned, and the restoration contractor, Livingston Builders, executed a near doubling of the size of the house by expanding the loggia on the east side while maintaining its essential classical proportions and detailing. The restoration also called for a second-floor bedroom addition. George Sanchez and Phil Maddux provided landscaping that supported, but never intruded on, the classic architecture.

Southside is a home that brings its architecture inside. Throughout the spacious living room, architectural details set a tone of calm and restraint. Using the same pediment as the living room, the dining room was conceived as a period room, but with the enhancement of Chinese Chippendale fretwork that sets off the original fireplace, period furnishings, delicate wallpaper, and an original George III chandelier. The exacting standards of the restoration required that all the original wood floors be taken up and replaced to accommodate modern air conditioning. The air conditioning was vented under the house so none of the ceiling or wall architectural details would be marred by vents.

In the conservatory, or breakfast room, the challenge was the original ceiling, which was addressed with a new vaulted ceiling. On the exterior the solution was a bright new copper roof. The existing arches along the courtyard wall provided a discipline of repeating forms for the room.

At the other end of the house, the expanded loggia repeats the same pilaster design as the conservatory but in stone rather than wood. In this area of new construction, walls could be increased in depth to provide pocket spaces for twenty-first-century blinds. As it did historically, beyond the enclosed area, the open loggia reveals an expansive view of pool and terrace.

Perhaps most troublesome in the task of designing the perfect resolution of new and old was the question of elevation. Working outside the flexibility of the Mediterranean Revival style, in which extravagant details may hide construction difficulties, the challenge of classicism leaves no easy concealment for unresolved problems. For example, at Southside the ground slopes down from the lakeside to the street. Since Clarence Mack typically designed his homes using mezzanine levels, there were several floor levels within the interior. Thus, to deal with changing levels on both the exterior and the interior, all the windows had to be realigned on the exterior. To unify the original house and the old carriage house, the new connecting area logically became a family access. Inside, different levels provided new opportunities. The new billiard room was placed in the old garage. The new stairway provided a location for fanciful decoration with palms and shells as well as access to guest rooms at different levels.

Southside remains a home of air and light. Framed by its powerful southern landscape, its grandeur is tempered by openness. Despite the alteration and addition of interior spaces, Southside maintains its classic serenity.

PREVIOUS PAGES Southside's lakefront facade is unified by its strong horizontal massing. Yet the facade is never static but is punctuated with rectangular and arched window groupings.
OPPOSITE The dining room's architectural detailing maintains the symmetry and sense of scale evident throughout Southside. The table is by Wood and Hogan. Drapery trim is from Clarence House. Chair fabric is by Manuel Canovas.
TOP A portion of the guest wing added in the restoration uses arches on the first floor instead of the paired windows that dominate on the original facade. It functions as a family entrance to the new wing.

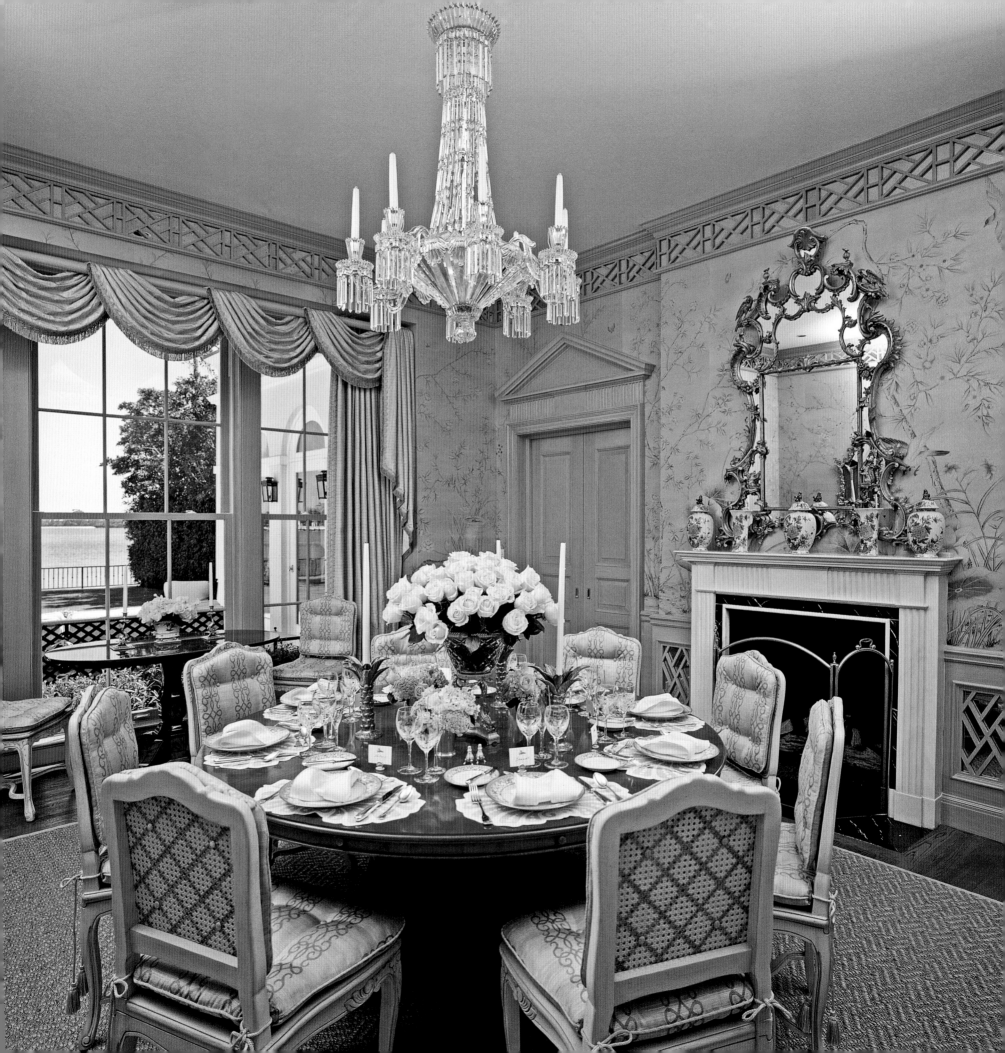

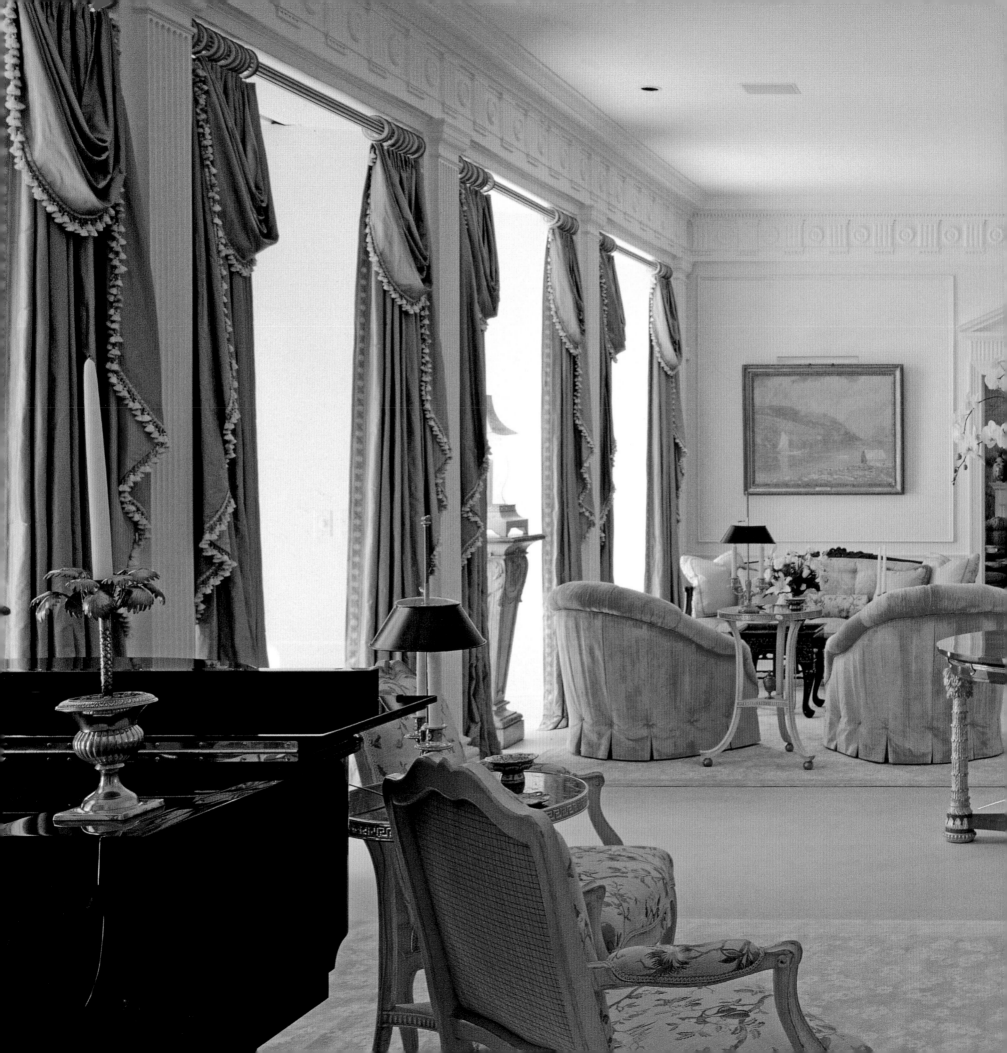

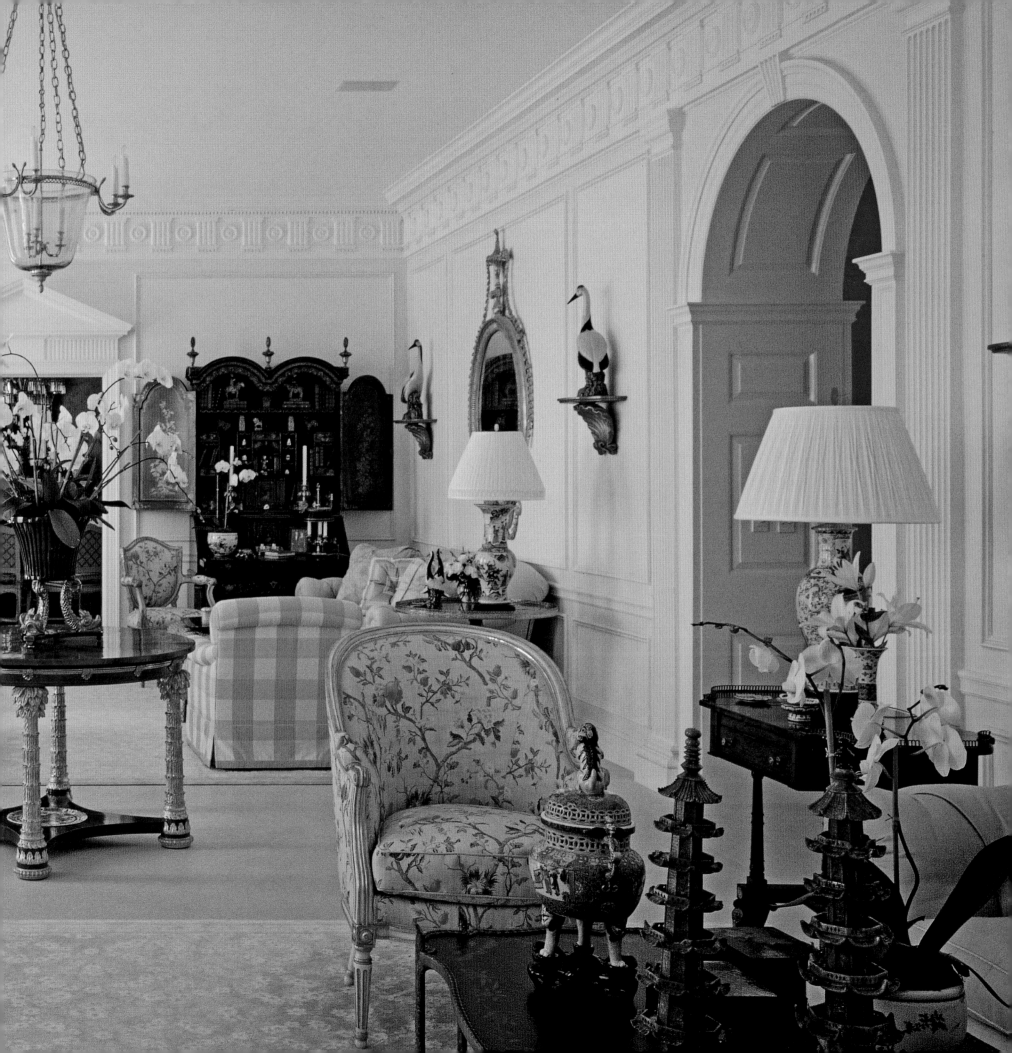

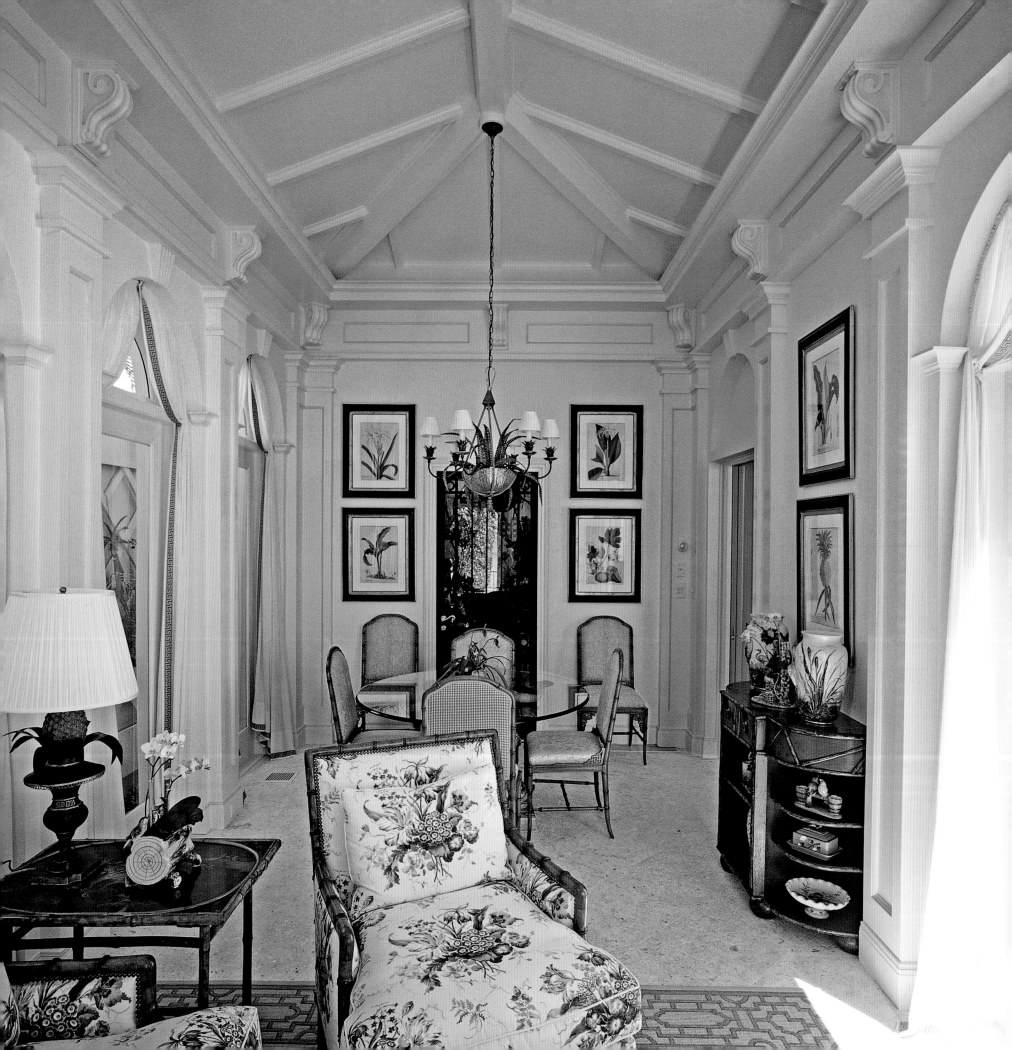

PREVIOUS PAGES *Shades of blue and apricot predominate in the living room with an early nineteenth-century German center table whose palm foliate legs provide a decorative theme for the room. The secretary is an English antique. A dolphin-footed English antique planter holds an orchid.*

OPPOSITE *In the conservatory, part of the original house, a constricting nine foot ceiling was transformed into a vaulted ceiling.*

ABOVE *A former garage area provided space for a new billiard room.*
ABOVE LEFT *The "Paradiso Indiano" wall fabric in the billiard room by Fonthill, Limited.*

BELOW *A new stairway accesses the guest wing. Its curved form transforms a standard access into another statement of classical balance and proportion.*
BELOW LEFT *The graceful lines of the new stairway complement a delicate wall decor of orchid botanicals.*

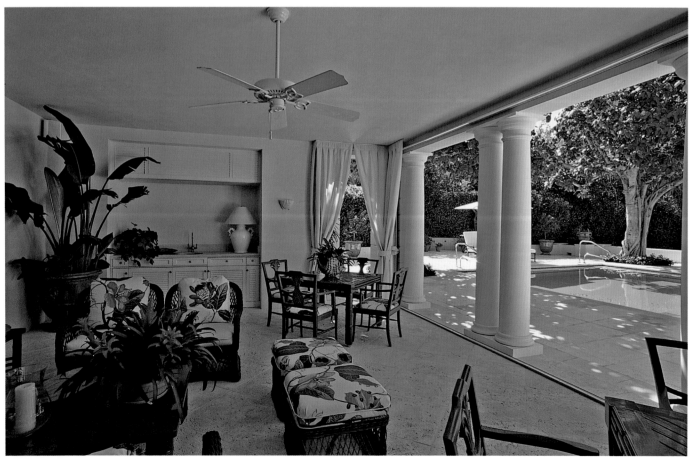

TOP LEFT The new enclosed loggia relies on stone rather than wood detailing and provides expansive views of the pool and Lake Worth.

BOTTOM LEFT The open loggia provides an outdoor area adapted to a Florida lifestyle.

OPPOSITE The lakeside loggia, which looks south, is a dominant feature of the water side of the home. As part of the restoration project, the original loggia was expanded using typical classical details.

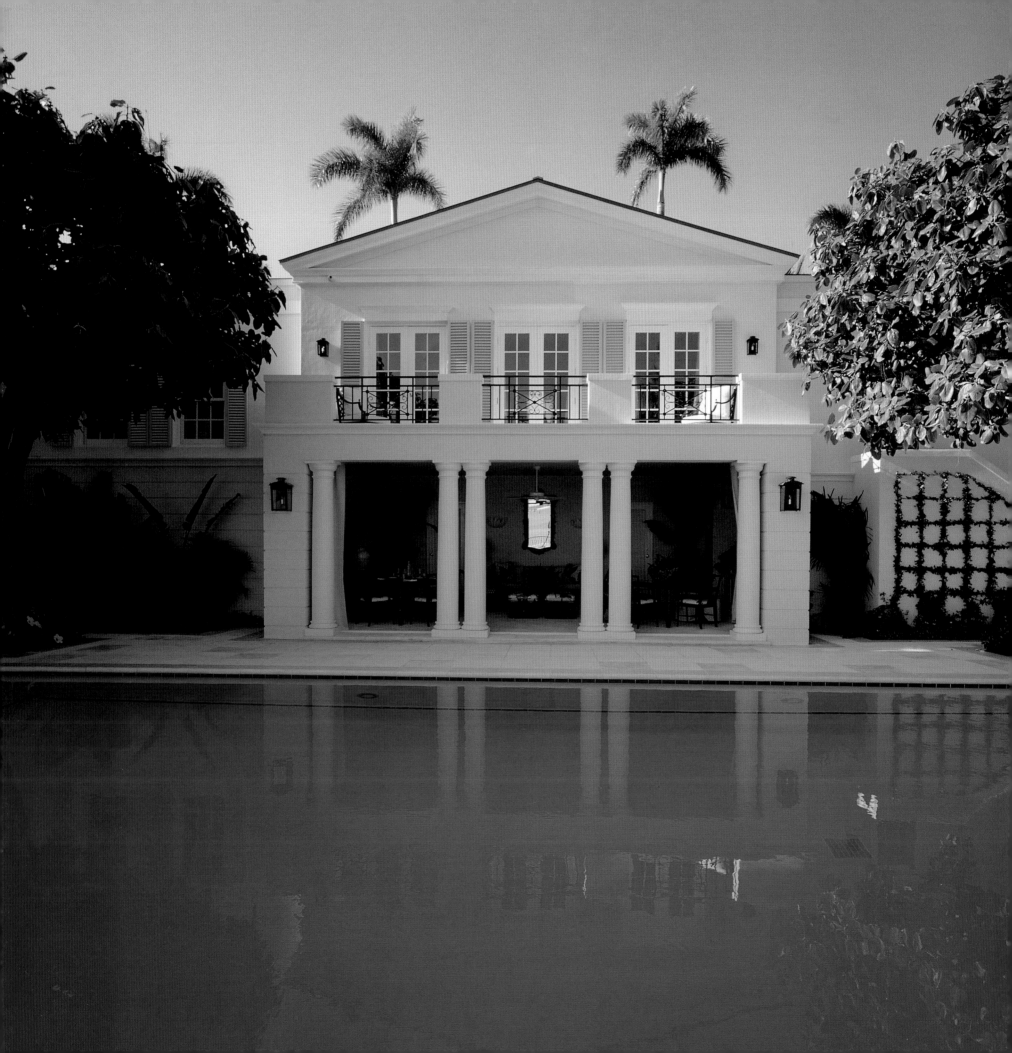

OPPOSITE Clarence Mack's original entrance was executed in a restrained classical style with a Doric columned portico and a fanlight over the door. A classical pediment interrupted the line of the roof to emphasize the doorway. The restoration maintained the original classical design of the front facade and entrance.

ABOVE The repeating theme of paired windows with shutters on the first and second floor elevations provides continuity and discipline to the facade. A continuous string course marks the transition between the two floors. Laurel trees line the front drive.

LEFT An arch with a keystone provided a niche for a classical urn and linked the original house with the new section of the front facade, which was added in the restoration.

FOLLOWING PAGES Southside viewed from the lake presents a strong horizontal orientation balanced by the new second-floor addition for the master bedroom suite in the center. The pool umbrella fabric is from Giati. Scott Snyder designed the pool furniture.

Las Palmas

Ballinger Award homes come in all styles and sizes. Some have undergone significant expansion as part of their restoration. And some, like the 2001 Award to Las Palmas, the home of Suzanne and Robert Wright, are a study in subtlety, a subtlety that restores and preserves and introduces changes without altering the personality – the character – of the original design. Las Palmas is this kind of discreetly tempered restoration.

Las Palmas was built in 1940, although its architect, John Volk, began its design in 1938 for Sam Harris, a Broadway producer of great renown. Harris was at the center of a group of gifted Palm Beachers who enriched the culture and society of the town with their intimate ties to the Broadway stage and to Hollywood productions. Harris was George M. Cohan's partner and with Cohan controlled no less than seven Broadway theaters and produced over eighteen Broadway musicals from 1904 to 1919. After Cohan's retirement, Harris partnered with Irving Berlin, with whom he co-owned the Music Box Theater; with the Marx Brothers with whom he produced *Animal Crackers*; and later with Cole Porter, Moss Hart, and Rogers and Hammerstein.

Throughout his long and eminently successful career, Harris produced some of the music that, in the view of one biographer, helped define American musical comedy. Harris's and Cohan's music from the World War I era, "I'm A Yankee Doodle Dandy," "It's A Grand Old Flag," and "Over There" – still rings in our ears as a patriotic part of our heritage. During the Great Depression, Harris produced plays that lifted America's spirits such as *You Can't Take It With You,* which had a run of eight hundred thirty-seven performances and was consistently produced for fifty-eight years at every level of the theater from high schools to a Hollywood movie.

In the 20s and 30s Harris and his wife were living in a Mediterranean Revival home. How remarkable that with all Harris's immersion in stage craft and the magnificent illusion of Broadway, he settled into a new home marked by John Volk's trademark classical calm and elegance instead of a dramatic Mediterranean Revival mansion. Theatrical ties ran strong with Volk too. His very first commission in Larchmont, New York, was for Edward Albee Sr., grandfather of the playwright.

OPPOSITE Las Palmas's front facade relies on balance and classical organization. A half-balcony extends over the front door. The mass of the house is disguised by landscaping.
ABOVE A peacock is part of a hand-painted dining room mural by Marc Beauregard.

When Volk designed Palm Beach's own theater center, the Royal Poinciana Playhouse in 1957, he turned again to the dignity and ordered rules of a classical style, instead of a more evocative and emotional Mediterranean style.

Perhaps the classical restraint of Las Palmas offered a balance and an enclave of calm for owners immersed in a world of theatricality? Perhaps people bombarded by the flamboyance of the world of entertainment are sometimes drawn to the stability of a classical heritage? Coincidentally, like Sam Harris, Suzanne and Robert Wright are distinctly a part of the special nexus of entertainment and communications through Robert Wright's position at NBC, where he is now Chairman and CEO and Vice Chairman of General Electric.

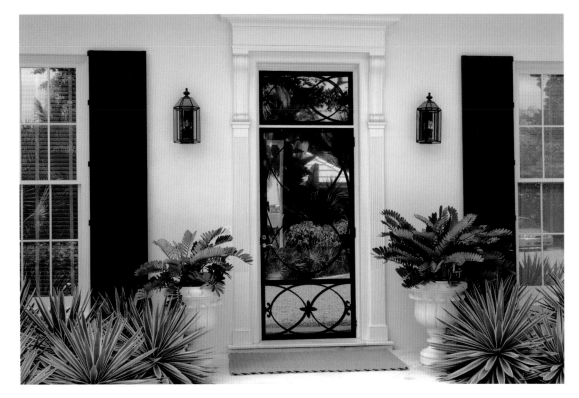

The Harris house occupied a fabulous lakefront location on the far north end of the island. Today its setting is enhanced by the splendid palms that suggested its modern name. The Wrights' intent was always to preserve Las Palmas in its massing and scale while changing its interior arrangements to accommodate modern, active Florida family life. With their architect, Gwynne Thorsen, and Worth Builders of Palm Beach, the Wrights adapted many areas of the original home to meet this goal. But the original footprint of Las Palmas was not changed. Walls were reframed, windows were replaced, but in Thorsen's words "the wonderful bones" of the house were kept.

In its first incarnation as the Harris home, Volk's late Georgian architectural design was complemented by a federal decor, designed by Dorothy Hammerstein, of the theatrical Hammerstein family. With the help of Leslie Heiden of Heiden Designs in New York City, Suzanne Wright transformed the severity of the original federal decor into an easy informality. Elegant chinoiserie pieces were added to accent and complement a collection of Chinese Trade paintings. Throughout the

main rooms, Volk's original pocket doors were retained. As a result the rooms stand wide open to each other. In the living room, as in all the main rooms, Volk's design extends the interior to reach out toward the lake and the Florida surroundings.

The restoration transformed the original dining room, pantry, and back stair into a spacious family room joined to an open kitchen and informal dining area which expand the feeling of living with the out-of-doors. The formal dining room carries on the themes of the other main rooms, with shells elegantly displayed. An exotic touch is the delicate faux chinoiserie mural, hand painted by Marc Beauregard, with a peacock for one of its figures. In the entrance and hall the original marble was preserved, and one of Volk's elegant staircases rises to the second floor with a simple grace note of another peacock displayed on the window ledge.

Staff quarters, cramped bedrooms, and a utility stair were eliminated to create a spacious master suite on the second floor. The suite includes an exercise area, the master bedroom decorated in tones of yellow and gold, and the beautifully conceived walnut-paneled library. The second-floor guest suite had its ceiling raised and received an interior tray ceiling treatment as did other second-floor rooms.

Volk's careful details remain on the lake exterior where an upstairs loggia overlooks the lake, the pool, and the dock. When Volk added the pool in the early 40s it was remarkable for state-of-the-art pumping machinery that filled it in thirty minutes with salt water from the incoming tide. A special accent is the pool-side cabana, which had French doors added in the restoration. The cabana, like the guesthouse, is furnished with nautical accents of model ships and hulls, a telescope, Nantucket baskets, and a glorious teak and holly floor.

Las Palmas' landscape plan, which was created by Michael Levine, frames the house and outbuildings in a tropical setting. The plan includes thirty-two species of palms and emphasizes a variety of tropical shrubs instead of areas of grass.

Before its restoration Las Palmas had received a death sentence. It had been shown to the Wrights with the proverbial realtors' curse, "this is a tear down!" The Wrights defied the conventional wisdom that it is easier and more satisfactory to tear down and rebuild. Like the other recipients of the Preservation Foundation's Ballinger Award, Las Palmas demonstrates the enduring value of outstanding architecture, especially when it is sensitively restored and adapted to modern tastes.

ABOVE Iron grillwork in a graceful restrained design decorates the front door at Las Palmas.
OPPOSITE TOP RIGHT The simple guest house is framed by massed plantings. Two octagonal windows balance the entry.
OPPOSITE RIGHT Detail of plantings and gate.
OPPOSITE LEFT Plantings and palms screen the guest house from the main residence.

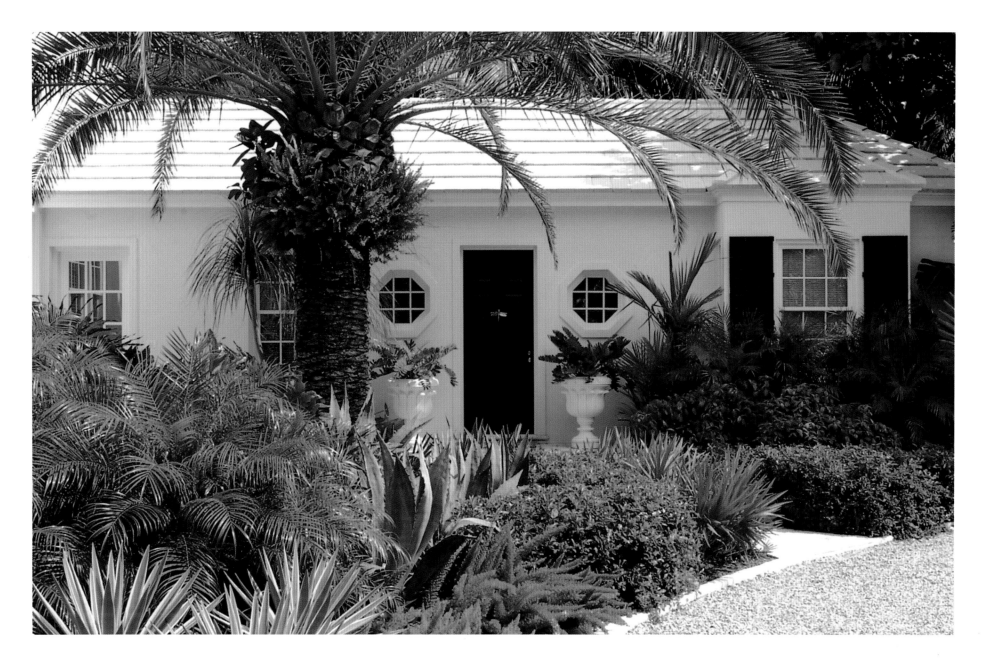

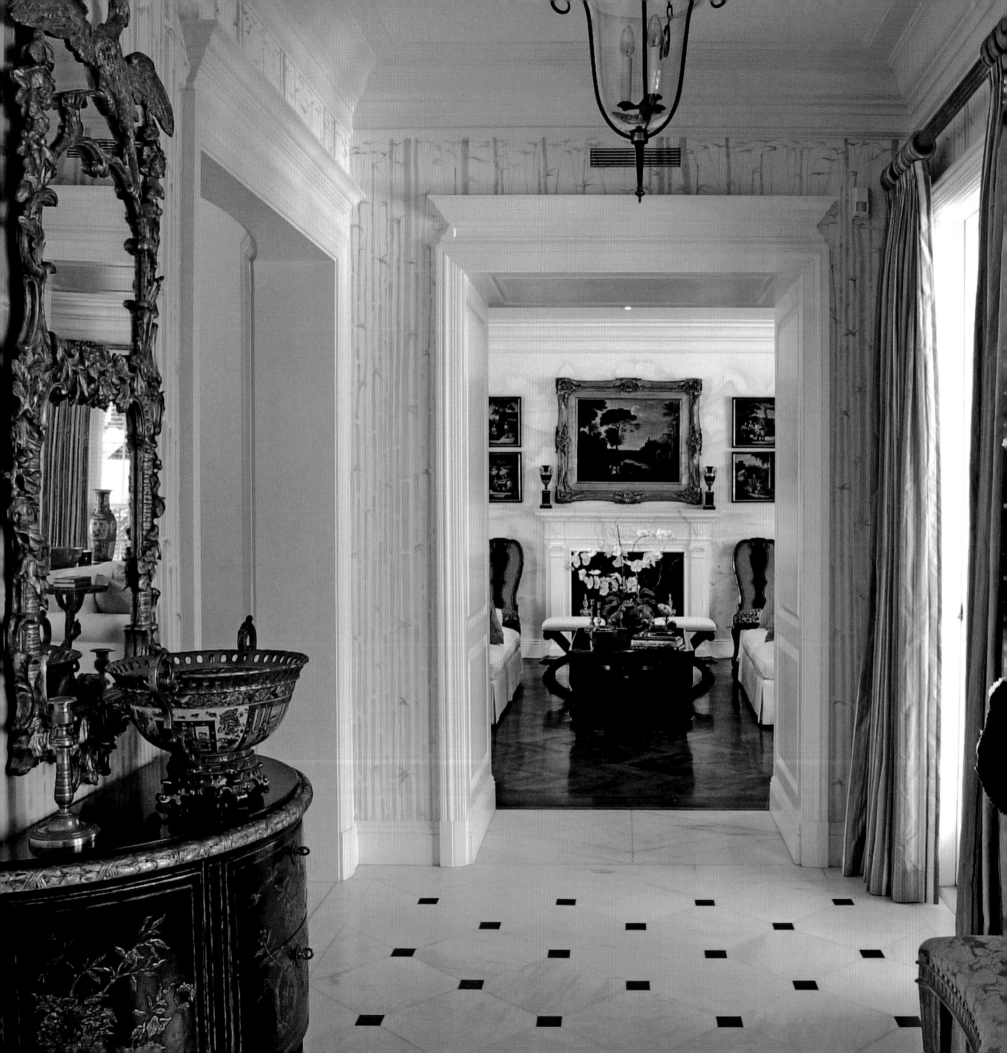

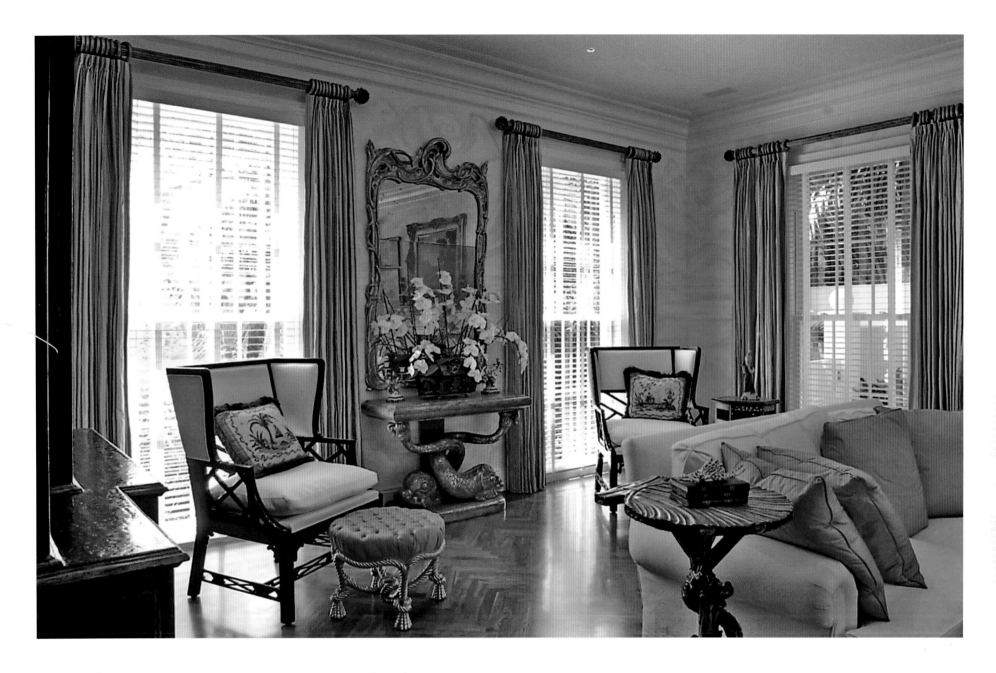

OPPOSITE *A view through the entrance hall toward the living room shows the easy informality of Las Palmas's modern interior design. Volk's original pocket doors maintain the open flow between rooms.*

ABOVE *Tall windows in the living room emphasize the openness of the room. The drapery fabric is by Christopher Norman.*

RIGHT *Suzanne Wright's collection of shells is displayed in the family room. A shell-encrusted table adds interest to the decor.*

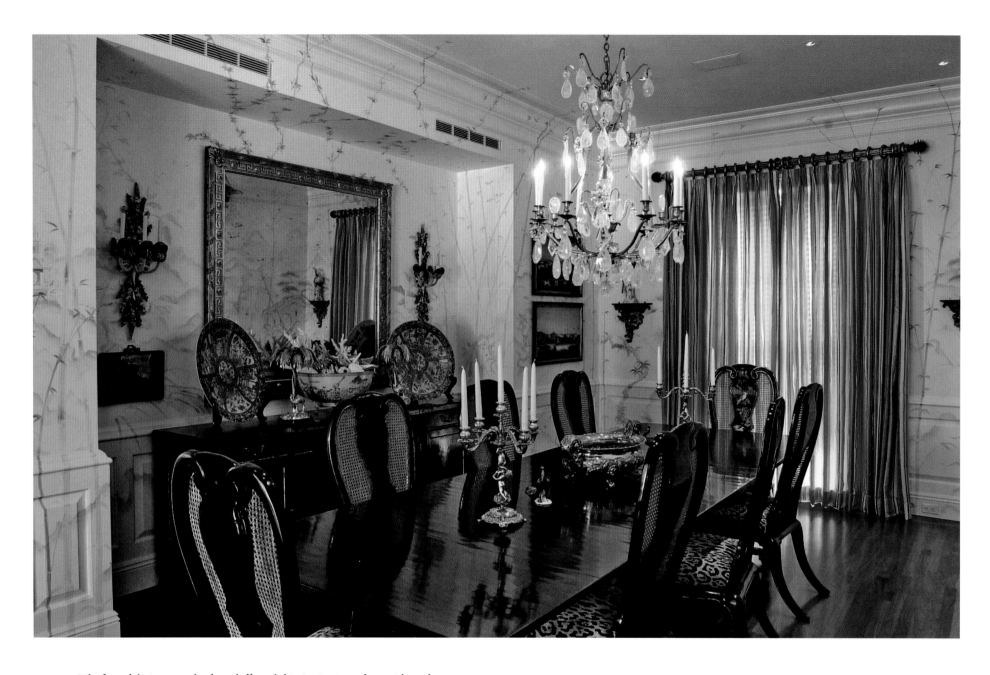

ABOVE *The formal dining room displays shells and chinoiserie pieces along with an elegant chandelier. The leopard-print chair fabric is by Clarence House.*

RIGHT *The hand painted dining room mural is by Marc Beauregard.*

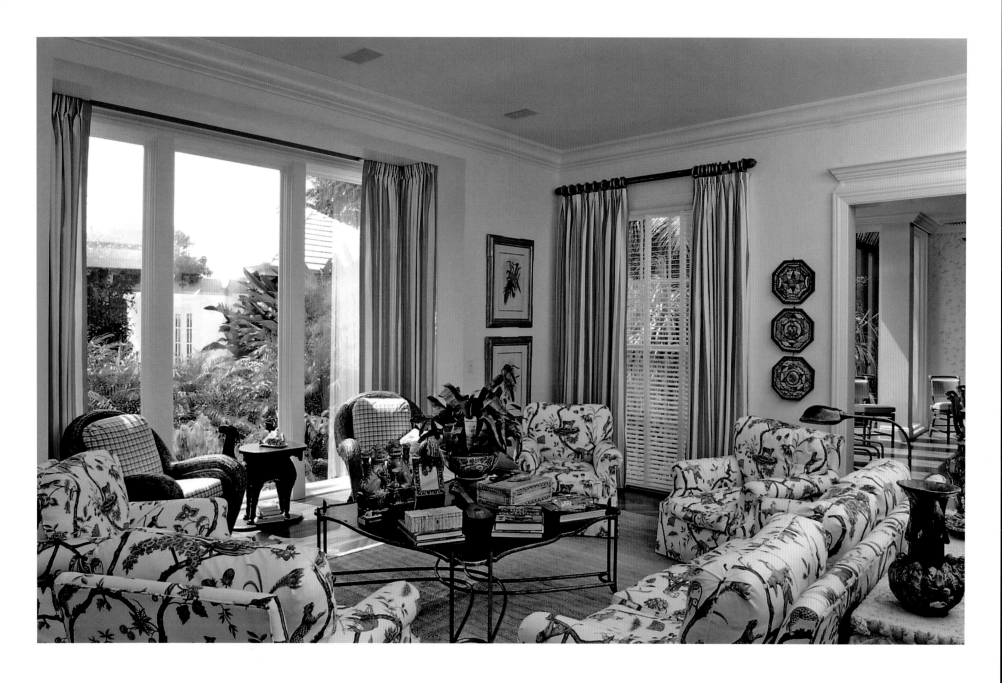

ABOVE *The family room opens out to the pool and patio. The octagonal frames hold a collection of "sailors' valentines," a Nantucket tradition of shell plaques created by sailors at sea for their loved ones at home.*

RIGHT *The family wing includes an informal dining area.*

ABOVE AND LEFT *Changes on the second floor allowed the space to be reorganized to include a handsome walnut paneled library as part of the master bedroom suite. The library also functions as an office and media room.*

OPPOSITE TOP *The guest house relies on a nautical theme in its decoration with a glass top dory serving as a coffee table.*

OPPOSITE BOTTOM LEFT *The pool-side cabana is furnished with nautical accents to reflect the Wrights' interest in boating. Framed sailor's valentines encrusted in shells hang on the cabana's walls.*

OPPOSITE BOTTOM RIGHT *The floor of the cabana is made from an array of rare woods.*

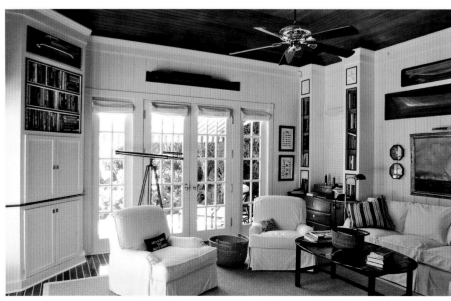

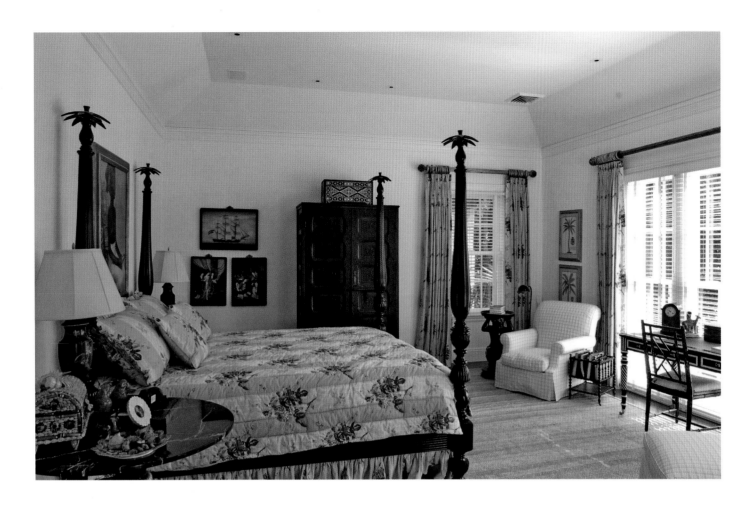

OPPOSITE TOP *John Volk's graceful curved staircases were one of his signature architectural details.*
OPPOSITE BOTTOM LEFT *Detail of peacock in a stairway niche.*
OPPOSITE BOTTOM RIGHT *An elaborate oriental pagoda provides a contrast to the simple lines of the stairway.*

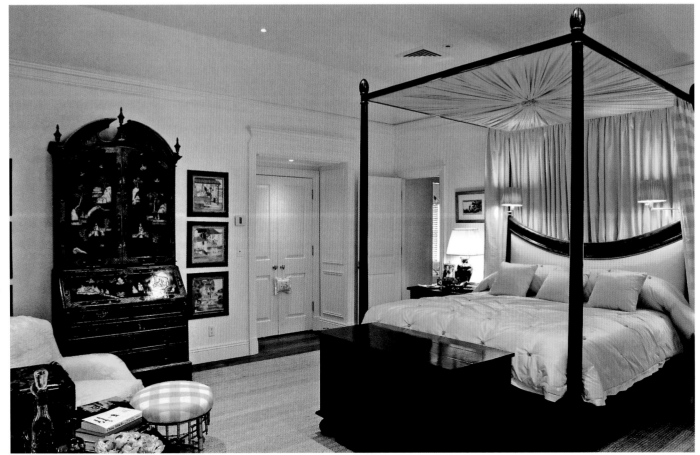

ABOVE *Detail of the pineapple finial bed.*
TOP LEFT *Tray ceilings expand the volume of the upstairs bedrooms.*
BOTTOM LEFT *A chinoiserie piece provides a focal point in an upstairs bedroom with a canopy bed.*

Las Campanas

Las Campanas, the 1922 Marion Sims Wyeth house which received the 2002 Ballinger Award, has the distinction of being the only Ballinger Award home to be divided in half. As originally designed by Wyeth, this Mediterranean Revival home was joined to its neighboring Wyeth-designed home to the east. In 1949 the two homes were divided by a party wall.

After Paris Singer and Addison Mizner captured the interest of Palm Beach society with their successful launch of the Everglades Club in 1918, Singer formed a development company to build homes adjacent to the club property. In this speculative endeavor he was joined by the architect, Marion Sims Wyeth, who was just beginning his long and successful career in Palm Beach. In 1922, when Las Campanas was built for the New York stockbroker Jay F. Carlisle, Wyeth was the president of the newly-formed development company.

In 1923 and 1927 additions were made to Las Campanas. In particular the 1927 addition, also designed by Wyeth, added loggias, terraced gardens, tiled floors, and stone decoration. The bell tower or campana of the original house, from which our Ballinger Award home derived its name, was however a part of the eastern extension of the structure, which was separated from the house that retained the name in 1949.

Cathy and Irving Bailey, who purchased Las Campanas in 2000, acquired an outstanding example of Wyeth's early work in the Mediterranean Revival style. With the help of Scott Snyder of Scott Snyder, Inc., and his project architect, Virginia Dominicis, the Baileys accomplished an equally outstanding restoration.

The major changes in the restoration focused on adapting the center of the house to improve access and light to a reconfigured second story. Although local zoning regulations limited its height, a solution was found by adding a stair tower with clerestory windows that opened the center of the home to natural light. Las Campanas's trefoil-arched loggia windows were protected by the device of adding a second layer of glass and columns on the exterior. The enclosed pool area was redesigned with landscaping by Mario Nievera.

Wyeth designed an entrance for Las Campanas that was modest by the 1920s standard of dramatic Mediterranean Revival architecture. Located on a gable end of the house, the entrance, except for its cast stone crest with the name of the house, seems almost an afterthought. In the interior architectural and decorative appointments, however, Wyeth provided all the drama associated with the great houses of the 20s in Palm Beach. Behind the almost severe entrance lies a richness of painted ceilings, delicate ironwork, leaded glass windows, and cast stone decoration. The private patio is framed on two sides by arched colonnades. The living room of

Las Campanas rises to a height of twenty-eight feet. It is acknowledged to be one of the finest rooms in any historic Palm Beach home.

The restoration of Las Campanas demonstrates that the process of restoration is flexible. For many aspects of the house, for example the paneled ceilings, exact authenticity was enforced. In some areas, such as the additional door and trefoil-arch that were created to better link the dining room and the outdoor loggia, changes that were additive and repetitive were allowed. In a few areas, like the new stairway, a whole new architectural concept was introduced in order to rectify the damage of unthinking historical changes. When Las Campanas was separated from its neighboring

house it was left with an awkward cramped stair area. A new concept, the stairway with its tower, was needed to provide a volume of space that balanced the spacious volumes of Las Campanas's main rooms.

Under the direction of the Baileys and Scott Snyder, Las Campanas demonstrates that restoration is art, not science. The right solution must be found to harmonize the character of the past with the needs of the future. Yet the restoration must still reflect the discipline of the original. Las Campanas's successful restoration epitomizes the artistry at work in all the Ballinger Award restorations.

OPPOSITE An iron-studded gate provides entry to Las Campanas's pool and patio.
TOP Original ironwork provides a screen from the loggia to the outside.
RIGHT The dignified entry to Las Campanas with its period lighting fixtures conceals the importance of the interior spaces Wyeth provided.

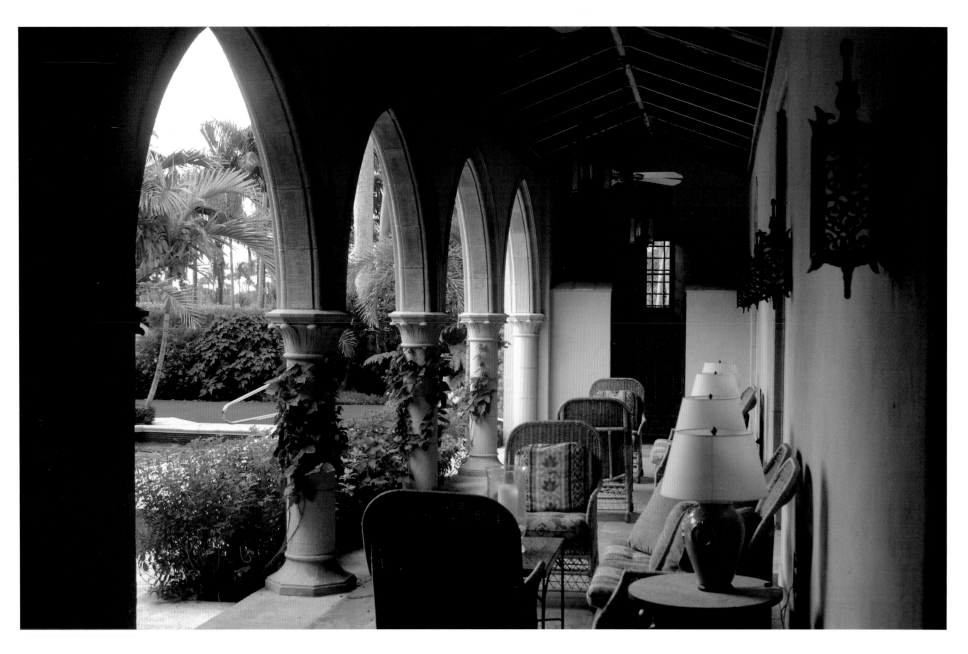

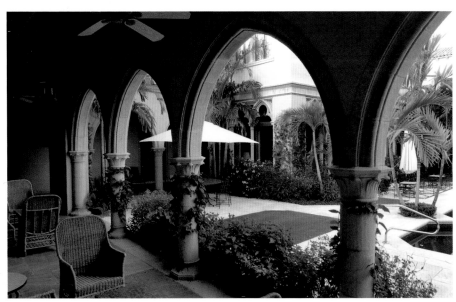

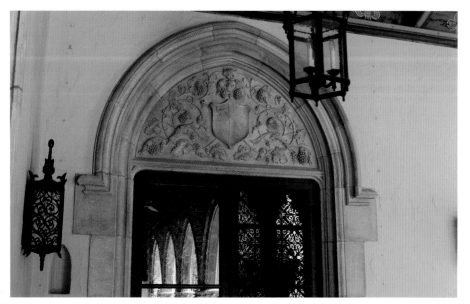

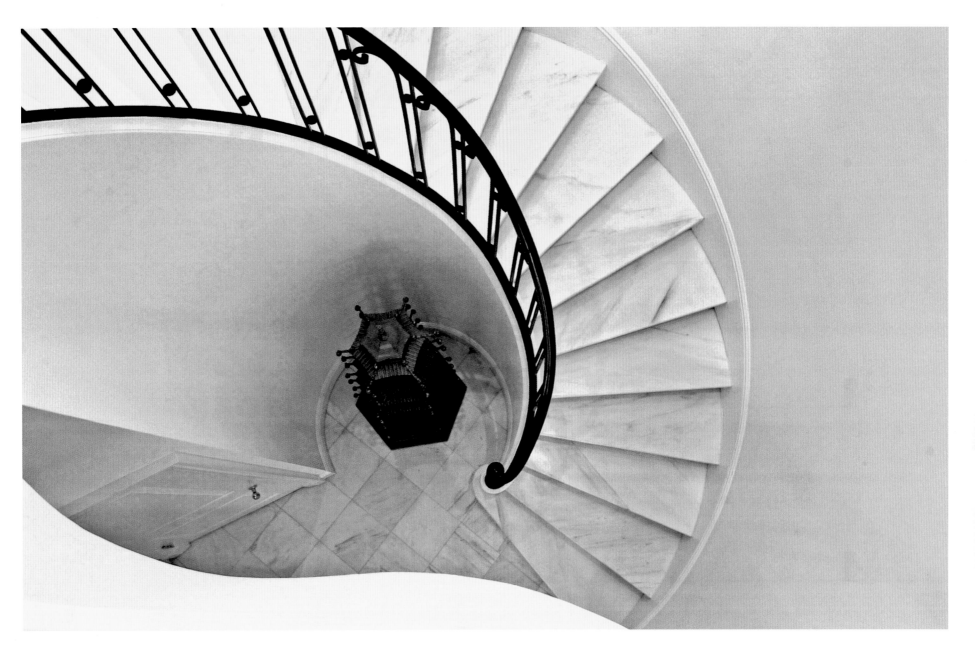

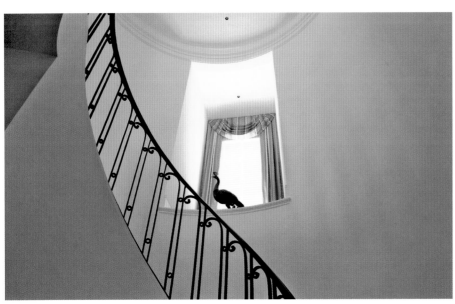

ABOVE *The open upstairs loggia offers both a pool and a lakefront view. A classical railing provides a restrained pattern.*

OPPOSITE *Palms and lush plantings frame the lake facade of Las Palmas. The open first and second floor loggias create a transition between indoor and outdoor spaces.*

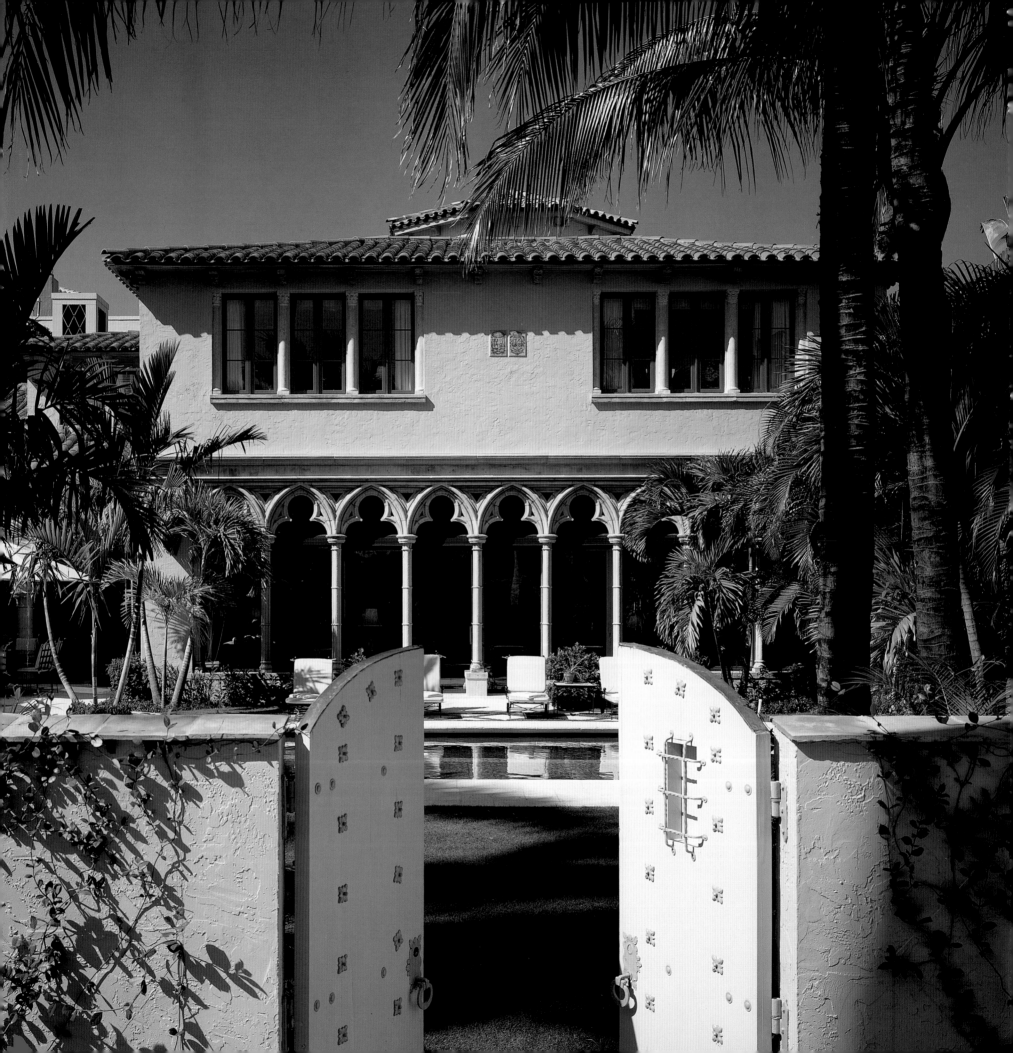

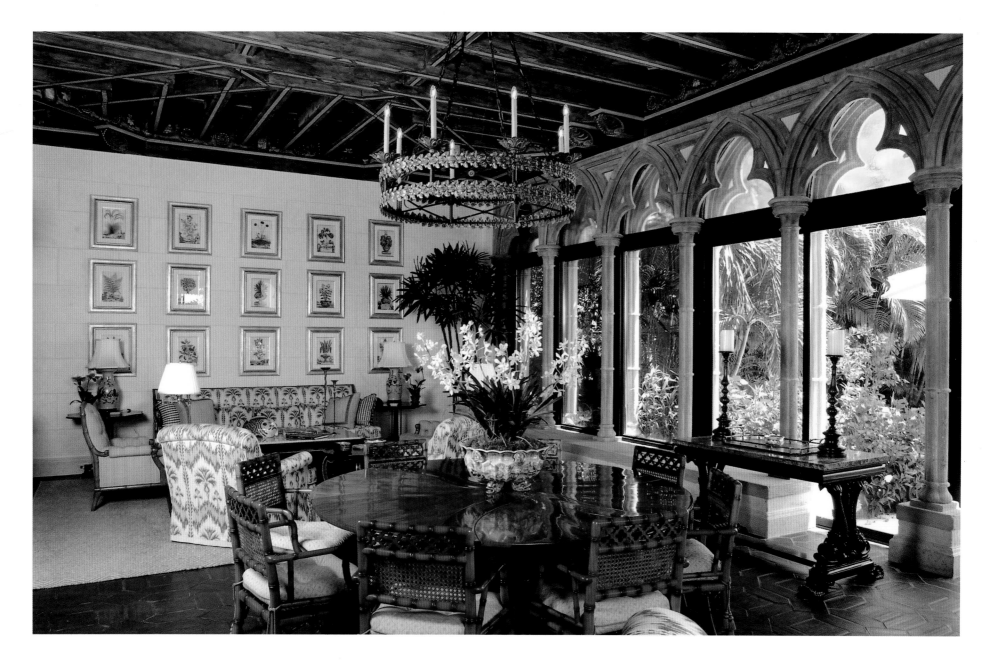

OPPOSITE TOP *The pointed arched columns along the side loggia were carefully restored.*
OPPOSITE BOTTOM LEFT *Pointed arches on the side loggia contrast to the trefoil-arches across the courtyard.*
OPPOSITE BOTTOM RIGHT *An elaborate stone arch decorates a doorway to the loggia.*
ABOVE *The family room, which opens to the courtyard, was decorated with a French antique chandelier and Italian botanical prints. The original painted wood ceiling in the room required only cleaning.*
RIGHT *Cast stone blocks surround a doorway from the loggia to the house.*
FAR RIGHT *Stone details add interest to a door centered on the new pool.*